art in action

nature, creativity and our collective future

E A R T H A W A R E
E D I T I O N S

Earth Aware Editions
17 Paul Drive
San Rafael, CA 94903

415.526.1370

www.earthawareeditions.com

Library of Congress Cataloging-in-Publication Data available.

ISBN-978-1-932771-77-0

Palace Press International, in association with Global ReLeaf, will plant two trees for each tree used in the manufacturing of this book. Global ReLeaf is an international campaign by American Forests, the nation's oldest nonprofit conservation organization and a world leader in planting trees for environmental restoration.

10 9 8 7 6 5 4 3 2 1

Cover image: © 2001 *Where Do We Go From Here?*, The Icelandic Love Corporation
Back Cover image: © 2005 *World #7*, Ruud Van Empel
Title page image: © 2005 *Globe in Classroom, Chalmette neighborhood*, Chris Jordan
Page 5: © 2005 *The Source*, Shana & Robert ParkeHarrison

Printed in China by Palace Press International
www.palacepress.com

art in action

nature, creativity and our collective future

EARTH AWARE
EDITIONS

san rafael, california

Natural World Museum

Presented by
Autodesk

UNEP
The United Nations
Environment Programme

This book is dedicated to Richard Vencill Smith,
who provided seed support to cultivate the vision that has
manifested as the Natural World Museum.

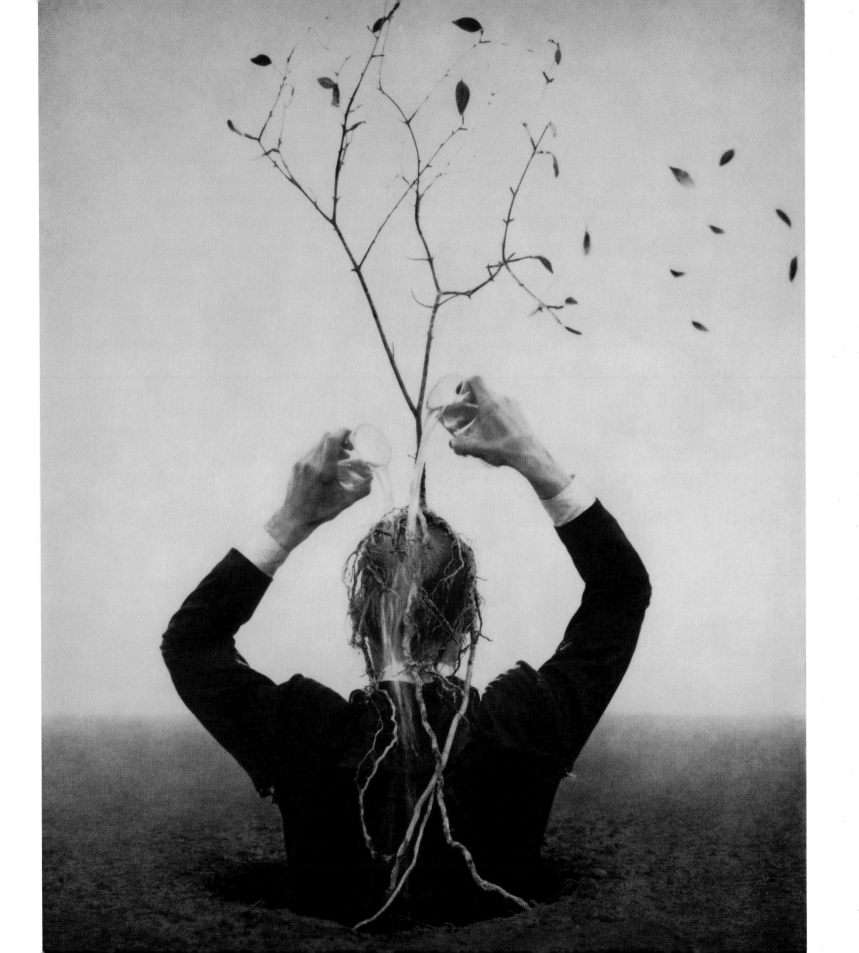

contents

4 protect

3 interact

5 act

preface

The environment can be humanity's greatest friend or, if poorly managed, our most implacable foe. Ecosystems provide our life-giving needs: from the atmosphere that shields us from the sun's rays and supplies the air we breathe, to the broad diversity of life that gives us our food and much of our fabric and building materials. Since the United Nations Environment Programme (UNEP) was founded more than three decades ago, the international community and the people of the world have developed an increasingly sophisticated understanding of both the importance and the fragility of the natural systems on which our society and our development depend and the need to consider environmental questions in all areas of decision making.

UNEP is the world's leading environmental agency and environmental arm of the United Nations System, providing leadership and encouraging partnerships for conservation efforts by inspiring, informing and enabling nations to improve quality of life without compromising that of future generations. UNEP joined forces with the Natural World Museum (NWM) to use the universal language of art as a means to unite people in action and thought across social, economic and political realms. Art in its many forms can stir communities into action, empower individuals and focus leaders' attention on issues that matter.

NWM, in partnership with UNEP, presents art through innovative curatorial programs under the Art for the Environment Initiative, including art exhibitions, international symposia, publications and youth outreach. We hope that in sharing artists' deep sensitivity to the plight of the planet that their art will play a significant role in inspiring people to preserve the natural world. By sharing the images and personal experiences of artists, we hope to rouse reflection, critical thinking and creativity among individuals, communities and leaders from all corners of the earth.

Given the seriousness of the issues, and the truly alarming statistics related to global ecosystem decline, it would be understandable if one took a pessimistic view. Taking a serious environmental issue and moving it into the realm of art enables us to inspire people to unite in positive action and thought. Rather than taking a doom-and-gloom approach, through the Art for the Environment initiative, UNEP and NWM aim to generate enthusiasm. For every problem there is a solution. It is

time for people to become part of the solution.

This process has been evolving over time, marked by milestones such as the 1972 UN Conference on the Human Environment, which gave birth to UNEP; the 1992 Earth Summit, which gave us Agenda 21; the Millennium Summit, where the Millennium Development Goals were agreed to; the 2002 World Summit on Sustainable Development and, most recently, the 2005 World Summit. These conferences have all helped to raise the profile of the environment on the international development agenda, as well as in the minds of the public.

Furthermore, World Environment Day is one of the principal vehicles through which the UN stimulates environmental awareness and action around the world. Each year, World Environment Day is celebrated on June 5th, and NWM has produced art exhibits for WED in San Francisco, Algiers, Algeria and Oslo, Norway.

The fusion of art and environment is a powerful means for effecting positive social change. The work collected in *Art in Action: Nature, Creativity, and Our Collective Future* illustrates the junction between humans and nature. The stories behind each work help us illuminate our present and our future.

In approaching this book, NWM's team curated works of art from world-renowned artists into a bound exhibit that explores the bigger picture of a future we all share. Sixty years ago, the environment was not among the issues that were foremost in the minds of the founders of the United Nations. Today it is evident that if we are to fulfill the promise of the UN Charter—to promote social progress and better standards of life in larger freedom—we will have to intensify our efforts to protect and wisely use what remains of the world's natural capital.

ACHIM STEINER, Executive Director
United Nations Environment Programme (UNEP)
Under-Secretary-General of the United Nations

In 2006, Achim Steiner became the fifth Executive Director in UNEP's history. Before joining UNEP, Steiner served as Director General of the World Conservation Union (IUCN) from 2001 to 2006. His professional track record spans across the fields of sustainable development policy and environmental management, with first-hand knowledge of civil society, governmental and international organizations. Steiner, a German national, was born in Brazil in 1961, where he lived for ten years.

the artists and their stories

In the environmental realm, science and art are inextricably linked. While science determines how we measure the health of our planet — the parts per million of greenhouse gases in the atmosphere, for example, or the genetic changes in species resulting from the loss of habitat due to deforestation — art allows us to visualize our relationship to the natural world. Art has a rich set of tools to represent our world, from irony to allegory, metaphor to humor. In short, science provides the facts while art tells the stories.

We asked the artists to share their stories of inspiration and motivation, and the messages they are imparting through their artwork. For many of the artists, the artwork depicts the representation of the landscape; expresses appreciation for all species; explores our natural world lost, despaired and reconstructed; describes the fantasy of paradises anew and gone awry; and articulates the tension of the role of art between entertainment and education. Together, the stories told by the seventy-nine artists from around the world paint a portrait of our natural world today and the potential pathways — both positive and negative — we may follow from here.

The works speak to us in as many ways as there are artists. Marjetica Potrč has taken an activist position to her artwork, building a dry, ecologically safe toilet in La Vega barrio, a district in Caracas without access to the municipal water system. The photographer Simon Norfolk visually shares the devastation of war upon our landscape. Takagi Masakatsu's video offers an "Eden-like" portrayal of our landscape. Alexis Rockman's depiction of our farmland and Patricia Piccinini's sculpture installations of "the family" contextualize the biotech industry's explosive advances in genetic engineering, creating a scary blueprint of our future. Andy Cao shows us the beauty of a garden created from forty-five tons of colored recycled glass collected from the Los Angeles municipal waste stream. Charles Alexander's lovingly painted portraits of the orphaned great apes living at the Lola y Bonobo sanctuary in the Congo are especially poignant: each of the animals has witnessed a violent death of his or her family by bushmeat hunters. Masaru Emoto's images investigate the effect of human attitude on a molecular level. Newton and Helen Harrison are prophetic in predicting our environmental future of rising waters and disappearing coastlines.

These works are not merely stories, of course. Some also offer social and political commentary. This has long been one of artists' gifts to the world, and as awareness grows about the state

and fate of our planet, a growing corps of artists is addressing environmental themes. But whether overtly activist or not, artists can teach us about the vast and rich web of life, the multitude of species that reside here and the interconnectedness of it all. Along the way, we can't help but learn that even the smallest, most seemingly insignificant creatures affect, and are affected by, humankind's actions and well-being, as well as those of all other living things.

Each chapter asks us to celebrate, reflect, interact, protect and act, demonstrating the diversity of life on earth and the legacy that the next generation will inherit.

Can art really change the environment? Perhaps not directly, but it is a powerful communications medium that can open our eyes, mind and heart. Such stories can play a powerful role, helping us to understand the big picture, view the specific details and connect the dots between cause and effect. As they have in so many other ways, artists' stories help not just to portray an image, but also the "frame" in which it sits. Art can build awareness, the first critical step in changing our collective story from one that exploits and destroys nature for the benefit of humankind, to one that coexists with the natural world, nurturing and valuing it, and all of its life-giving properties.

No book can change the natural world. Yet these stories and artworks, which are as varied as our diverse and beautiful planet, tell a single story: Earth needs our help.

RANDY JAYNE ROSENBERG, Curator
Oakland, California USA

Randy Jayne Rosenberg has curated many art collections for organizations such as The World Bank, the International Finance Corporation and Carnegie Endowment for International Peace. Her curated traveling exhibitions include *The Missing Peace: Artists Consider the Dalai Lama* and *Envisioning Change*. As an exhibiting artist, Rosenberg has had numerous one-person shows at museums and galleries in the United States and abroad.

fred tomaselli

olafur eliasson

walangari karntawarra

alex putney

robert bateman

susan plum

nicholas kahn & richard selesnik

takagi masakatsu

marci macguffie

andy cao

ingrid koivukangas

bernie krause

hirokazu kosaka

jennifer steinkamp

jaune quick-to-see smith

chris drury

 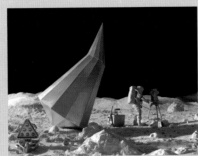

celebrate 1

Immersing ourselves in nature, deeply connecting to it, is becoming a rare indulgence. Few of us read the night sky to navigate or work the land to feed our families. Weeks, even months go by without our bare feet ever touching the earth. We forget what it's like to eat fruit directly from the tree, collect pebbles from a stream or listen to complete silence, free from industrial noise. But while our connection to the natural world may be tenuous at times and nature itself is increasingly compromised of environmental ills, most of the earth's wonders remain intact. The natural world awaits us, inviting us to rediscover it. Artists create a door for us to step outside and revel. With imagination and vision they can lead us down rabbit holes as wondrous as Alice's, and they can show us representations of the world as Eden or invent new universes for us to explore.

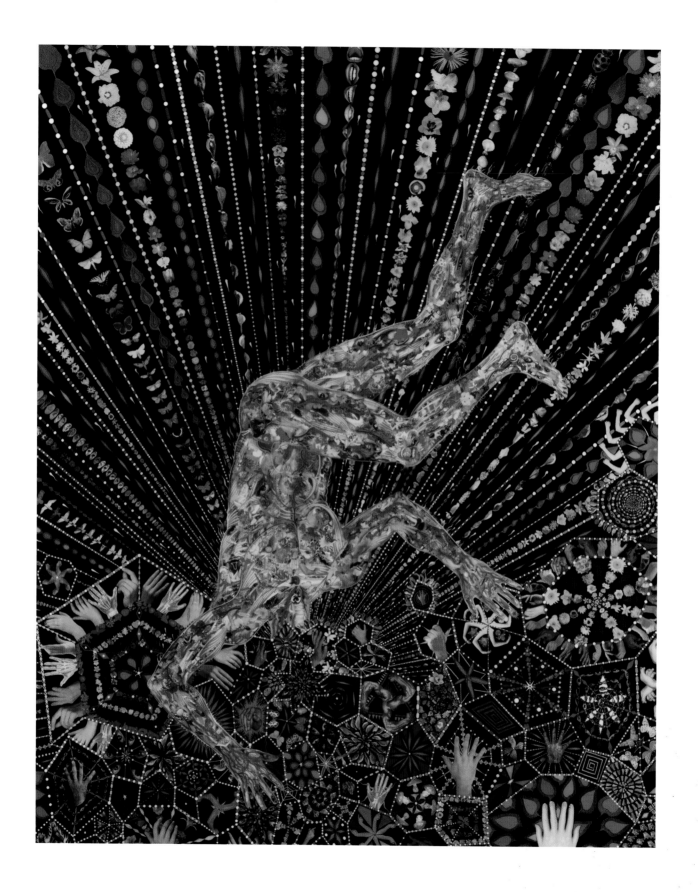

fred tomaselli

FRED TOMASELLI heaps volumes of information into his work, "more than most people can absorb," he says. "It's my personal form of maximalism." Tomaselli grew up in Disneyland-adjacent, a Southern Californian landscape in which "nature always seemed to have the hand of man, where neat orange groves were irrigated by magical spigots that came out of the ground. With my theme park-stoner-agricultural background, my only idea of wild nature was of its fabrications or facsimiles." But Tomaselli soon ventured into the nearby canyons and coastal chaparrals, where green snakes slithered through brown hills and waterfalls trickled into fresh pools without the assistance of pumps and conduit. "When I first went out there and dropped acid, this nature I thought I had been seeing became remarkably complex, and I felt an awareness of the incredible lattice of life."

As a hobby, he began rendering life drawings and academic nature studies. "It was about trying to actually see what I was looking at. The act of trying to describe the world as an artist slowed me down to the point where I could do that." He has shifted to train his eye inward. "I am now trying to describe something a little more slippery. It is about trying to describe my consciousness in a more direct way." His photo collage *Organism*, into which he incorporates datura, rose and hemp leaves, depicts a man losing himself, becoming one with the crowd, like someone who has fallen into a mosh pit. "It makes me think of getting lost in another person, becoming one with nature and being one with chemistry."

While Tomaselli no longer takes psychedelic drugs, he remains awake to the world they revealed to him. "It's something I got from acid and that has been rejuvenated without drugs, through my own immersions in nature and my love of gardening." If he sees a danger in chemicals, it lies in the glimpse of utopia they provide. "I think utopianism is dangerous and generally misguided. It seems that every time people try to create a perfect world they end up inadvertently creating hell on Earth." He cites the hippie era of the 1960s and '70s and the punk rock scene as examples of radical utopian movements that have crashed and burned. "Likewise, our current adventure in Iraq is misbegotten utopianism put forth by the neocons who dream the unrealizable dream that democracy will flourish wherever they decide to drop bombs," he says. "I'm angered yet fascinated to watch all that idealism and enthusiasm wash up on the shoals of idiots."

ORGANISM, 2005
mixed media, photo-collage, acrylic, gouache, and resin on wood panel
2.5 x 2 M

olafur eliasson

'FOR ME, the weather raises so many fundamental and exciting questions about spatial and temporal matters. I am interested in its social potential, its way of influencing our experiences, emotions and thoughts, its dimensionality and unpredictability. Weather makes the notion of time more palpable, as it always involves a movement or flow. It creates a sense of duration, weaving together what may otherwise appear as individual moments in our lives. Despite meteorological predictions of the future, the unpredictability of the weather makes it a phenomenon that cannot be colonized or turned into a commodity. It still retains the qualities of a public domain.

"The weather is important both in relation to us as individuals and as a community. Generally I believe that one cannot separate the individual from her surroundings. Changes in the weather—not just climate changes, but also the many changes that occur during a single day—may influence our experience of space and situations, whether in urban or less mediated settings. It also has an enormous potential as a social organizer in that it constitutes a kind of shared environment and physicality. If I, for instance, travel alone, my sensitivity or engagement in the weather and its relation to the landscape may be completely different than if I experience the weather and landscape in the midst of a group of people; that is, in a different social setting. Changes of weather, on both a micro and a macro level, ultimately reconfigure the conditions of our lives and our identity."

THE WEATHER PROJECT, 2003
monofrequency light, reflective panel, hazer, mirrored foil, steel
27 x 22 x 1,554 M

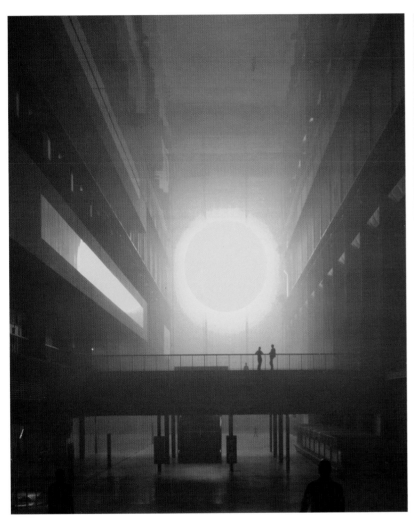
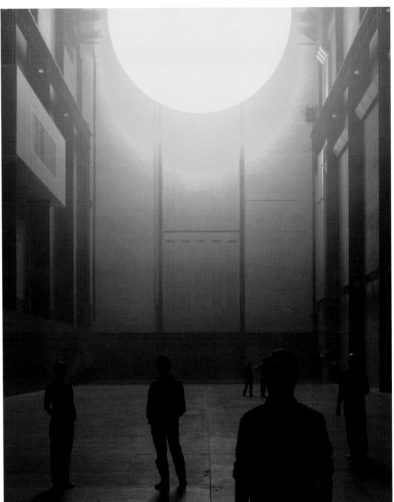

walangari karntawarra

KARNTAWARRA IS the Australian Aboriginal name for the female creator, and her lineage can be traced all the way to the present day. Perhaps because Walangari Karntawarra is said to be her direct descendant, or perhaps because he is simply a talented and intuitive artist, his work evokes a powerful connection between the past and the present and between mankind and the Earth. He says his paintings are "like a bridge between Aboriginals and the white fellow."

Karntawarra says that Aboriginals approach all their relationships with a unique intimacy, especially their relationship with nature and with the land. "When we talk about our country, we are talking about our family. It's not an inanimate object, it's our mother, and like our mother it gives us life." He explains the Aboriginal story of creation: "When we pass away and we go into the realm of the spirit, our spirit goes into a holding place, and that place is the Milky Way. We become stars, born in the heavens, and when we come back, it is as a falling star. We become a part of the Earth again. We contain all the elements. We become a part of everything. We take on a new life in the natural world. Maybe as a human or maybe an animal or even a tree or a rock. Never as a building or a car. Then the cycle starts again." The Aboriginal belief in reincarnation brings a sense of the sacred to their world. "You don't know if that tree is your brother or your sister. You have to look after everything because it is sacred."

Karntawarra's paintings are not figurative, and yet they accurately depict this sacred world. "My signature is using chaos. People are captivated by the bright colors and organic patterns. They relate to chaos because chaos is part of the universe. Whatever you do follows the order of chaos." Karntawarra instinctively employs sacred geometry and fractals like the Mandelbrot set—"God's thumbprint"—thus simultaneously painting the inner world, outer space and the places we inhabit in between. "Because it is organic, it makes people feel that they can relate on a cellular level." He feels that viewing his art is a purely individual experience. "Everyone sees what they want to see—divers and surfers see the coral reef, astronomers see the sky, biologists see cell structure. Because I paint chaos, it is all those things."

WATER DREAMING 951, 1997
acrylic on canvas
30 x 61 CM

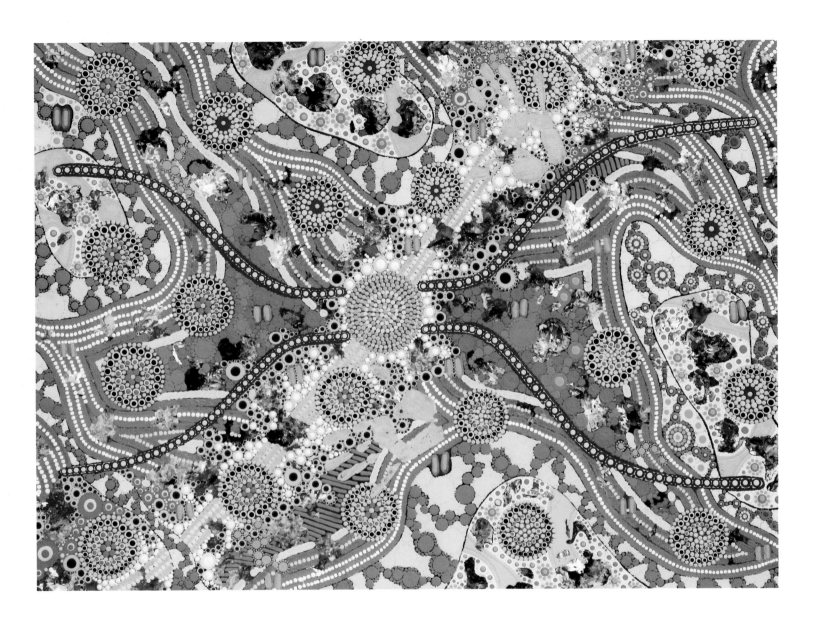

alex putney

A S HUMANS, we are often limited by our willingness to accept only what can be perceived with the five senses. But in denying what is not apparent, we miss out on a world rich with information. Alex Putney's work taps into that world by using the tools of science to map sacred geometry that recurs throughout the natural world—from the subatomic level to the stars and galaxies. He incorporates hard data into artworks that support his Vedic worldview. "It is a spiritual work, but the language I am using is scientific," he says. He is particularly interested in the power of resonance. "Our ancient sacred traditions teach about the inaudible patterns of vibration that unify consciousness, imperceptibly aligning the chakras of the human body with the chakras of the earth."

Putney is concerned about the high-frequency sound waves given off by much of our modern technology and how they might be affecting our biorhythms and chakra alignment. "The collective effect of these high frequencies is negative to the human body, particularly to the water in the body." He says that exposure to low-frequency sound from instruments like the didgeridoo or from Tibetan chanting counters these effects by synchronizing the rhythms of the brain and crystallizing the water in the body. "Consciousness shifts down into a meditative, long-wavelength pattern, which is where the beneficial effects of meditation begin."

Vibrations occur on a macro level as well. On December 7, 2001, the Naval Research Laboratory's GOES-10 satellite survey of the Pacific region recorded anomalous atmospheric conditions. Infrared observations revealed an octagonal tiling of oscillating concentric circles. The unusual data was archived on the Kauai Naval Research Laboratory's Web site. Putney integrated the satellite images in a digital rendering to illustrate how the entire earth was unknowingly touched by this event, as it encircled, and in that sense united, the entire organism of the planet.

Nature observed through the filter of science becomes systematic and, on a geometric level, almost uniform. Patterns found in brainwaves are repeated in storm systems and in the atmospheric vortices of gaseous planets. "My inspiration was the mandala, the circle within a square that appears throughout art history and the semiotics of humanity," says Putney. "It is found in Egyptian temples as the Coptic cross. In Buddhist temples it is the Kalachakra. And in Mayan temples it represents Hunab K'u, the Universal Creator. This mandala pattern is produced by quantum iterated functions and can be applied to the universe both on the micro and macro levels simultaneously."

Putney's images use the lens of science to focus on the light of spirituality. "Although I am not a scientist, I am synthesizing the work of scientists. I feel that these images are analytical in their nature and application," he says. "Ayurvedic science and psychoacoustics open the door to expanded consciousness, to which indigenous wisdom keepers have remained keenly attuned."

OCTAGONAL QUANTUM FRACTAL, 2006
digitally iterated function
61 x 61 CM

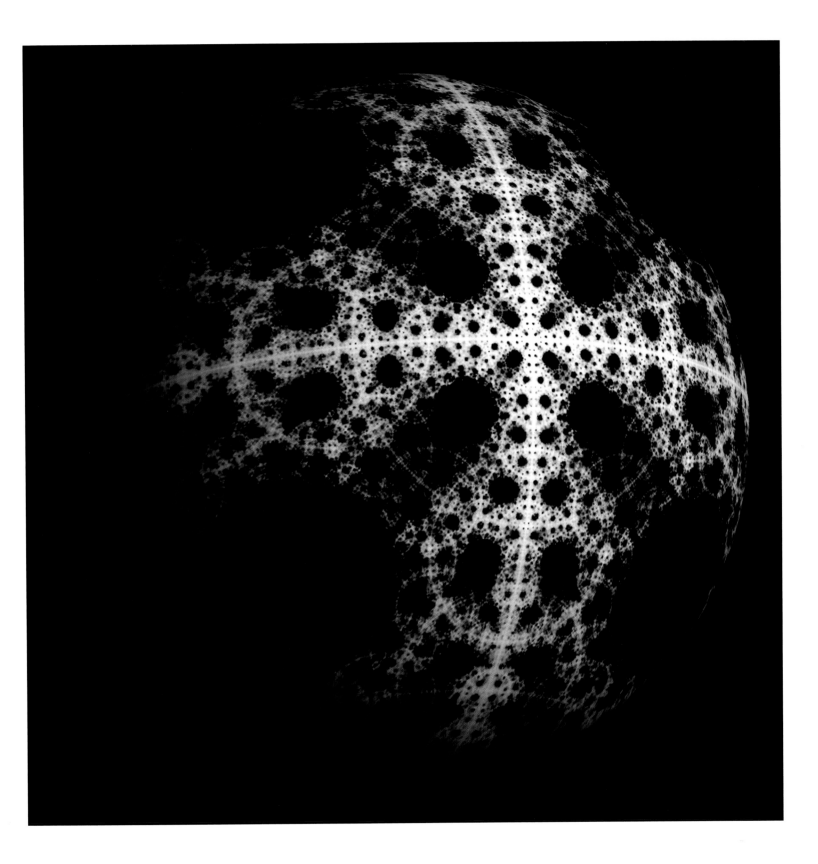

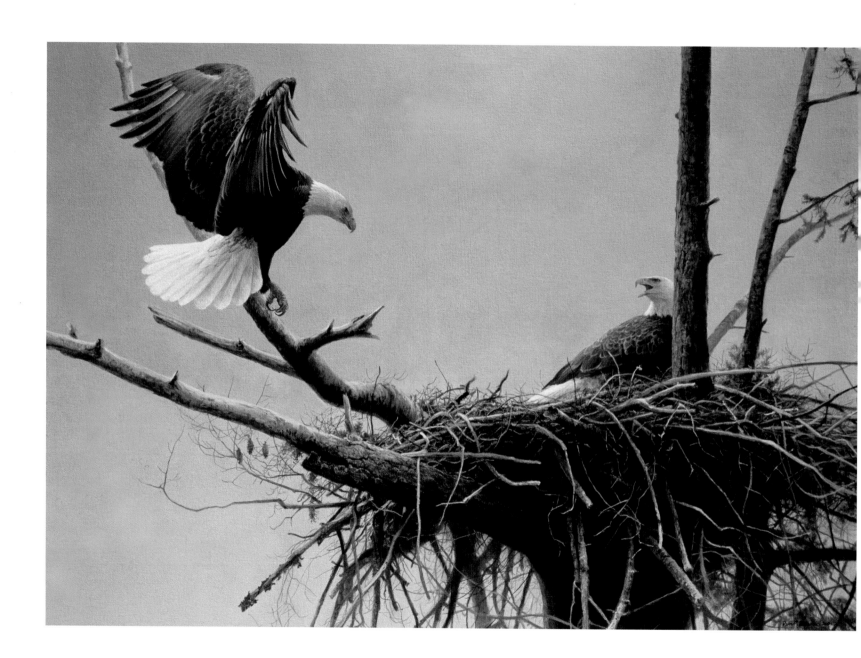

robert bateman

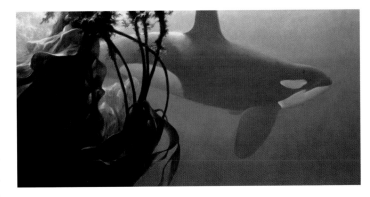

'THERE IS an old song entitled 'The Best Things in Life Are Free,' but the best things in life are not free any more. Clean air, clean water, the song of a bird were once free. Now these things and all the ecosystems they rely upon are available at a cost. If we want to have them, we have to spend.

"Woody Allen has described nature as basically 'one big restaurant.' Perhaps, but in nature there is no free lunch. We have been taking and taking from nature and spending little on renewal and restoration. We can pay now or we can pay later, but if we pay later, it will cost a whole lot more.

"Do coal-fired generating plants produce cheap electricity? Where on the price tag does it mention the long-term cost? Is dumping dangerous chemicals into the Love Canal, where it then seeps into the Niagara River, a cheap way to dispose of chemicals? No, it is actually extremely costly in human and financial terms. We need to do a true cost accounting in all our economic activities. Our cost-cutting society is living in a destructive dreamworld.

"In the lyrics of 'The Big Yellow Taxi,' Joni Mitchell pleads, 'Say to the farmer, put away your DDT now, give me spots on apples but save me the birds and the bees.' I ask, would you buy apples with spots and even pay more for them if it meant that we could save the birds and the bees? What about paying more for all our agricultural products if we could eliminate pesticides and bring back the viability of the family farm? Would you pay more for shrimp if it meant we did not have the wasteful slaughter of "by-catch," which is a result of large-scale, industrial fishing? Would it be worth a few more pennies for our paper if we could get rid of dioxins and furans? I hope that the answer is yes, because the best things in life are not free." bring back the viability of the family farm? Would you pay more for shrimp if it meant we did not have the wasteful slaughter of "by-catch," which is a result of large-scale, industrial fishing? Would it be worth a few more pennies for our paper if we could get rid of dioxins and furans? I hope that the answer is yes, because the best things in life are not free."

above: OCEAN RHAPSODY-ORCA, 1999
acrylic on canvas
1.2 x 2.4 M

opposite: THE RETURN, 2001
acrylic on canvas
91 x 122 CM

23

susan plum

I N MARCH 2006, astronomers using the Spitzer Space Telescope observed a highly unusual nebula in the shape of a double helix, similar in form to DNA, situated near the center of the Milky Way. Its size is hard to fathom; the scientists estimate it to be around 80 light years in length. Like a sprinkling of iron filaments responding to the pull of magnets, interstellar dust and gasses trace magnetic fields in the atmosphere to create nebulae. But most develop into indistinct shapes or, at best, appear as spirals. This double helix formation, however, indicated "a high degree of order."

Susan Plum translates the beauty and mystery of nebulae and cosmic knots into works of art. Manipulating the earthly elements at her disposal—propane, oxygen, liquid, glass and a blowtorch—she creates "drawings in space," three-dimensional glass works. She then translates them into two-dimensional drawings and paintings, such as *Naturaleza Extrana (Strange Nature) I*. Plum says she was particularly amazed by the images of the helix because of its proximity to the

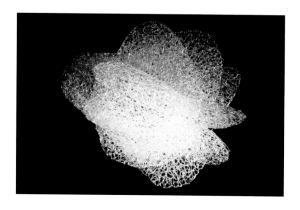

massive black hole at the center of the galaxy. As a student of pre-Hispanic spiritual traditions and of Mayan culture, she knows that in 2012 the Mayan calendar ends with an unprecedented astronomical alignment of planets at the galactic center. "This DNA-shaped nebula is directly in that alignment," she says. "It seems the Mayans were on to something."

The interplay between ancient traditions and modern times informs much of her work. "The woven work in glass that I have done over the last several years was originally inspired by the Mayan goddess Ixchel, the first weaver of the Americas. I later discovered that Mayan and other Mesoamerican traditions use the weaver's loom as a metaphor for the universe. The loom of the universe is believed to be constructed of filaments of light, from which the heavens and the earth are said to be woven. These woven strands of light can become entangled around the earth, and it is the job of Mayan shamans to untangle this 'discord.' Thus, the act of weaving, for the Maya, symbolically rebuilds and re-energizes the world."

above: XOCHITL I (FLOWER I), 2005
flameworked 2mm pyrex glass
61 x 48 CM

opposite: NATURALEZA EXTRANA I (STRANGE NATURE I), 2006
mixed media on board
1.2 x 1.2 M

art in action

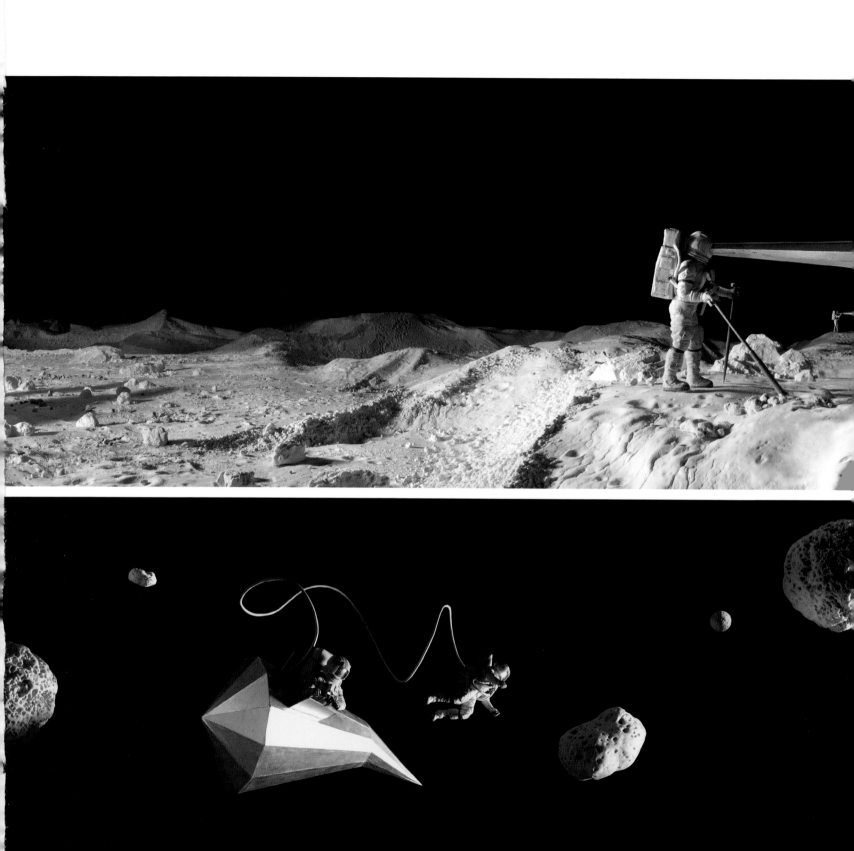

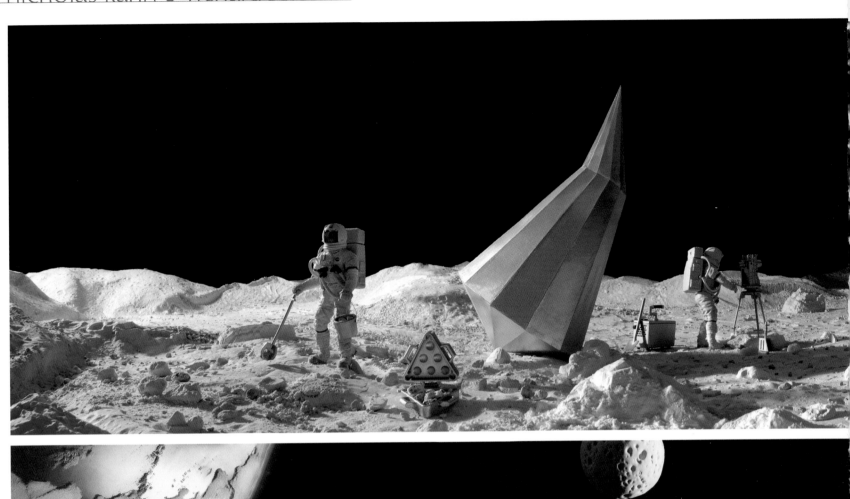

nicholas kahn & richard selesnik

NICHOLAS KAHN and Richard Selesnick have been collaborating since the 1980s on panoramic photographs and sculptures that portray fictional worlds, historical events, and the expeditions of the Royal Excavation Corps. Each pictorial series is accompanied by complex texts and curious artifacts that enhance the viewer's sense that these alternate realities might actually have existed. The inclusion of invented language and ritual, with references to actual historical events, further blurs the line between imagination and fact. The Apollo Prophecies take place simultaneously on the moon in Edwardian times and in the late 1960s. Kahn and Selesnick provide highly stylized texts that complement the nonlinear history-bending aspect of their work. A short excerpt from the Apollo Prophecies text follows:

It is a little-known fact that when the Apollo astronauts returned from the moon, they brought back evidence of a previously unknown lunar expedition. This evidence consisted of several cardboard canisters containing lunar breccia, and, more significantly, a document written by the early explorers that prophesied the future arrival of the NASA astronauts themselves.

Most saw the document as a forgery, not least because the early explorers viewed the coming astronauts as cosmic deities. Whether authentic or not, the spirit of the prophecy is hard to deny—if any man is to be transformed into a god, what better candidate is there than one who has ascended into the celestial sphere and stood alone on a distant world?

overleaf: APOLLO SERIES: LUNAR LANDING, 2004
archival digital print
25 x 183 CM

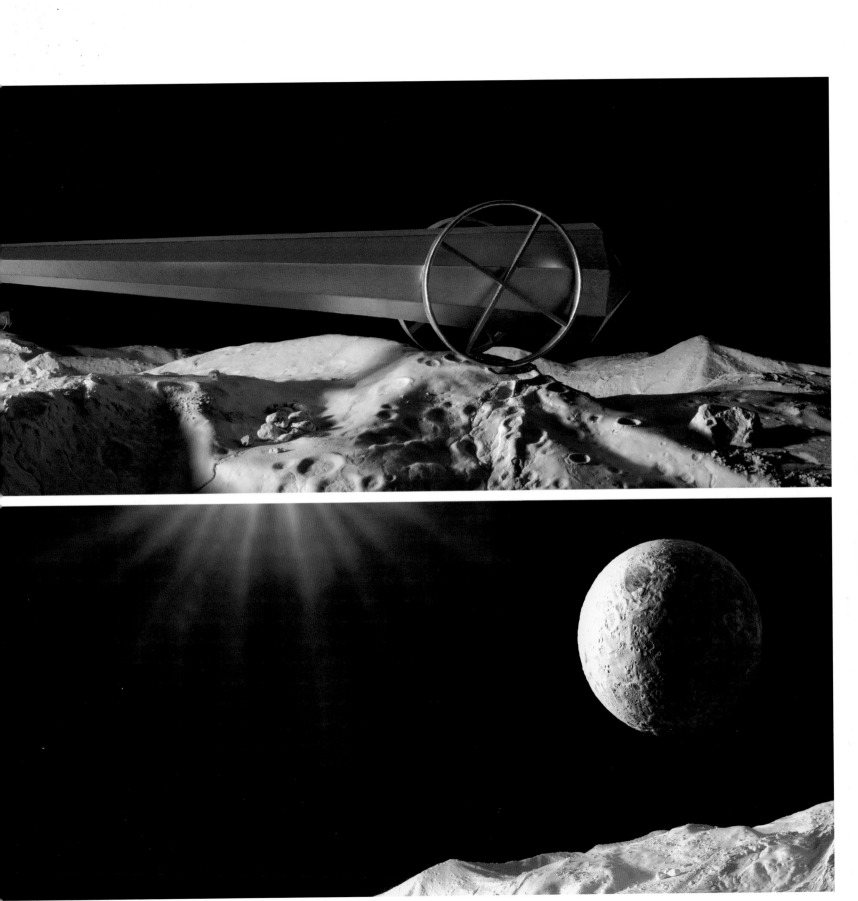

takagi masakatsu

K YOTO NATIVE Takagi Masakatsu reminds us to delight in the natural world. Whether creating computer-generated collages and animations or many-layered audio arrangements, Masakatsu has a light, playful touch. He says, "If I walk into the forest, sometimes the colors and sounds surround me. Not always. If I can be there in that moment, I can see the color of wind or the movement of tiny things. I just watch carefully and follow and imitate those things. For example, the wind in springtime looked pale yellow in my eyes. That's strange, but those things happened to me several times. Maybe it's just my imagination, but maybe not."

above and opposite: THE COLOR OF EMPTY SKY, 2005
video stills
5 MINUTES, 4 SECONDS

marci macguffie

INSTALLATION ARTIST and painter Marci MacGuffie finds inspiration in the patterns of nature, particularly in the movements of things delicate and filamentous. She observes grasses, feathers and hair moving in the wind, yet she does not attempt to control these forms in her work. "As a frenetic enthusiast, I examine simultaneous flows of nature, embracing all energetic forces as more than arbitrary occurrences," she says. As an artist, MacGuffie creates site-specific environments and then observes their evolution as they are subjected to the forces of nature—specifically, the force of human nature. Viewers are invited to interact with her artworks by rearranging the many magnetized brushstrokes she affixes to walls that have been coated with ferromagnetic paint. Her aim is to work beyond the boundary of the rectangle and "fracture the space" between the artist, the viewer and the art. She begins each piece by setting a tableau of repeated lyrical patterning from the natural world, but as the installations are transformed through human intervention, new patterns emerge. The words "peace" and "love" sometimes appear. Some people leave a name; others create faces. The markings all reflect the human desire to affirm individual existence and to make oneself known.

MacGuffie's drawings and paintings exhibit the same attention to pattern and flow. While her installations are an invitation to the viewer to participate in the "athleticism" of creation, her drawings and paintings come from her own internal, physical reactions to the environment around her— from mockingbirds mimicking cell phones on the street to the light coming through the window. In *Hummingbirds Cannot Be Trapped* she is responding to the unique nature of these tiny birds, their energetic hovering and the almost imperceptible velocity of their wings. "Hummingbirds will die if they are caught indoors. I relate to that, but not in the obvious sense that I would rather not be caged. Instead, I feel that the best things cannot be contained—things like inspiration." MacGuffie holds the optimistic view that when the right causes and conditions arise, good ideas emerge.

ESCAPE CLAUSE, 2006
ferromagnetic paint, magnets, wood, plexiglass
DIMENSIONS VARIABLE

andy cao

When Andy Cao's *Glass Garden* was situated in his backyard, the woman next door peeked over the fence to thank him. She said her hyperactive kids became mellow when they gazed at the blue expanse of glass gravel, which he had arranged into a landscape based on his childhood memories of Vietnam. "There is something about cobalt blue that mesmerizes, it is so rich and deep," says Cao. "Glass is translucent, so it constantly changes throughout the day, and as it changes, your mood changes. It affects you psychologically. In the morning it is calming and soothing, at noon it becomes very energetic and bright, and when the moon is out it has an incredible lightness. There is nothing like walking on glass pebbles in the moonlight—it's like treading on gems, like walking on water. You don't realize it's forty-five tons of glass."

Americans dump more than ten million tons of glass into the municipal solid-waste stream every year. Only about 20 percent of that is recovered for recycling, a process that requires a good deal of energy. The used material must be pulverized and then heated to temperatures of 2,600 to 2,800° Fahrenheit. Ten years ago, in search of a new medium for his landscape design, Cao found himself standing on a mountain of broken plate glass. "As I was looking at this raw material, things just clicked. Why not play with it? Here is something so beautiful, why not make use of it?"

Cao was a pioneer in the use of glass gravel, but the technology had to catch up with him. His first bucket of broken windshields was too sharp to be garden-friendly. At the recycling plant, bottles of different colors were all crushed together, but Cao wanted to use the browns and greens and blues separately, painting the landscape with washes of glass. By trial and error, invention and resourcefulness, he has introduced recycled glass into the world of art and landscape architecture. It is a welcome addition to the landscaper's tool kit, especially as urban sprawl is sending homeowners deeper into thirsty desert settings, where lush lawns have no place. Glass gravel can now be bought in various gradations of color and texture, and Cao is developing glass tiles that retain the character of the original bottles. "But," he says, "I'm not as interested in products as I am in how we can reinvent humble, everyday materials and use them to create total environments."

THE GLASS GARDEN, 1998
recycled glass installation
DIMENSIONS VARIABLE

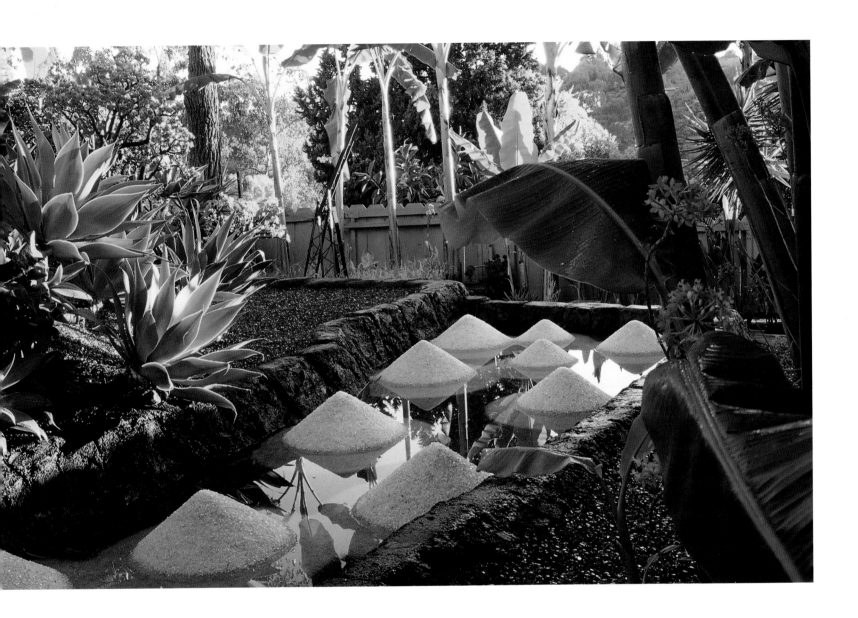

ingrid koivukangas

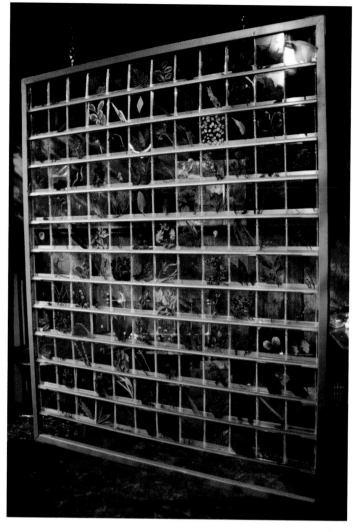

LAND-BASED environmental artist Ingrid Koivukangas is a first-generation Finnish-Canadian. She traveled to Finland in 2001 as artist-in-residence at Svenska Konstskolans i Nykarleby Vänner, an artists' colony on the Baltic Sea. She arrived in mid-March, at the tail end of the "time of darkness" and immediately set out for Lapland.

"My cousin Vesa has a lodge in Lapland and invited me to join him and his family in Yllas, north of the Arctic Circle," says Koivukangas. "The land was still white with snow and ice but daylight greeted me every morning. I discovered that early spring daytime temperatures do not exceed -20°C. At night the sounds I thought were rifle shots were actually tree limbs exploding as they froze in the -40°C air. If this is spring, what could it possibly be like in the middle of winter, surrounded by darkness and certain death, should one venture forth dressed inadequately?

"My entire life I'd been told of Finnish *sisu*—our toughness, our ability to beat the odds, our determination. My ancestors relied on their sisu to survive for generations in the harsh, dark, cold land. Yet with its harshness comes an awesome beauty. As I stood beneath the northern lights, watching them dance, hearing them crackle and sigh, I began to understand more deeply why I had been taught that all things are sacred, that each animal, rock and tree is alive with spirit and is to be honored— that we coexist with all other living beings on this earth. I felt a deep reverence for this land that had provided sustenance and shelter for countless generations. My ancestors—and yours— could not have survived if they had not realized and honored their connection to the natural world. And we will not survive if we don't begin to remember, if we don't begin to hear our ancestors' voices."

FIVE CIRCLE PROJECT: VANCOUVER, 2002
natural materials housed in 144 cases
152 x 168 CM

bernie krause

NORTHEAST OREGON. Lake Wallowa. While collecting oral histories, music and natural sound in Idaho and central Washington, my colleague and I met many Nez Perce Indians who wished to have their traditions preserved and so permitted us to record their stories. Personal exchanges of family histories played an important role in establishing trust over a period of many months. From the combined perspective of artist and naturalist, I have long been intrigued by the ways in which members of nonindustrial societies appear to use the sound of their respective habitats. For example, many groups are able to determine the type, number and condition of game and other creatures hundreds of yards away through dark undergrowth by sound alone. It is astounding how closely the music in these cultures reflects the complex rhythms, polyphonies and sonic textures of the habitats where they thrive. One tribal elder we interviewed, Angus Wilson, suddenly became very pensive and quiet one afternoon when I told him that I was a musician. "You white folks know nothing about music," he said, half-serious, half-teasing me. "But I'll teach you something about it, if you want."

Early the next morning we drove from Lewiston to Lake Wallowa, one of the many campsites in northeastern Oregon where Chief Joseph and his small band of Nez Perce lived and hunted for centuries. Wilson led us to the bank of a small stream and motioned for us to sit quietly on the ground. In the chilly October mountain air, we sat huddled in fetal positions, arms wrapped tightly to our sides, trying to keep ourselves warm for the better part of an hour, every now and then glancing in the direction of Wilson, who sat stoic and motionless upstream about fifty feet away. For a long time we heard nothing except for the calls of a few jays and ravens. After what seemed like a very long period, a slight breeze came from up the valley and began to stir the branches of some of the aspen and fir trees. Suddenly, from nowhere, the whole forest burst into a cathedral of sound. As though from a huge pipe organ with all the stops out, a cacophonous chord echoed from everywhere throughout the valley. Wilson, seeing the startled look on our faces, walked slowly in our direction and said, "Do you know what makes the sound yet?" "No," I responded, shivering and irritated. "I haven't the slightest idea." Without another word, he walked over to the bank of the stream and, kneeling low to the water's edge, pointed to the different lengths of reeds that had been broken by the wind and the weight of the newly formed ice. Slipping a hunting knife from the leather sheath hanging at his belt, Wilson cut one of the reeds at the waterline, whittled some holes, and, without tuning the instrument, brought the transformed reed to his lips and began to play a melody. After a long while he stopped and said with quiet assurance, "This is how we learned our music."

—Excerpt from *Into a Wild Sanctuary* by Bernie Krause

above: BERNIE KRAUSE IN THE FIELD

hirokazu kosaka

'STEPPING OFF the bullet train. 12:57:24. I arrive at the Kyoto train station precisely on time. To my left stands an eighth-century, five-story Buddhist pagoda, and on my right, a cab with an automatic door and a five-inch Sony TV on the dashboard, waiting for me to enter. I arrive at my family's 800-year-old home, where my father greets me from his gravel garden. He points up to the eaves of the house. There I perceive a spider I have known from my childhood. My great-grandfather told me once that this spider hails from a line of spiders that can be traced to a seventeenth-century ancestor.

"The word 'verandah' originates from an old Sanskrit term meaning to 'meet.' The Japanese word is *engawa*, written with two Chinese characters, *en* (relation, fate) and *gaga* (side, edge). The verandah space plays matchmaker, belonging to both exterior and interior spaces. The verandah is an in-between space where people encounter both nature and artifice. Nature, the outer realm, wild and not man-made, and the human house, the bold landmark of human existence, are joined at the verandah. A man-made construction for entirely human pleasures, the verandah is decidedly not natural. But unlike a room in the house, the verandah is distinguished by its natural elements, by its inclusion of nature. The open air and view, where birds and insects mingle, is the primary attraction of the verandah. Whereas a room divides spaces into inside and outside, the verandah embraces both. It is both natural and not natural. It is neither black nor white but all the shades of gray. The verandah is not a yes or a no, but infinite maybes. The verandah is an embodiment of ma, a space-between, in physical form.

"My mother serves us a wonderfully simple meal of miso soup. The soup arrives in delicate lacquerware bowls, each capped with a thin lid. She removes a lid, releasing the steam and the scent of the soup. My mother turns over the lid and, gazing at the moisture condensed on the underside, gasps and says, 'How wonderful the verandah looks today.'

"The verandah does not end at its wooden edges. As a construct for the inclusion and enjoyment of nature, the blurry boundary of the verandah extends outward, into the air, the breezes, the plants and scenery around it. According to a commentary of seventeen-syllable verses, the four seasons of Japan are divided into as many as seventy-two subseasons and have names with sensory appeal, like spring mist, hazy vernal moon, breeze in the pine tree, summer dodo, chirping autumn insect, red maple leaves and snowy view. Nature is defined by the feelings and sounds it evokes. And it is these sensations that define the verandah. Without the breeze, the murmur of nature's activity, and the sway in the day's temperature, a verandah is not a verandah."

FROM THE VERANDAH, 2003
installation
DIMENSIONS VARIABLE

jennifer steinkamp

DERVISH CONSISTS of four high-definition projections of individual trees, whose twirling branches are inspired by a ritual practiced by the priests, or dervishes, of the Mevlavi sect of Islam. In a trance, the dervishes whirl in a motion that symbolizes the soul's communication with the divine and its release from earthly ties. In Steinkamp's piece, the movement of the branches contains elements of both release and containment—while the whirling motion of the trees is fanciful and seemingly enchanted, their movement is limited by their roots.

With "the mechanism of our senses" in mind, trees rightfully assume meaning: as fellow citizens, they carry self-awareness and embody a kind of consciousness. And it is tremendous, marvelous, to observe a tree stretching, yawning and sincerely enjoying being a tree (meanwhile by the curb we see the dejected urban tree, sometimes with its once-pliable limbs torn off). A cognizant tree's leaves curl and receive, and its branches twist, beckon and murmur. Tree sitters attempt to translate and convey a tree's desires, its capacity for empathy and a bottomless sorrow for humankind's short-sighted destructiveness.

Trees invite us to watch and smell and sense warmth or cold or dampness, to revel in the sensation of bubbles of beer squeezed through the tube of the throat, sparkling and detonating on the way down, to interrupt workaday concerns for the pleasure of playing with a cat. Or to rest your sword blade against the tree, gratefully slide to the ground to admire a red-capped toadstool.

—Excerpt from *Fruiting Bodies* by Gail Swanlund

DERVISH, 2004
digital animation, projection
CONTINUOUS VIDEO LOOP

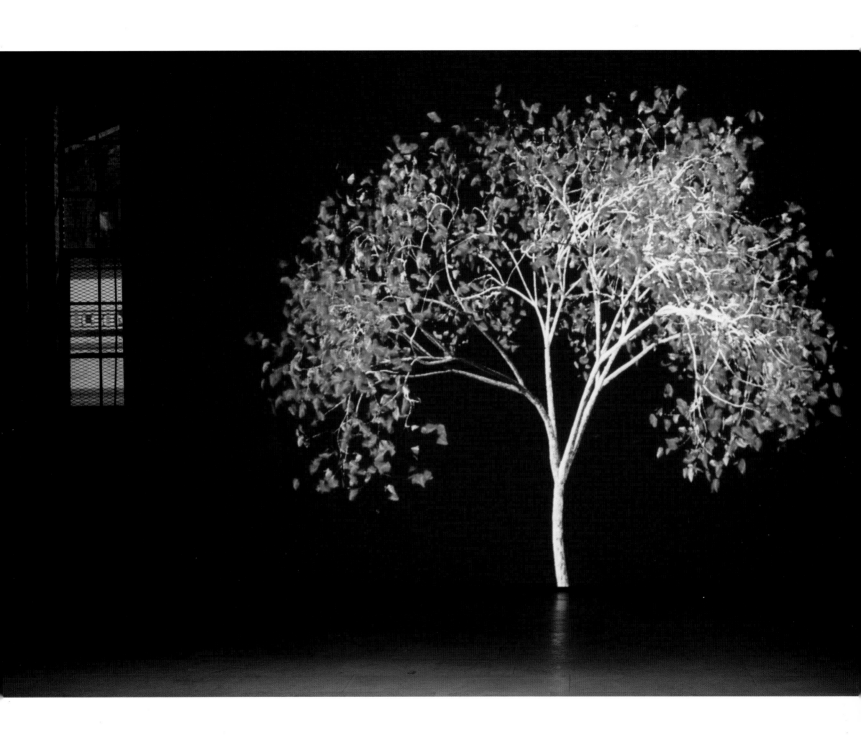

jaune quick-to-see smith

'MY INSPIRATION is my Native philosophy, which is steeped in hard science. I believe this holistic view can save the planet. Many scientists, writers and naturalists, such as David Suzuki, spend time with the Native American community to learn more about this science.

"This planet that we all share is the life-giver for every living thing, including the people. Our food, water and the air we breathe is made here. Early humans, all tribal peoples and Native Americans refer to our life-giving planet in the female gender, a goddess form that gives birth to all of life. Euro-Americans have become detached from that image and ruthlessly pillage our resources in a non-sustainable way, threatening the future of all living things including we human beings. My painting *Carousel* depicts a female form in traditional Native dress to represent the life-giving planet with symbols for plants, animals and humans suspended from the edges. The title metaphorically refers to the seasonal movements in a circle or the cyclical rotation of night and day.

"I can only hope that humans will begin to understand that their bodies are molecularly made of the same soil, water and air as all the plants and animals. For when they finally come to that reality, they will see that caring for this planet is the same as caring for their own bodies."

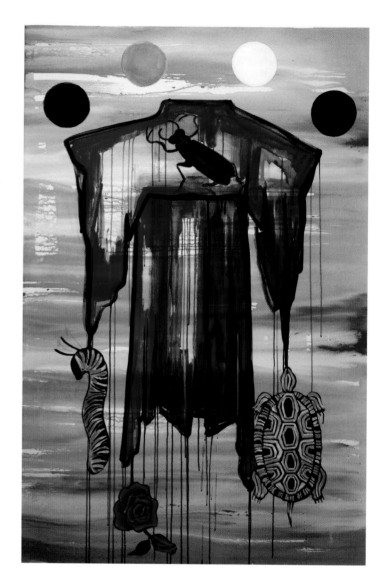

CAROUSEL, 2004
oil & acrylic on canvas
2 x 1.2 M

chris drury

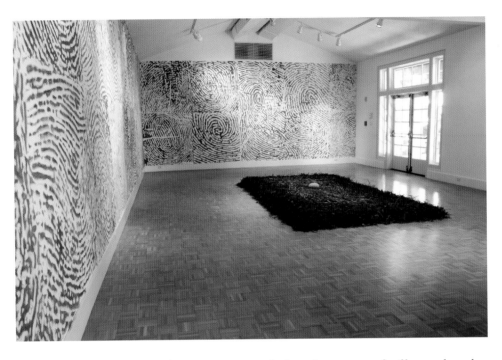

OUR FINGERPRINTS mark where we touch the world. They also map our individuality. But when enlarged to the massive scale used by Chris Drury in his installations, they become foreign landscapes. We could easily get lost in their mazes.

In his ongoing explorations, Drury has chosen the omnipresent form of a spiral to illustrate the connection between micro systems and macro systems, the external universe and the universe within. And he is passionate and tireless in his artistic expression. "I think creativity is a survival mechanism whereby the ones who survive are the ones who can think their way around problems."

Whorls: Installations by Chris Drury includes a wall of conjoined fingerprints magnified thousands of times and rendered in earth from outside the gallery, as well as two other site-specific, nature-based works. He has carefully arranged branches in the center of the room in a pattern based on the cardiac twist, a double spiral that describes the movement of blood in the heart. "It is a pattern that can also be found in fingerprints as well as in many places in nature," says Drury. Taking the pattern upward and outward, he and his assistants constructed the third piece—a mammoth sixty-foot vortex of willow and poplar sticks woven around a redwood tree in Southern California.

Drury's work sheds light on what seems like a secret code of the natural world. The simple whorl on the tip of your finger is cipher to the greater order of things. It is written in the human heart, in the flow of sap in a tree, in hurricanes and in the Milky Way. The next time you watch the water swirl down the drain, or your heart skips a beat, you might want to pause and remember that we are all connected to something so much larger than what is apparent.

FINGERPRINT (FROM INSTALLATION AT VILLA MONTALVO, SAN JOSE, CALIFORNIA), 2005
installation
DIMENSIONS VARIABLE

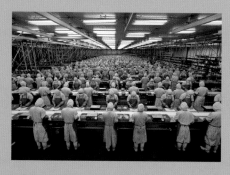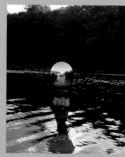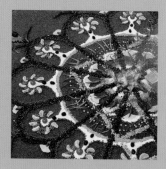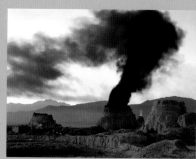

ruud van empel

lori nix

edward burtynsky

simon norfolk

chris jordan

nancy chunn

laura mcphee & virginia beahan

katrín sigurðardóttir

william kentridge

pat steir

joe mangrum

mark dion

leslie shows

erick swenson

verne dawson

sven påhlsson

chester arnold

sant khalsa

adriana varejão

yoko inoue

john lundberg

susan magnus

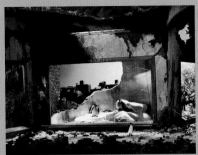

reflect 2

If, as they say, the revolution begins from within, cultivating an awareness of nature can be a form of environmental activism: when we take the time to consider our surroundings, there is a shift in the way we approach the world. The images these artists present might be grim or discomforting, but they might also inspire wonder in the most ordinary things as long as we are willing to open our eyes. Seeing and contemplating are the antidote to apathy and indifference. By letting stillness overcome busyness, we become reflective, like a lake after rain; the turbulent concentric circles fade out and the surface mirrors the sky. We can generate understanding and appreciation, and discover incredible strength and beauty as well as savage cruelty and decay. It doesn't just surround us, it is within us—our own beauty and cruelty, our own majesty and mystery, is reflected throughout nature. We see mirrors of ourselves in atoms and garbage heaps, in fractals and factories, in primates and poppies and galaxies. Art has the power to arrest us, stop us in our tracks and make a connection with the profound universality extant in nature.

ruud van empel

RUUD VAN EMPEL creates illusory worlds of hyper real, lush nature that are populated by enigmatic adolescents. These fresh-faced babes are both transfixing and unsettling. They appear at the edge of their innocence, on the brink of discovering that the fairy tale is not as it seems. What kind of world will the children inherit?

Van Empel uses photography and computer technology to assemble images that trick our perception. His work creates a balance between reality and perfection, a cross between narrative painting and staged photography. The viewer peers into an artificial world in which life is on display, a showcase of idealized beauty in a secluded world. It is attractive and unattainable. And in its midst, we find children who possess a dignity that the polluting masses have lost.

WORLD #3, 2005
cibachrome
84 x 59 CM

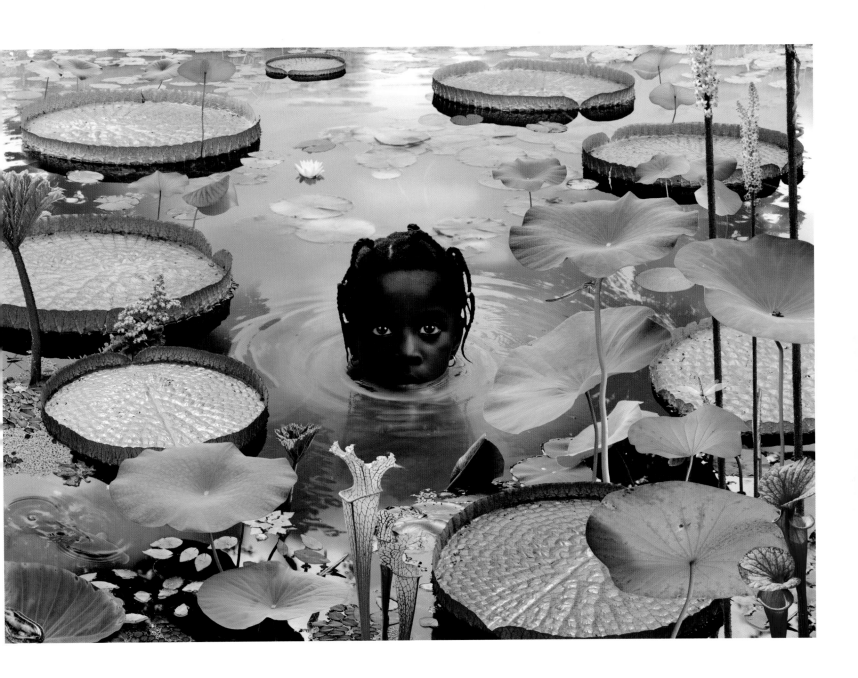

WORLD #7, 2005
cibachrome
1 x 1.5 M

lori nix

ONE WEEKEND when Lori Nix was in junior high school in Topeka, Kansas, she went to the movies. *Something Wicked This Way Comes* was playing. As the film was reaching its climax, a voice came over the loudspeaker calling Nix to the concession stand. A couple of annoyed teenagers booed her in the darkness. She found her father in the lobby, on a rescue mission. When they left the theater, Nix discovered that part of her town had been clawed by Mother Nature. A tornado had ripped through her neighborhood, tearing roofs off houses and felling trees. "I was totally excited by it," she recalls. She went out to play in the woods and found a stove that had been set down there by the tornado. "It still had a ham in the oven, nearly cooked to perfection."

Propelled by her continued fascination with the uncontrollable physical world, Nix creates miniature vignettes in which nature challenges human progress. She began by building miniature dioramas influenced by the aesthetic of the disaster movies of the 1970s—floods, tornadoes, blizzards and insect infestations. In her recent works, nature continues to dominate but on a more intimate level—ants on a cupcake, hornets in an abandoned museum. "Things are cyclical," she says. "Nature was here before we were. Humans are making a mess of things but nature—animals, plants and insects—will prevail and ultimately retake what is theirs."

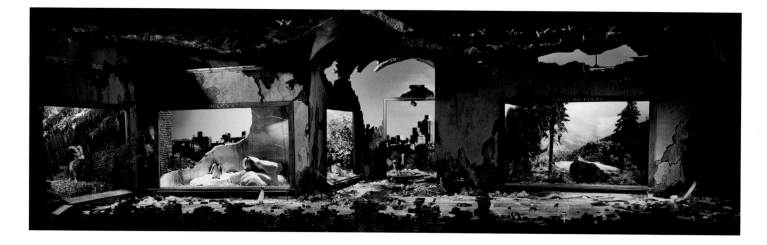

above: THE CITY: NATURAL HISTORY, 2005
color photograph
48 x 152 CM

opposite: THE CITY: MUSEUM OF ART, 2005
color photograph
1 x 1.2 M

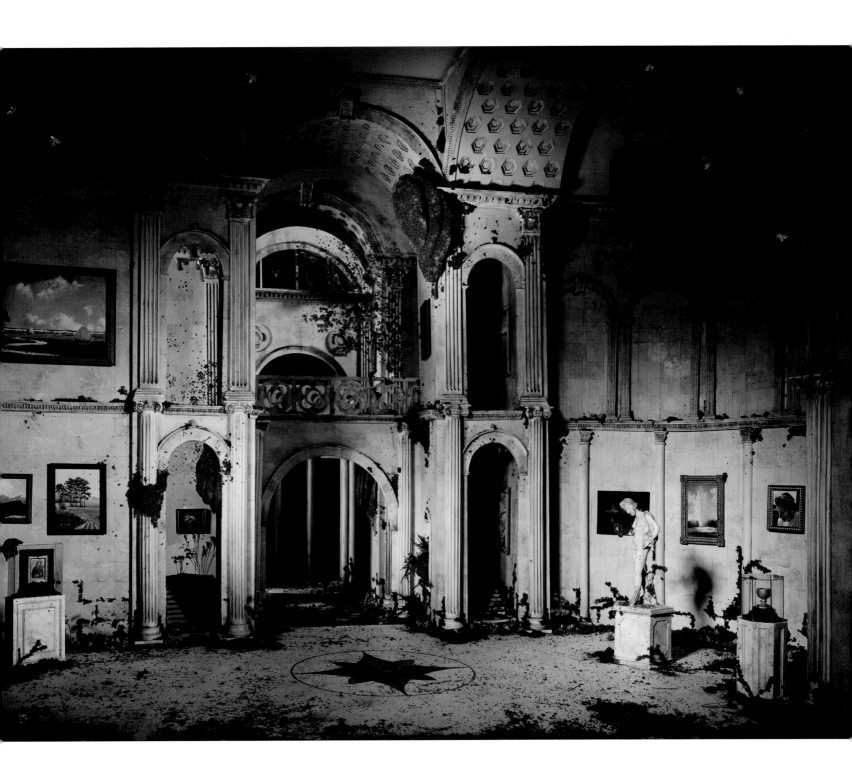

edward burtynsky

IN 2005, the organizers of the TED (Technology Entertainment Design) conference awarded photo artist Edward Burtynsky a generous grant and the opportunity to team up with several major companies that pledged to help him fulfill his three greatest wishes. The conference is an annual "idea fest" of today's leading thinkers and attracts mavericks from across many disciplines. Nobel laureates, CEOs and pop stars alike gather under one roof; Matthieu Ricard, Richard Dawkins, Jane Goodall, Frank Gehry, Quincy Jones and even Rupert Murdoch have been among the participants. The TED Awards honor inventors, entrepreneurs, artists and others who have extraordinary vision and the potential to protect and enhance the future of life on earth. Burtynsky shared the 2005 award with the singer Bono and the inventor Robert Fischell.

Burtynsky's large-format color photographs reveal human-kind's impact on the environment. He presents images of some of the most significant ways in which people have defaced this planet—blasted quarries, strip mines, the Three Gorges Dam project in China, mountains of old tires. Burtynsky frames these shocking images in a way that renders them mesmerizing,

even beautiful. "You need to give people a reason to stop and look. What I do is set up a tension. We are visually compelled to look at the very thing we are trying not to see, like forbidden fruit."

So what did he wish for? He wished that his artwork might persuade millions of people to join a global conversation about sustainability, so www.worldchanging.org was created, a site Burtynsky describes as "a handbook for a green future." He wished to motivate children to imagine new ideas for sustainable living. To that end, WGBH in Boston is producing a series of television vignettes about a fictional family called the Greens who introduce the idea of sustainability to children. And finally he wished to create an IMAX film that would make his work accessible to a broader audience, a project for which his audience must be patient.

But Burtynsky himself is not a patient man. "We are disconnected from what we call nature," he says. "It exists here now, and if we're not careful it might not be here tomorrow. The time for thinking and acting is now."

MANUFACTURING #17, DEDA CHICKEN PROCESSING PLANT, DEHUI CITY, JILIN PROVINCE, 2005
chromogenic print
1.5 x 1.7 M

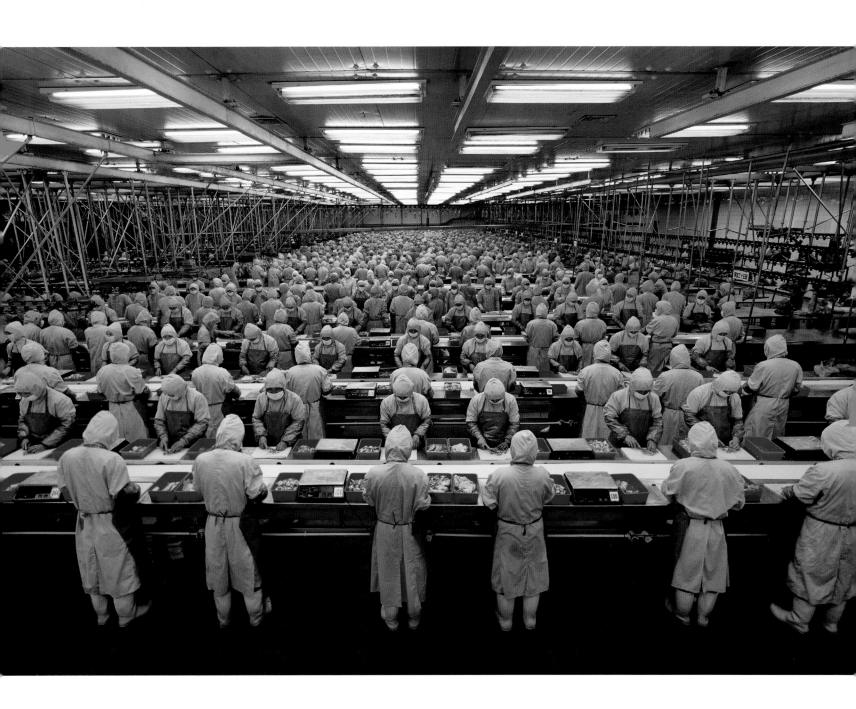

simon norfolk

'EUROPEAN ART has long had a fondness for ruin and desolation that has no parallel in other cultures. Since the Renaissance, artists such as Claude Lorraine and Caspar David Friedrich have painted destroyed classical palaces and gothic churches, bathed in a fading golden twilight. These motifs symbolize the impermanence of the greatest creations of civilization—the empires of Rome and Greece, or the Catholic Church. Eventually, they too would crumble, vanquished by savages and vanishing into the undergrowth. The only thing that could last, that was truly reliable, was God. And man's only rational response in the face of God's power was awe.

"The landscapes of Afghanistan are also 'awesome,' in the original sense of the word, but the feelings of dread and insignificance they inspire are not related to the power of God but to the power of modern weaponry.

"Afghanistan is unique, utterly unlike any other war-ravaged landscape. In Bosnia, Dresden or the Somme, for example, the devastation appears to have taken place within one period, inflicted by a small gamut of weaponry. However, the sheer length of the war in Afghanistan, now in its twenty-fourth year, means that the ruins have a bizarre layering, different moments of destruction lying like sedimentary strata on top of one another. A parallel is the story of Heinrich Schliemann's discovery of the remains of the classical city of Troy in the 1870s. Digging down, he found nine cities deposited on one another, each one in its turn rebuilt on the rubble of its predecessor, only to be destroyed later.

"Afghanistan keeps similar artifacts in what seems to be a Museum of the Archaeology of War. Abandoned tanks and troop carriers from the Soviet invasion of the 1980s litter the countryside like agricultural scrap, or they have been used as footings for embankments and bridges, so they poke up out of the earth like malevolent fossils. The land has a different appearance where there was fighting in the early '90s. The tidy, picked-clean skeletons of buildings are separated by smooth, hard earth where de-mining teams have swept the area. In places destroyed in the recent U.S. and British aerial bombardment, the buildings are nothing but twisted metal and charred roof timbers—the presence of unexploded bombs deters all but the most destitute scavengers—giving the place a raw, chewed-up appearance.

"Mikhail Bakhtin called this kind of landscape a 'chronotope,' a place that allows movement through space and time simultaneously, a place that displays the 'layeredness' of time. The chronotopia of Afghanistan is like a mirror, shattered and thrown into the mud of the past; the shards are glittering fragments, echoing previous civilizations and lost greatness. Here there is a modern concrete teahouse resembling Stonehenge; an FM radio mast like an English maypole; the pyramids at Giza; the astronomical observatory at Jaipur; the Treasury at Petra; even the votive rock paintings in the caves at Lascaux.

"In a way, I had seen the destruction of Afghanistan before—not directly, but in the *Illustrated Children's Bible* given to me by my parents when I was a child. When the pictures showed David overcoming Goliath, these Afghan-looking mountains and deserts were the background. As Joshua fought the battle of Jericho, these trees and animals were drawn in the middle distance. More accurately, the landscapes of Afghanistan are how my childish imagination conjured up the Apocalypse, or Armageddon. I felt I had already lived these landscapes in the fiery exhortations of a childhood Manchester Sunday school: utter destruction on an epic, Babylonian scale, bathed in the crystal light of a desert sunrise."

opposite: AFGHANISTAN CHRONOTOPIA: BRICKWORKS, 2001
archival print
1 x 1.3 M

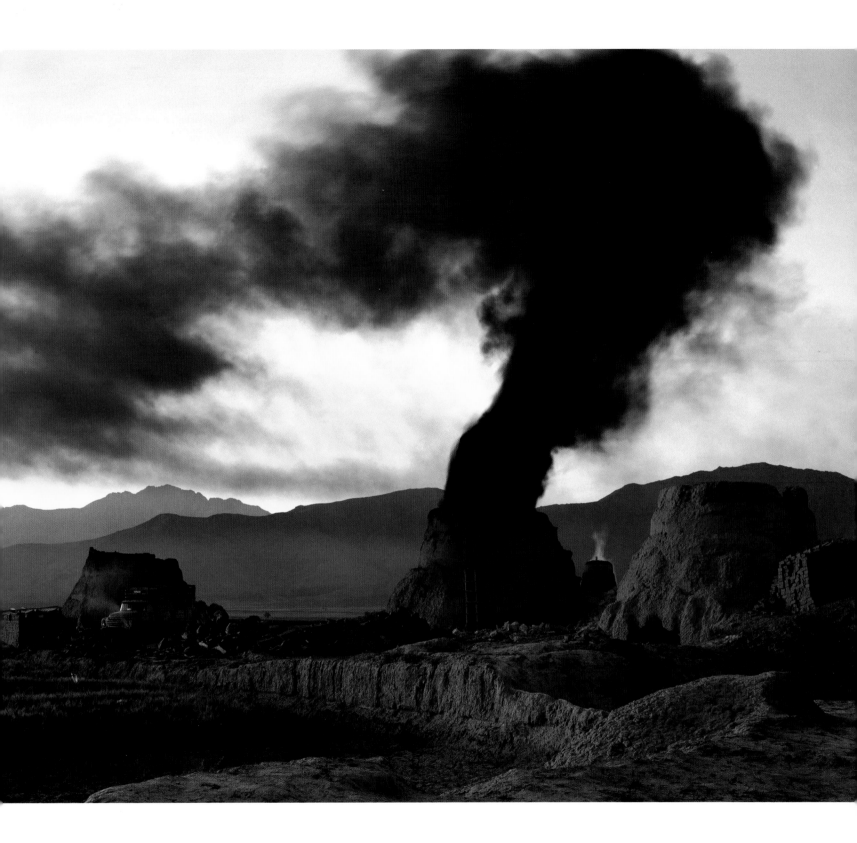

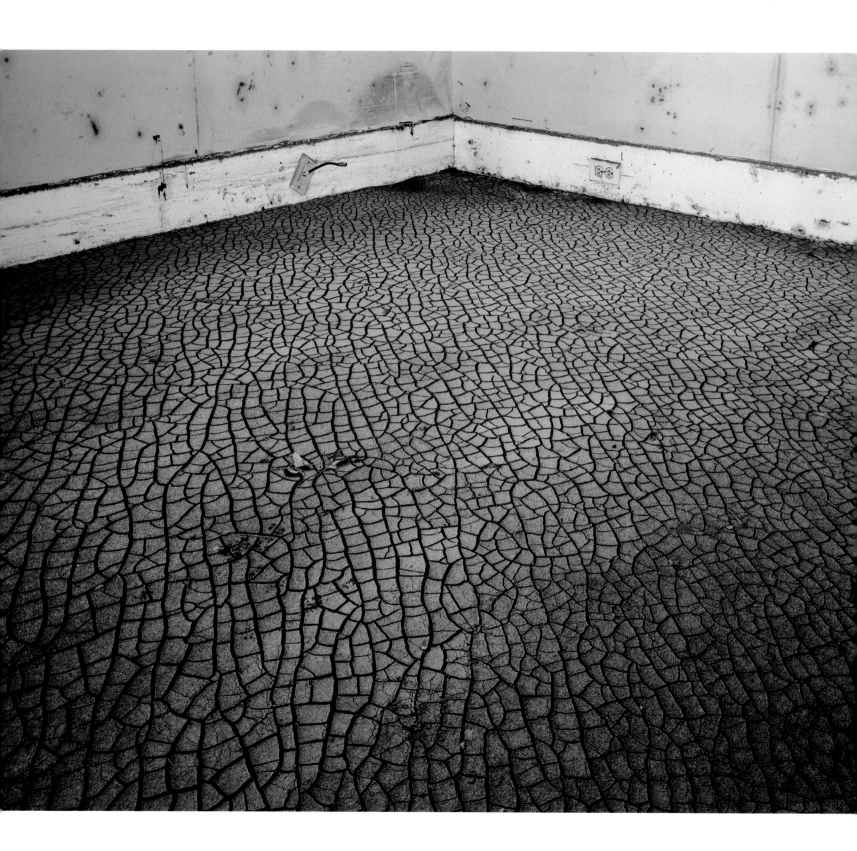

chris jordan

'THESE PHOTOGRAPHS from New Orleans in November and December of 2005 portray the cost of Hurricane Katrina on a personal scale. Although the subjects are quite different from those in my earlier *Intolerable Beauty* series, this project is motivated by the same concerns about our runaway consumerism.

"There is evidence to suggest that Katrina was not an entirely natural event like an earthquake or tsunami. The 2005 hurricane season's extraordinary severity can be linked to global warming, which America contributes to in disproportionate measure through our extravagant consumer and industrial practices. Never before have the cumulative effects of our consumerism become so powerfully focused into a visible form, like the sun's rays narrowed through a magnifying glass. Almost 300,000 Americans lost everything they owned in the Katrina disaster. The question in my mind is whether we are all responsible in some degree.

"The hurricane's damage has been further amplified by other human causes, including failures of preparedness and response on many levels; existing poverty conditions; levee problems that were mired in political maneuverings; poor environmental and wetlands practices that left some areas more vulnerable; and the conspicuous absence of federal resources that were already being used in the Bush Administration's wars in Iraq and Afghanistan.

"From that perspective, my hope is that these images might encourage some reflection on the part that we each play, and

the loss that we all suffer, when a preventable catastrophe of this magnitude happens to the people of our own country. Katrina has illuminated our interconnectedness, and it makes our personal accountability as members of a conscious society ever more difficult to deny."

above: DOLLAR STORE NEAR BURAS, LA, 2005
archival inkjet
51 x 61 CM

opposite: LIVING ROOM FLOOR,
NINTH WARD NEIGHBORHOOD, 2005
archival inkjet
51 x 61 CM

nancy chunn

THERE ARE three popular endings to the children's story about Chicken Little, who misguidedly reasons that the sky is falling when an acorn hits her on the head. All the stories begin in the same way: In a panic, Chicken Little scuttles off to warn the king, spreading paranoia to all those she meets along the way. In one version, she finally meets the king and he tells her she's crazy. In another, he placates her by giving her an umbrella to protect her from the sky and she carries on in ignorant bliss. But in the most common version, Chicken Little and her friends are lured into the den of Foxy Loxy, who proceeds to eat them all for supper.

In Nancy Chunn's reinterpretation, Chicken Little does indeed enter the fox's den, but it is the den of Fox News, where she takes on the role of shock-media maven, broadcasting fear to the nation. This is Chunn's first major work since her meditations on the September 11th attacks. "Where do we go after 9/11?" she asks. "We are now in a culture of fear. You cannot turn on the TV without being told to be afraid, because fear sells." She notes that the media churn out anxiety-inducing narratives on a daily basis, warning of harmful products, menaces to society, rogue nations, environmental crises, health hazards and a general sense of peril. "Warnings and admonitions are pumped into our consciousness 24/7. Of course, these are designed to hook you into watching the broadcast."

Chunn's *Chicken Little in the Garden* consists of thirty-eight canvases that retell the first episode of the fable. Instead of an acorn or a rock, a television hits Chicken Little. And instead of the sky falling, it is the depleted ozone layer that she fears, as well as killer bees, acid rain, tornados, DDT, deforestation, oil spills, the extinction of the spotted owl and other real and exaggerated fears of the modern age. Chunn plans to complete nine more panels to illustrate the complete Chicken Little story.

Fear can be a motivator, but some people simply shut down when they are inundated with it. While Chunn addresses serious concerns, she does so with a light touch and wry humor. "I take the opportunity to complain, bitch, gripe and scream about the social, political and cultural issues of the day," she says. "Exercising my First Amendment rights is a must. But humor is my way to get scary and profound ideas across without being preachy."

CHICKEN LITTLE AND THE CULTURE OF FEAR: SCENE 1 (THE GARDEN), 2004
acrylic on canvas (38 panels)
3 x 6 M

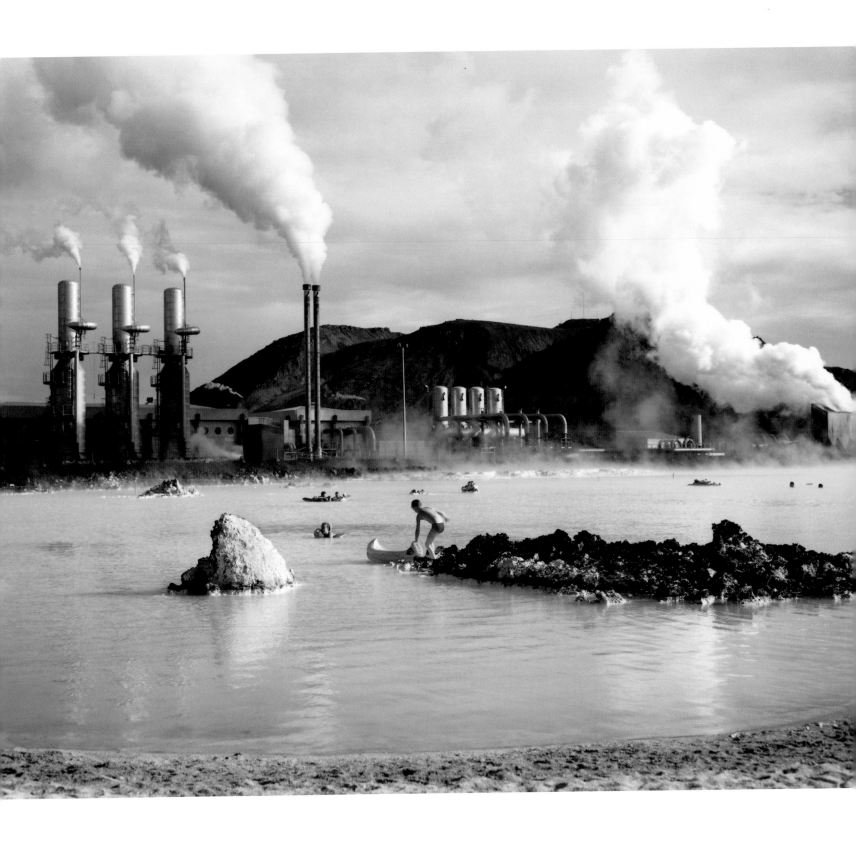

laura mcphee & virginia beahan

IN THIS image from *No Ordinary Land*, Laura McPhee and Virginia Beahan present a scenario that sets off alarms. The viewer automatically wants to call out to the child, to stop him from wading in runoff from an industrial plant. The eerie color of the water, the plumes of smoke and the foamy rocks are all reminiscent of the toxic dump sites that we've become accustomed to seeing. Hazardous waste and noxious poisons have become the norm. But the truth behind this image should inspire hope rather than shock.

The high concentration of volcanoes along the Mid-Atlantic Ridge rift zone makes for an energetic underground environment throughout Iceland. Clean, naturally produced geothermal energy is Iceland's second largest source of energy, with nearly 6,000 Gigawatt-hours (GWh) consumed annually (a single GWh can bring nine million quarts of freezing water to a boil). Geothermal power plants produce about 17 percent of the country's electricity and meet the heating and hot water needs of almost 90 percent of the nation's homes. The boy in this image is safely enjoying naturally heated mineral water, while the pumping station in the background is harnessing geothermal energy.

McPhee and Beahan worked together for fourteen years photographing richly varied environments with an eight by ten inch Deardorff view camera and producing large-format images from around the world. Their book, *No Ordinary Land*, includes images from Sri Lanka, southern Italy, Costa Rica and other exotic locales. "The Iceland image is emblematic of a lot of the work we've done together in that it's an image that is at once disturbing but also magical," says McPhee.

McPhee has gone on to independently create a photo essay of the three years she spent in Idaho, which turned out to be not any less exotic than her globe-trotting. "It was very interesting because I was working in my own country, but not my own culture. I found it fascinating, as an urban dweller, to work in a valley where there were only a hundred people. I discovered that so many of the issues that face us as a country and as individuals, and also globally at this point, are enacted in this place—everything from species extinction to gun laws." She found the situation fascinating as well as challenging to many of her own assumptions.

McPhee and Beahan take a wide-angle view of the world, even when their cameras are packed away. McPhee asks, "Where do we fall in the debates? Do we stop using telephones and petroleum products? Stop wearing gold and silver? The problems aren't as easy to solve as one might think."

THE BLUE LAGOON, SVARTSENGI GEOTHERMAL HOT WATER PUMPING STATION
PORBJÖRN, ICELAND, 1988
Chromogenic print
51 x 61 cm

katrín sigurðardóttir

A PRISTINE GLACIAL valley is no place for an enormous disembodied human head. Its eyes blinking with wonder, it knows it is out of its element.

Icelandic artist Katrín Sigurðardóttir creates unspoiled environments of untenable proportions, then beckons the viewer to enter. But she is teasing. Utopia doesn't welcome human intrusion. "How can you incorporate yourself into utopia? This world is beautiful and seemingly perfect, but the body cannot fit into it."

Sigurðardóttir presents utopias just beyond reach because, she says, utopia exists only in the mind—in the imagination or in memory. The disorienting scale of her work creates an uncomfortable, dizzying relationship between the viewer and the work. There can be no oneness with this nature, only voyeurism and inaccessible terrain. Whether you are stomping around in hiking boots or reading the travel section of the newspaper just imagining faraway places, you can only get so close to paradise, she says. "You can never touch it. If you touch it, you break the magic. Setting foot in it, you pollute the utopia."

Driven by curiosity, viewers of *High Plane*

climb up a steep ladder that leads to an opening on a wooden platform, but when they reach it, they find they cannot enter. Only the head fits. "You end up feeling completely exposed," says Sigurðardóttir. "Something surreal and sad occurs when a person enters my works. They are physically excommunicated from those small locations, close and distant at the same time."

The topography she presents in *High Plane* is deceptively familiar and identifiable. "I could point you to the approximate places in the world where these mountains are situated," she says. "But once you have arrived, you won't find these mountains." She uses a similar landscape in *Haul 2005*, for which she constructed a miniature world inside a number of small transportation crates that fit together as a continuous landscape. The composite only existed as a whole for a short time. The boxes were sold separately and sent to their owners around the world—from Reykjavik and Texas to Turin and Sydney. "Just like land that is divided up and 'possessed' by different people, the work is now divided," she says. "One of the metaphors in the work addresses the environment, in that we human beings have this mission of dividing and conquering all of nature."

above: HAUL IV, 2004
plywood, polystyrene, vatican stone, landscaping materials, hardware, transit labels
CLOSED: 30 x 30 x 23 CM, OPEN: 61 x 61 x 10 CM

opposite: HIGH PLANE, 2001–2005
polystyrene, wood, steel
4 METERS HIGH

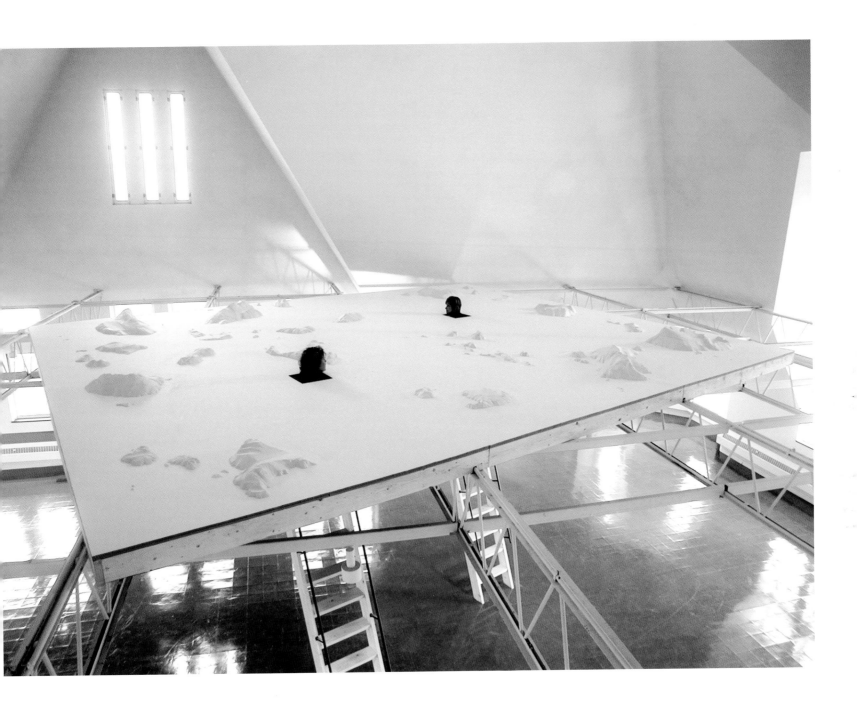

william kentridge

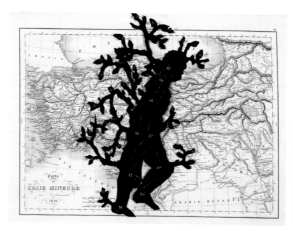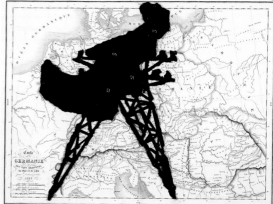

WILLIAM KENTRIDGE has lived his entire life in politically charged and environmentally striking Johannesburg, South Africa. His work often observes the predicament of being human—a game of give and take, sacrifice and success, that no one ever really wins. In a series of drawings, he presents shadowed figures traversing a map of the world. They are at a midpoint of transmutation—a man turning into a tree, a woman turning into a pylon. The work points to our survival instinct, our need to keep moving in the face of change. Kentridge speaks about the depiction of utopian landscapes in traditional African paintings as "documents of disremembering." He says, "Collective memories are extremely short. Or, at any rate, they are tranquilized to make way for daily living."

His drawings are not utopian, nor are they nihilistic. He says they "emerge from urbanity" but are "of spaces which are not natural or neutral...For the most part, the drawings proceed rather dumbly, with only occasional stops for assessment or judgment. Elements of a landscape throw themselves up as appropriate and become the structure of a drawing. Pieces of a drawing lose their hold and must be removed. There are no points, geographical or moral, that I am trying to illustrate. The drawings are empirical, naturalistic. But they are approached with some sense that the landscape, the veld itself, holds within it things other than pure nature."

Kentridge often alludes to the divisiveness of apartheid and his uncomfortable position of being a member of the privileged elite, but the allusions are subtle. He steers away from overt political statements. "I have never tried to make illustrations of apartheid, but the drawings and films are certainly spawned by and feed off the brutalized society left in its wake," he says. "I am interested in a political art—that is to say, an art of ambiguity, contradiction, incomplete gestures and uncertain endings, an art and a politics in which optimism is kept in check and nihilism at bay."

This uncertainty is made corporeal in his charcoal drawing of a figure standing alone in a sparsely furnished room, leaking. Water pours from his suit, filling the room. Does the water originate from within him or from the outside? Is there a difference? The human body is more than 70 percent water. It sustains us, but at the same time it poses a threat. We can drown in just a few drops. The man in the suit seems to take these ideas into consideration, but he is immobilized by his own nature.

above left: PUPPET DRAWING, 2000
construction paper, tape, chalk, pins on Atlas page
33 x 46 CM

above right: PUPPET DRAWING, 2000
construction paper, tape, chalk, pins on Atlas page
33 x 46 CM

pat steir

PAT STEIR'S paintings invite meditation. She says, "I dive into the landscape and then break away from it in order to meditate on it from a distance." Steir's studies of water and its unending transformation are contemplative and do well without analysis. While the water flows continuously from the glaciers to the sea, then back into the atmosphere, the viewer can quietly bear witness. "There are two kinds of art," she says. "One shows you things you've never seen before. The other makes you see things you've always seen, but with a different eye."

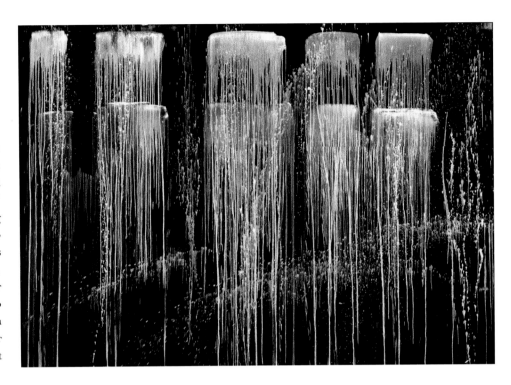

朧夜や酒の流し滝の月

oboro yo ya sake no nagareshi taki no tsuki

hazy night
sake is flowing
waterfall and moon

Bashó, 1818

DRAGON TOOTH WATERFALL, 1990
oil on canvas
2 x 3 M

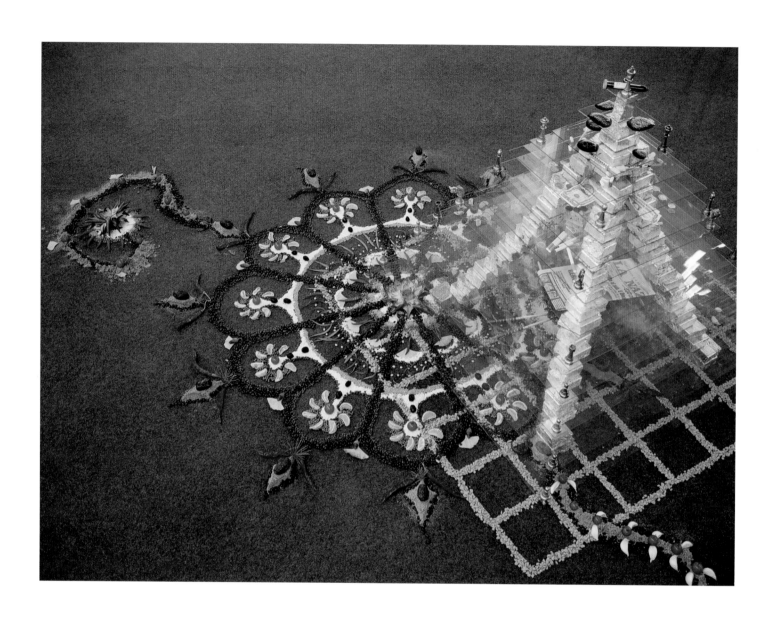

joe mangrum

THE DEADENING effect of commodification is a common theme in Joe Mangrum's work. It has sent him off the canvas and into the greater world, where he seeks to create "experiences of art" using found objects and plantlife. His work now appears as often in galleries as it does in public spaces. A pedestrian locked in a morning commute may be stopped short by a mandala of flower petals meticulously arranged across his path. The labor intensive and ephemeral nature of Mangrum's process may cause a casual observer to ask "Why?" instead of "How much?"—which is exactly his point.

When he was invited to present a new work at the 2003 Florence Biennale, Mangrum stepped off the plane in Italy empty-handed. He spent his first four days in Florence hardly sleeping, wandering the cobblestone streets in a meditative state, absorbing the atmosphere, feeling the history of the cathedrals and the Campanile, discovering the markets, traversing the Arno and the aqueducts. All the while he collected objects that spoke to him. With the recent United States invasion of Iraq, the idea of the world at war was a palpable presence in the air.

Mangrum was inspired to construct a pyramid of glass supported by gold-leafed bricks, the centerpiece of *Fragile*. The pyramid became home to a long list of organic and synthetic materials that symbolize the "commodities that drive us"—salt, coffee, timber, media, alcohol, tobacco and pharmaceuticals. At the pinnacle he placed oil and blood. At its base, he meticulously and deliberately arranged life-sustaining foodstuffs into an organic form patterned after the Duomo. This vivid illustration of the delicate balance between human instinct and commercial constructs hit a nerve with viewers.

But life-sustaining foodstuffs do not last an eternity. While one might acquire flowers composted in bottled form or a single brick covered in gold leaf, *Fragile* as a whole existed only in the "there and then," just as his current work often exists only in the here and now. Mangrum does make a point of documenting each of his creations. He says that photographs of his work, which he calls "a packaged reality," carry the dialogue further into the realm of oral history.

FRAGILE, 2003
glass, gold covered bricks, chess pieces, artichokes, beans, rice and various food items, salt, wood, coffee, alcohol, cigarettes, media, technology, newspapers, currency, pharmaceutical drugs, oil, blood
DIMENSIONS VARIABLE

mark dion

As TECHNOLOGY wedges its way into the process of understanding, the direct experience of nature is increasingly replaced by representations of nature. Despite the many degrees of separation—lights in tubes becoming dots on a screen becoming television images—one might look at a television and say "I've seen a waterfowl." A child is much more likely to have seen animated poultry dancing on a screen, or to have eaten poultry processed into neat little breaded chunks, than to have visited a chicken on a farm. It is more comfortable to keep a distance and to rely on another's testimony than to engage directly with the messy, unpredictable world.

Mark Dion's work illustrates how subjective representations of nature become established "facts." His *Library for the Birds* presents an ornithology that we can accept at arm's length. Employing the categorizing and exhibiting practices of natural history and art museums, he gives us a dead tree laden with books about birds. It has no birth or death, no eagle's eye or dander. Just words on a page, cages and other orderly attempts to contain its life.

While ornithology is an obvious passion of his, Dion has explored the intersection between art and nature using all sorts of specimens from the natural world. "Nature is one of the most sophisticated arenas for the production of ideologies," he says. "Once I realized that, the wall between my two worlds dissolved. I consider myself a visual artist with a keen interest in the science of life. My work is mostly about exploring questions around the representation of nature, which means that rather than being about nature, it is concerned with ideas about nature. By this I mean that my work tries to investigate what nature means for a particular group of people, in a particular place, at a distinct point in history.

"Our ideas about the natural world shift over time; for example, the notion that we should protect nature is quite a recent development in the history of human thought. I am trying to construct a conceptual chart of what some of the critical points are in the development of our ideas of nature today."

LIBRARY FOR THE BIRDS OF MASSACHUSETTS, 2005
12 zebra finches, maple tree, books, bird feeders, nets
5 M TALL

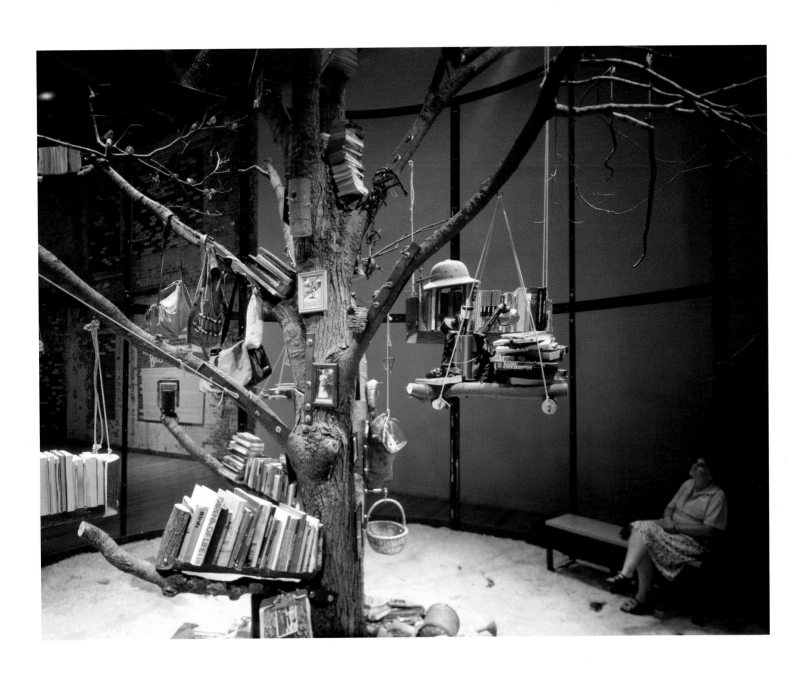

leslie shows

LESLIE SHOWS looks at the transformation of landscape as a demarcation of the passage of time. Human civilization has existed within a relatively narrow time frame, speedily evolving in what amounts to just a few moments of the planet's long existence. The geographic landscape has developed much more slowly in comparison and has endured catastrophes of epic proportion. In Shows's paintings, there is a suggestion of the human as a puny destroyer, chipping away at its host, leaving its messy mark on the land. "I like the quality of gritty, muddy, disappointing landscapes—everything is stripped to the basics, and you can begin to see the wonder in the most ordinary things, like crystal structures in clay."

In the grand scheme, human beings pose a minimal threat to the planet and a much greater threat to their own existence. "Civilization is heartbreaking and fun at the same time," she says. "It's easy to think of 'the environment' as something out there that we should feel guilty about, but I think it's especially sad to let human civilization flame out before its time. I make work, most of all, out of an appreciation for how mysterious, strange and wonderful our physical world is, and out of a desire to engage actively with it."

MEGATON FERRIS WHEEL EXCAVATOR, PSYCLONE, & SLAG PILES, 2005
mixed media on panel
1.2 x 2 M

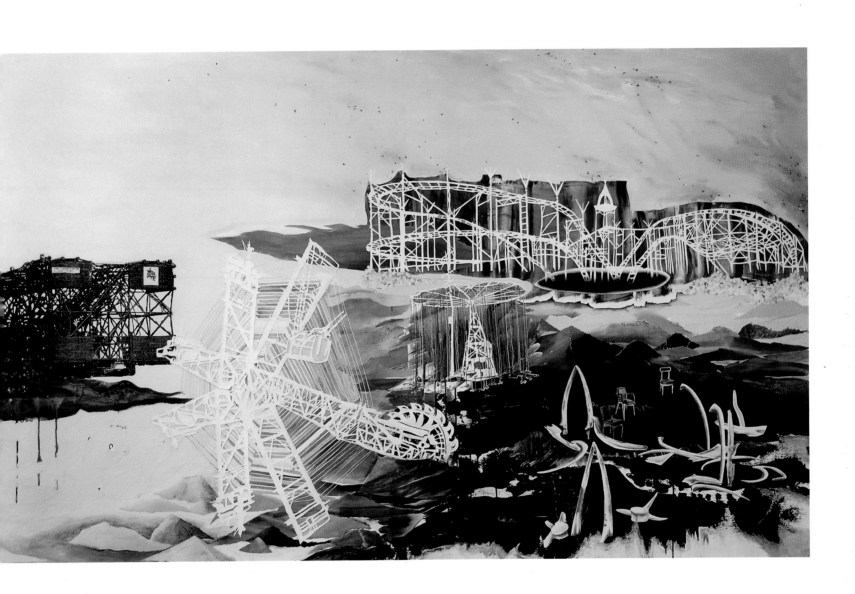

erick swenson

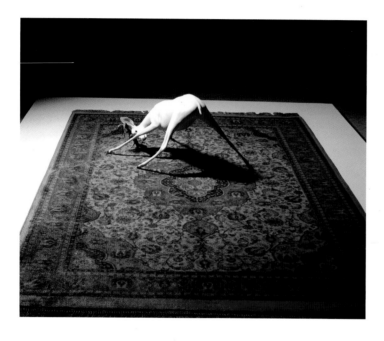

'I ONCE HEARD about some Japanese warships that sank in the sea and became the perfect environment for exotic corals to grow in. The ships still exist, like sculptures deep down in the beautiful clear water. This deer, dead on the street, is becoming a sculpture in its death. Its carcass provides the perfect environment for icicles to grow on. Its rack is like a chandelier.

"I'm attracted to the snow. There is a quietness to it. As long as it stays cold there is perfection, but we all know it's going to warm up and eventually everything will rot and decay. There is a tendency to want to keep a perfect moment, but that's not possible. Some people don't want to accept that the deer is dead. They want to inject some life into it. It's the natural order of things to die. We'll either destroy ourselves or something will destroy us."

above: UNTITLED, 2001
polyurethane resin, oil and acrylic paint
26 x 84 x 132 cm

opposite: UNTITLED, 2004–2005
polyurethane resin, acrylic paint, MDF, polystyrene
60 x 701 x 439 cm

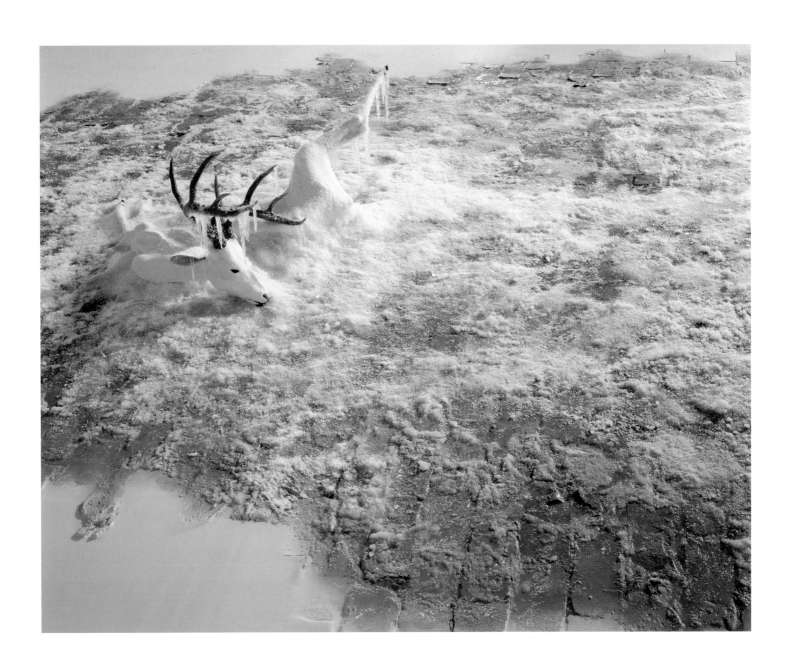

verne dawson

VERNE DAWSON likens painting beautiful pictures to pouring honey on a book. He figures, "If you have something important to say, then make people want to engage with it; make it beautiful, so they will spend time with it." It takes a little time for the allegorical quality of Dawson's paintings to percolate out from the seeming simplicity of his work. At first we see a verdant pastoral and what could be an early civilization, in which an uninhibited people enjoy skinny-dipping and wading through grasslands. But upon closer inspection, we see jet airplanes in holding patterns in the sky. This is not a primeval paradise after all. Perhaps it is an imagined future where nature coexists in harmony with technology.

Dawson has his sights set on both the past and the future. "I spent a lot of time in various caves in Europe and elsewhere, looking at prehistoric art and studying iconography," he says. He paints pictures of the past—imagining, for instance, how a prehistoric village in the Dordogne region of France might have appeared—as well as idealized versions of the future. Fantastic as it may seem, he based *Massacre of the Little People by the Big People* on what he believes to be accurate accounts of a little-known chapter of human history. Dawson says that tribes of little people "well under five feet tall" populated prehistoric Britain. Large people from the Nordic regions came and conquered the little people, slaughtering them. Those who survived went into hiding, and then became mythologized. "The more removed from society they became, the more they entered the imagination of the English, where they remain as leprechauns and spirits of the forest."

The story of the little people, and much of Dawson's other work, points to the small-mindedness of people in the way that they relate to each other and the environment. "They are oblivious to the earth, the way a bumblebee is to a field of clover because they are totally integrated." Early man was similarly integrated, he says. "They were nature worshippers. They had to be. They were so dependent upon it." As we become less aware of our connection to the earth, our reliance upon it remains. And because of this, Dawson says, "there always have been nature worshippers, and I suppose I am one of them."

MASSACRE OF THE LITTLE PEOPLE BY THE BIG PEOPLE, 2002–2003
oil on canvas
2 x 3 M

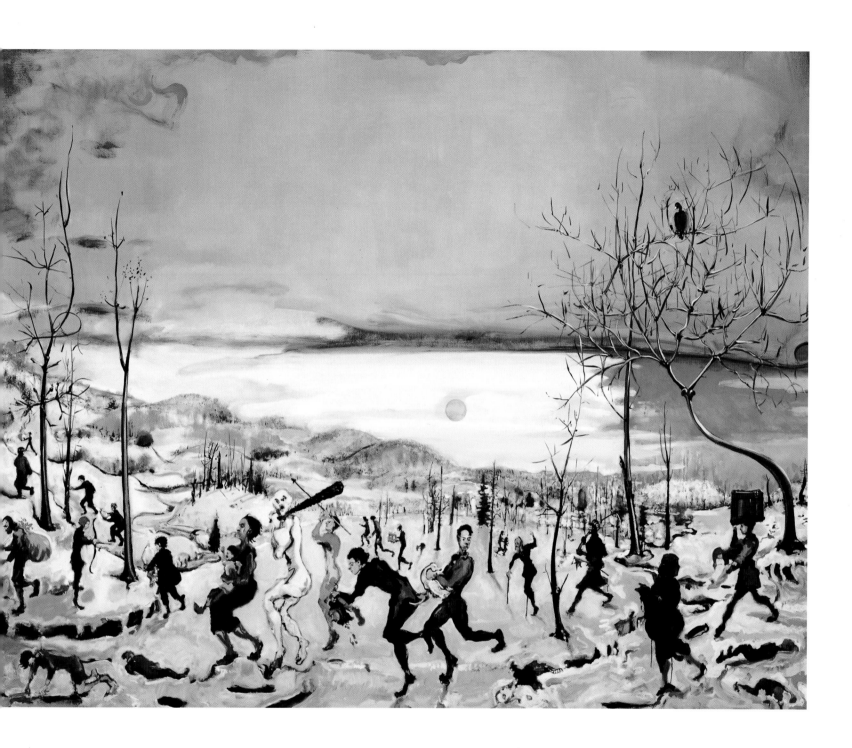

sven påhlsson

NORWEGIAN ARTIST Sven Påhlsson uses electronic art such as computer graphics, 3D animation and digital photography to explore the late twentieth-century issues of urban sprawl and car culture. Poorly planned urban development spread over vast distances threatens the environment by increasing our dependency on automobiles, and by destroying more than two million acres of parks, farms and open space every year. It also breeds isolation. And the inherent repetition of inorganic shapes that occur as a by-product of sprawl has a direct effect on human nature.

"There are no traditional or common spaces in suburbia for people to meet and interact in," says Påhlsson. "On the contrary, suburbia is made up of communities that appear to want to avoid any kind of interaction with the outside world. You have gated communities and closed windows, with the blinds shut." In his ten-minute computer-animated art video *Sprawlville*, Påhlsson sheds an eerie nocturnal light on suburban phenomena— housing developments, megamalls, supermarket aisles and parking lots. "I feel the parking lot images have an interesting duality," says Påhlsson.

"From a distance, they are colorful abstract patterns. But if you look closer, the high-resolution images reveal cars with great detail as they are casually parked in rows."

Påhlsson notes that while it was once efficient for people to work in the city and live in the countryside, today the highways are increasingly congested and dangerous. With the world's population tripling in the past seventy-two years (reaching 6.5 billion by late 2006), urban planners cannot seem to keep up with the growth. The resulting landscape is hackneyed and unsustainable. People have to live somewhere, and, like a fungus, they are spreading outward across the open spaces of the planet.

"How people can find a high quality of living in this repetitive environment is puzzling to me," he says. "It seems that the familiarity of the situation makes the subject of urban sprawl transparent in today's society. Most people both in and outside of suburbia seem either unaware or are already resigned to the situation."

above and opposite: SPRAWLVILLE: THE MALL IMAGE SERIES, 2002
digital photograph
90 x 110 CM

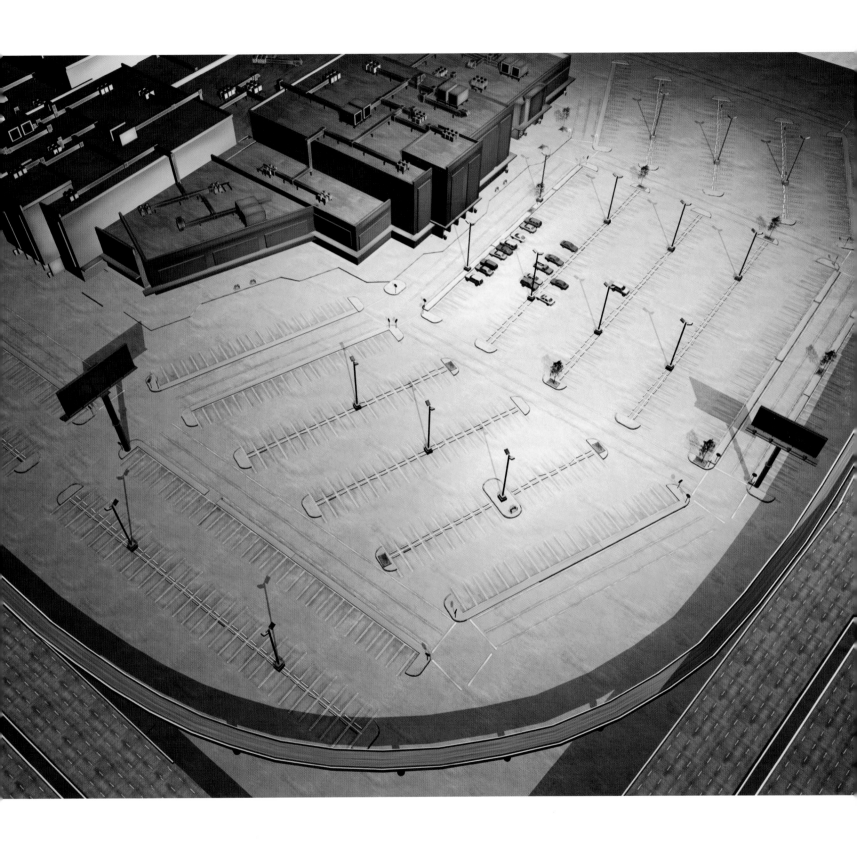

chester arnold

A NUMBER OF years ago, Chester Arnold presented a collection of his work called *Material Witnes*. He says it started innocently enough. It was meant to be a recollection exercise based on the theme of individuals observing the world as bluntly as possible. "The next thing I knew, I was entering contemporary American life and observing all the objects that enter and leave our lives," he says. "In the course of doing that, I ended up illustrating the excesses of society. It wasn't intentional. I'm not here plotting out my next show to change the world. It was driven by something visual. For the work to have magic for me, I have to feel that there is something mysterious going on."

Arnold's paintings strike a balance between his love of nature, his political and environmental interests and his appreciation of the craft of painting. "I think of myself in the middle of a spectrum of artists ranging from the wildlife painter to the overtly political artist. I personally don't find it interesting enough just to document nature, because I feel that nature already exists in a perfect form and anything I could do would only be a pathetic imitation. But on the other hand, if the work were so political that it lost its aesthetic charisma, that would also be something I couldn't deal with."

Arnold grew up in the 1950s on the edge of a forest in Germany where his father was posted with the U.S. military and where he developed a passion for the natural world. "I love the forest. I love the trees, and whenever one is felled I feel a pang of remorse. Something wonderful—environmentally and spiritually—has been taken away."

His paintings depict mankind in congress with nature: digging, chopping, often trying to keep nature contained and yet not entirely succeeding. Rust, rot and decomposition lurk. He presents these interactions from aloft, giving the viewer an unusual vantage point. "The perspective provides a distance that helps me or anyone to see it from a view that is less common. You begin to see the pattern of things, the shape of things. And if you can do that, maybe you have a little more insight and appreciation. If you can appreciate your paradise before you destroy it, then maybe you have a chance of saving it for yourself and future generations."

His work is at first inviting, then alarming. "The general museum-going public is still looking for art that is beautiful, that they can hang on the wall. But I feel painting could be more than that, he says. "It should raise questions, raise the hairs on the back of your neck. It can be used to explore issues that are more troubling than reassuring. If one would just stop and ask 'Why would anyone do something like this?' it would be satisfying. It would mean that the painting was interesting enough. Finding a moment of contemplation is one of the great challenges of our time. We become so bound up in what we're doing that we cease to see the world objectively, and I think that's one of the great values that art can have, that nature can have, that moments alone can have."

above: THY WILL BE DONE, 2006
oil on linen
1.8 x 2 M

below: DIGGER, 2006
oil on linen
1 x 1.2 M

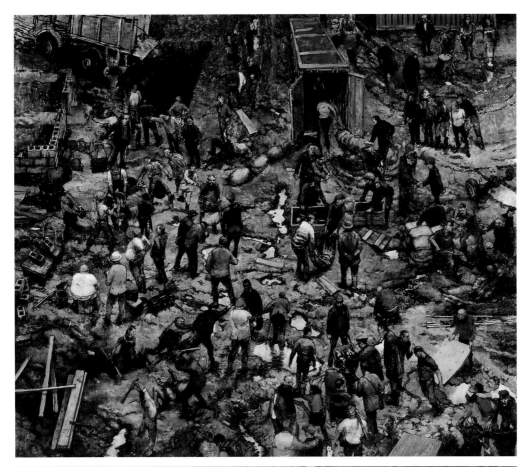

sant khalsa

L IKE BEES STASHING POLLEN in a hive, humans make themselves busy compartmentalizing the world around them, but on a scale that is not replicated in other organic systems. Our collection and redistribution of natural resources involves elaborate rituals—advertising and marketing, for example—that work to change nature's perceived value. Sant Khalsa's conceptual installation *Watershed* presses us to consider this activity in a new light.

Khalsa rearranges elements of nature and uses the language of the marketplace to further distance nature from its original state. *Watershed* is a conceptual installation consisting of a warehouse filled with corrugated boxes of bottled water, point-of-purchase displays and product information, including a mission statement and market research for her faux bottled water company. By sheathing the earth's most ubiquitous compound, H^2O, in plastic, she takes it out of the natural realm and into the realm of commerce. Water becomes "safe," and, in this culture of fear, that makes it a more precious commodity. The text on the bottle credits the water with desirable attributes (creativity, inspiration, change, balance, integrity, harmony and grace) and dictates its commercial value by declaring a price in tree pulp pressed by a mint (i.e., cash). The boxes are stacked to form a shelter, a shed of water. While deforestation, urban sprawl and pollution eat away at the estuaries and natural watersheds of the world, Khalsa is giving us one built on wordplay.

She addresses our commodification of nature again in *Western Waters*, a photo survey of retail water stores in strip malls in four Southwestern states. "What most interests me is both the necessity and the absurdity of these stores, and the way these venues have come to represent the source of a natural experience," says Khalsa. "Plastic bottles have replaced earthen vessels. To fetch our water, we travel in polluting automobiles to and from this fabricated representation of a river, well or spring. The stores attempt to provide the consumer with what they physically require and psychologically desire." Khalsa says that in the future the photographs may serve as historical documents, "either registering a fleeting fad or laying the foundation of what will become commonplace in our society."

above: PARADISE WATER, 2000–2002
photograph
20 x 23 CM

below: WATERSHED PRODUCTS, 2000–2002
plastic water bottles

adriana varejão

WHAT LIES behind the sterile environments we create for ourselves? Where is the boundary between the living and the dead? We as humans have a habit of trying to classify the world around us into good and bad, clean and unclean, appropriate and inappropriate, natural and unnatural. Adriana Varejão destroys the false security of our contained experience. She exposes the hidden life of inanimate objects, giving them wounds and scars we can recognize. If the rain forests in Varejão's native Brazil could bleed human blood, perhaps the clear-cutting would cease.

CONTINGENTE (CONTINGENT), 1998-2000
photograph
28 x 41 CM

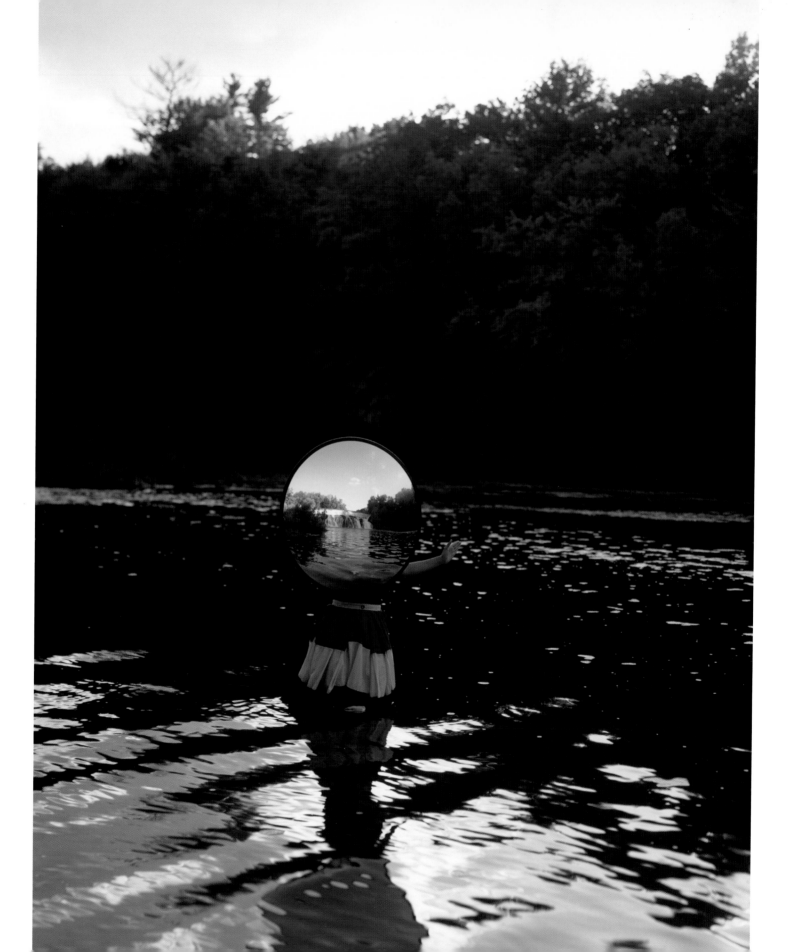

yoko inoue

CONVEX MIRRORS guide us around dangerous corners and hidden intersections by minimizing and distorting what is in plain view. They assist in surveillance activities, broadening the field of vision and revealing blind spots where shoplifters and assailants do their business. But whatever sense of security a mirror may provide in a bus terminal, a convenience store, a narrow street or hallway can be reversed when the mirror is stripped of its intended purpose. The warning OBJECTS IN MIRROR ARE CLOSER THAN THEY APPEAR takes on an unsettling meaning. Performance artist Yoko Inoue provokes such feelings of insecurity when she dons a thirty-inch convex mirror as a mask and steps into wide-open spaces.

Her work with mirrors began at a time when smoke and particles from the World Trade Center's towers were still thick in the Manhattan air. Traveling between empty airports and beleagered cities, Inoue was aware that the social context of her previous work was changing. With themes of surveillance, security, reflection and distortion in mind, she began to explore the power and mystique of mirrors. She found references to mirrors in historical documents where they are treated as rare objects of power and magic. Mirrors made of polished stone were precious family heirlooms and, in some cultures, were used for shamanistic rituals. There was a time not long ago when most people never saw their reflection. Now hardly a day goes by that we all don't see our own faces. A fixation on personal appearance is commonplace. Yet Inoue found that people tend to shy away from her convex mirror mask. "When you wear a mask you become a different being. You have to cope with the loneliness while someone else reflects on your being." Taking her mirror mask to a river, she contemplated the passage of water. Just as the river flows in one direction, she suggests that consumer culture is also getting carried away. In her reflection, the river flows in reverse. "It is reflecting in such a way that the river can go in both directions. And maybe we can also reverse what we are doing and start giving back."

In this and other works, Inoue explores the historical relationships between people and everyday domestic objects. Inoue says she is interested in the interface between spiritual purity and commercial corruption. "We see that even if the original purpose of an object was to be a token, a gift or an icon, its commercial and cultural displacement for another use creates new forms of worship and leaves a new series of relationships in its wake."

WIDER VISION, 2001-2006
digital print of performance
61 x 51 CM

john lundberg

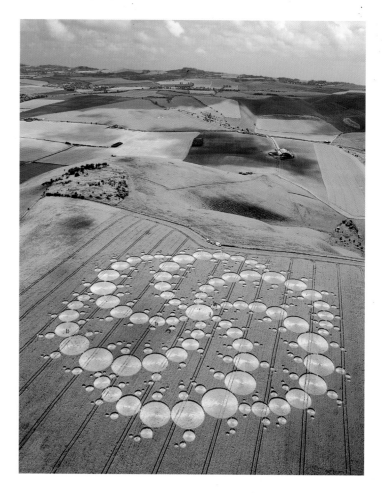

JOHN LUNDBERG is the founder of Circlemakers, a collective of artists who claim responsibility for a large number of the mystery-shrouded crop circles that have been appearing in the dark of night in British farmlands since the mid 1970s. Lundberg refuses to specify which of the many formations found in the farmers' fields are their work, because, he says, "in order for a circle to function properly, it needs to remain authorless." It is inaccurate to call them crop "circles," however; over the years the formations have evolved into intricate designs that include sacred geometry such as π, fractals, Fibonacci spirals, and the golden ratio, and can sometimes be as large as two football fields.

Lundberg likens the formations to Rorschach tests. For some viewers they are tabloid fodder; for others they are a sign that the military is waging covert psychological warfare or that interdimensional beings are trying to communicate. To many they become temporary sacred sites. "The circles are just a mirror for people to look into. We don't have any control over the narratives that build up around our work. The viewers project their own beliefs, hopes and fears onto the crop circle." He says he is not surprised that most people interpret their message as environmental. "From the beginning, people have been seeing the circles as an awakening, that there is a message being sent. The recurring interpretation seems to be that the earth is in peril. Obviously, they are seeing that because that's what is churning around in the culture at the moment. We are in trouble environmentally. We need to rein ourselves in and have a look at what's happening to the planet."

Lundberg welcomes the interpretation. "While the relationship of our work to the topic of global warming is something that its audience has constructed, on a personal level I think it is fantastic that environmental messages can be attached to and propelled by our work. In this context, they can be viewed as mass participation artworks. Historically, when you think of art you think of people creating sculpture or paintings. What we do is manipulate the fabric of our culture, which can be a much more potent endeavor."

The Circlemakers occasionally take on commercial projects. Lundberg was commissioned by Greenpeace to create formations in fields of genetically modified maize in Mexico, where the artwork received extensive coverage in the national media. He says, "Placing a symbol in the crop was much more potent than ripping up the maize. It was a very successful campaign."

CROP CIRCLE DISCOVERED ON 12TH AUGUST 2001 AT MILK HILL, WILTSHIRE, UK, 2001
OVER 274 METERS IN DIAMETER

susan magnus

'I am interested in how the natural world is displayed, represented and manipulated for educational, scientific and recreational purposes. Some of my work reflects a fascination with the ways nature is identified and catalogued—the preservation and naming of biological specimens and the science of mapping the world have been departure points for a number of my projects. In addition, methods of presentation and confinement that reflect the objectification of nature by collectors and biologists have at times featured prominently in my work.

"Much of the sculpture and photography I created in the 1990s found its genesis in my memories of childhood visits to the Vanderbilt Museum on Long Island and to other ethnographic and natural history museums. With an exciting mixture of horror and delight, I experienced pickled creatures in glass jars and taxidermy, dioramas of African savannahs and Arctic landscapes, a 3,000-year-old mummy, shrunken heads and assorted archival materials, including photographs documenting elephantiasis. While a sense of wonder is conjured by exploring diverse and idiosyncratic exhibitions, the preservation of things within the context of the museum evokes darker thoughts regarding the fragility of life and the inevitable futility of the curators' efforts. Moreover, the organizing principles used within the natural science museum often inadvertently reveal presumptions of hierarchy and humankind's position within this construct. The dichotomies of reverence and disregard, beauty and decay, found within these institutions continue to inform my work."

YELLOW REASON, 1994
primate cage, Plexiglass, steel, glass
160 x 81 x 122 cm

 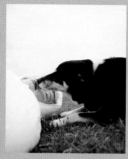 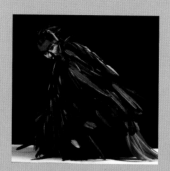 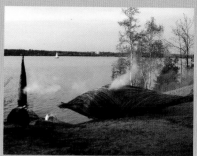

cecilia paredes

leonardo drew

the icelandic love corporation

christo & jeanne claude

cai guo qiang

amy youngs

el anatsui

masaru emoto

siobhán hapaska

janine benyus

francis baker

alexis rockman

patricia piccinini

shelley sacks

ken rinaldo

dustin shuler

sam easterson

reuben lorch-miller

alfio bonanno

lezli rubin-kunda

philippe pastor

christian kerrigan

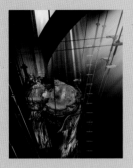
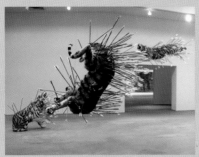

3 interact

Where is the dividing line between mankind and the rest of the natural world? Or is there a division at all? Is a city any less an organic construct than an anthill in the forest? Is the human race a host or a parasite? Throughout history, both art and science have tested boundaries, questioned assumptions and pushed us to reconsider our relationship with the world around and within us. Such explorations often lead to disturbing gray areas. While science ushers in an era of bioengineering, cloning and genetically modified food, the artists, seers and sages give us new ways to understand our changing world. With powerful images, sounds and words, artists tell stories that shape our perspective on the past and imagine our collective future. They reveal hidden patterns and archetypes and present new ways to see old problems. They delight us with their playful explorations and address the overwhelming emotional desire we have to interact with nature, to be part of the place, not just an observer. As long as art and science continue to test limits, new possibilities and new questions will arise.

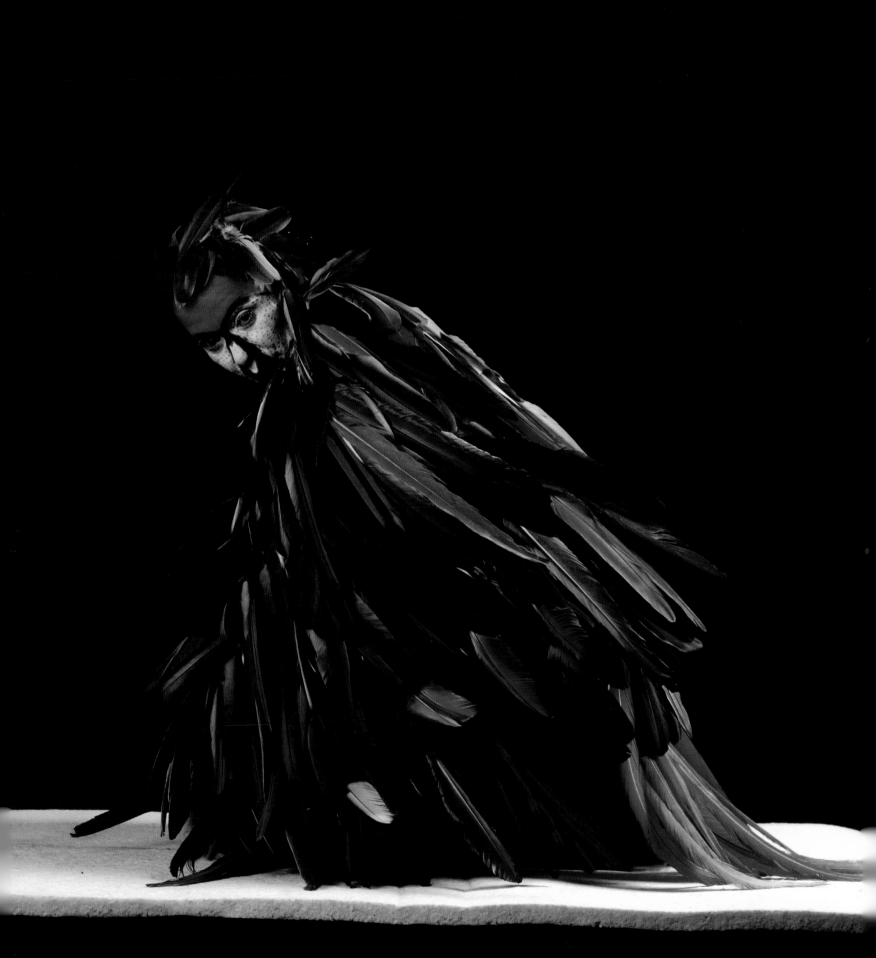

cecilia paredes

WHERE IS the border between the kingdom of the animals and the kingdom of the humans? Who governs it, and what happens when it is taken away? "I don't like boundaries between genders or between kingdoms," says Peruvian multimedia artist Cecilia Paredes. Paredes transforms herself using materials she finds in nature—the carcass of an armadillo, the spine of a fish, octopus tendrils and bird feathers—for the sake of merging human artistic expression with the beauty of the natural world.

Not long ago, Paredes heard the story of a "bird man" in Costa Rica, her adopted home, who had voluntarily become the guardian of hundreds of abandoned birds. Costa Rica's diverse ecological and geographical landscape provides rich avifaunal zones, forests, estuaries, swamps, lagoons and dry habitats in the lowlands that are home to more than 850 species of birds—and the poachers who make their living by capturing and selling them. The bird man nursed quetzals, macaws and other exquisite creatures that had been bought from illegal nest poachers in the villages or along highways in the provinces of Costa Rica. Buyers would soon discover that a bird in the hand is not worth two in the bush; a bird in the hand is, in fact, quite a lot of trouble. "They hadn't thought it through," says Paredes. "A little parrot takes up a lot of space. It's not just the cage but what he spills from the cage, the noise he makes." This guardian adopted unwanted birds, reeducated them at his sanctuary and set them free in the wild.

"I was so impressed by this story that I followed it. I wanted to keep track of birds he had saved and released into the wild." Paredes made friends with cage cleaners who collected feathers shed by a number of papagallos that were being nursed. "The papagallo is the most colorful bird after the toucan. Each week I would go to the zoo and pick up bundles of feathers." She used the feathers for her *Papagallo* photo-performance and to make a ceremonial shawl that she presented at the Venice biennial. She says, "It is for the ceremony of having triumphed in a life that is so endangered. I am honoring them."

PAPAGALLO, 2004
photo performance
1.2 x 1.2 M

leonardo drew

L EONARDO DREW collects the detritus of contemporary life and, having transformed it into something aesthetically acceptable, forces us to face it. His work is a study of deterioration and renewal. "I erode, I decay, I expedite nature's forces but I do not replace it," he says. "I am part of it. Part of a larger continuum. Over the years I've continued to study the natural process. The physical aspect of erosion. Things caught in the flow of life. As our bodies change, we become aware of the fact that we are not here for long. You're going through a transformation. You are in the flow of life—you do not escape it. That is the nature of nature."

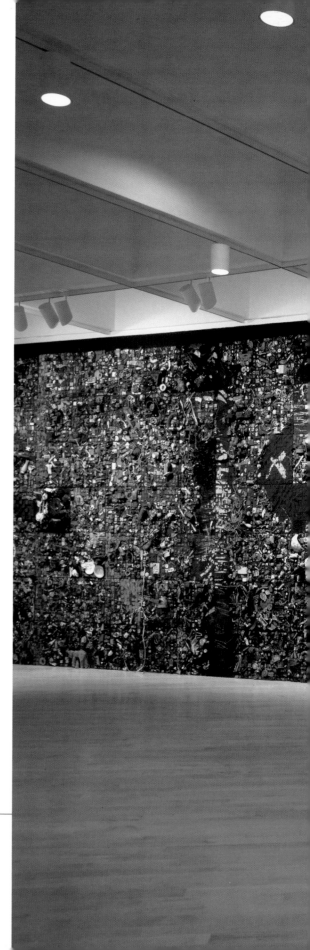

above: detail shot of opposite

opposite: NUMBER 77, 1999-2000
mixed media, paint, wood
4 x 18 x 2 M

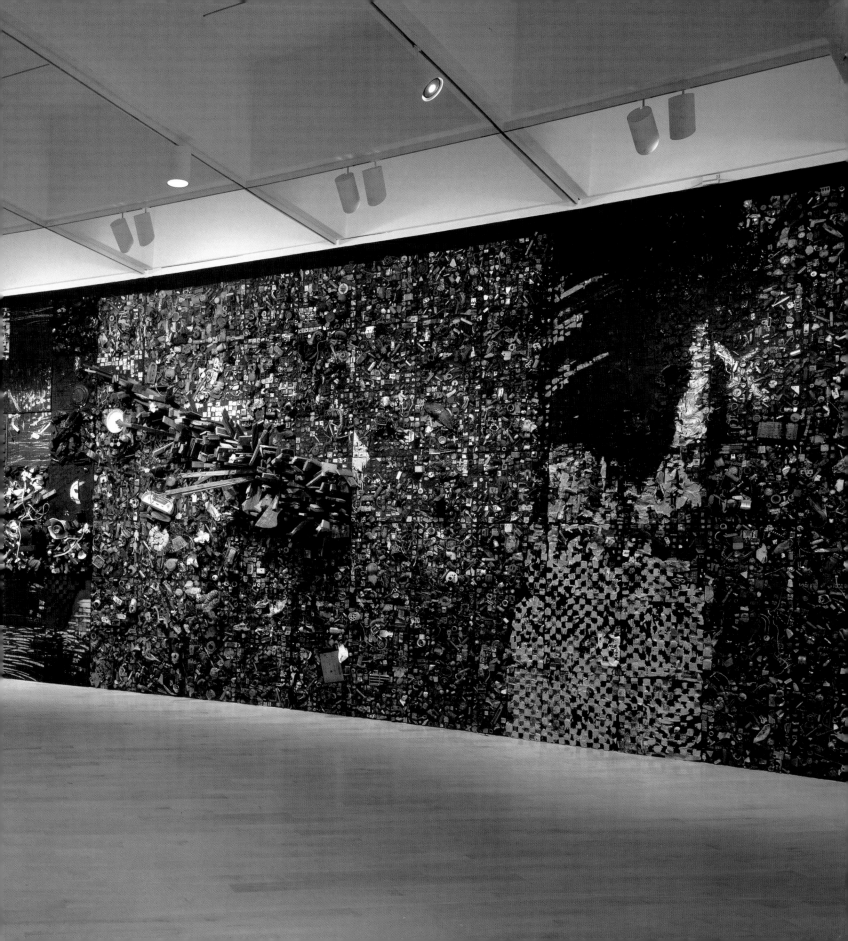

the icelandic love corporation

WHERE DO WE GO FROM HERE? by the Reykjavik-based art cooperative The Icelandic Love Corporation is based on a never-produced film about a never-existing world. Members Sigrún Hrólfsdóttir, Jóní Jónsdóttir, Eirún Sigurðardóttir and Dóra Ísleifsdóttir weave a tale of four elflike women who venture into a wild terrain, lured by its strange beauty. But they underestimate the power of nature as both a creative and a destructive force. They venture into dangerous territory and become trapped and injured. Their cry for help comes from the very depths of their souls and so does the answer. The squad that comes to their rescue is actually a representation of the internal capacity we all have to save ourselves. The Corporation wrote a poem to accompany the photo series.

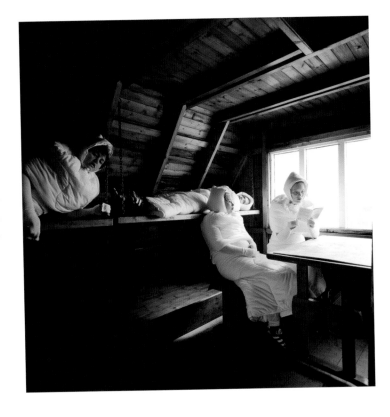

above, opposite and following pages: WHERE DO WE GO FROM HERE?, 2001
11 Diasec laserchrome prints
70 x 70 CM EACH

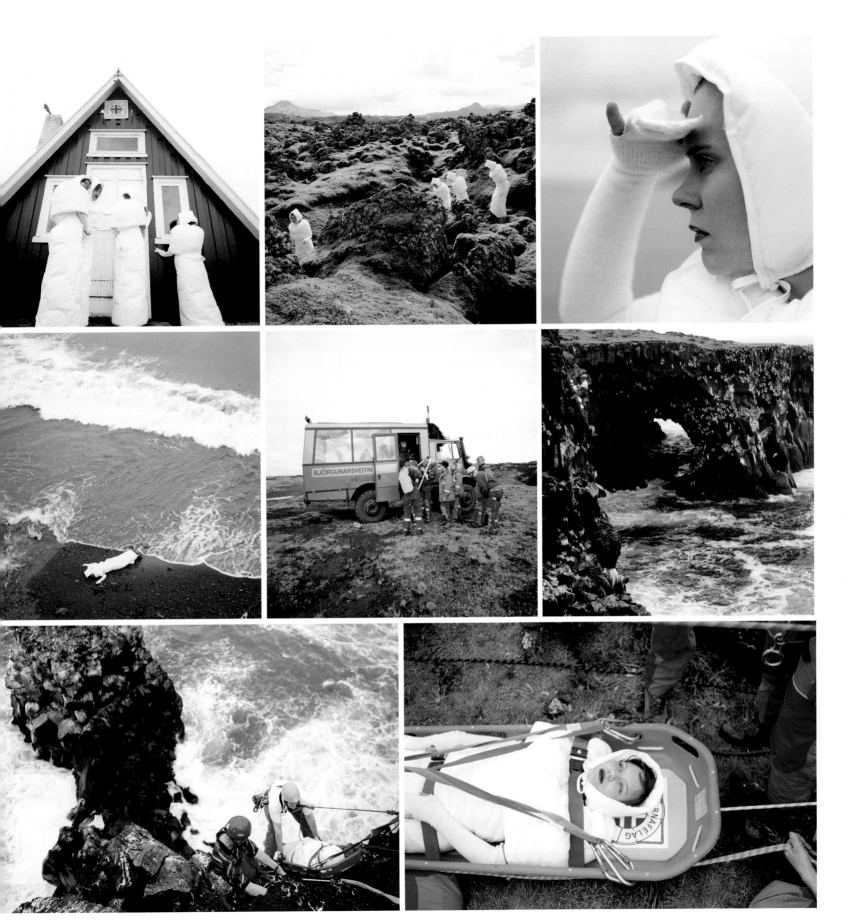

the icelandic love corporation

where do we go from here?

The soul is pure and proud
In our house of safety
There is never an angry cloud
Still outside there is plenty

Curiosity drove us from our happy nest
Looking for a new dimension
We hoped for all the best
In the land of beauty and tension

The cliffs are high and scary
The bodies are small and vary
The face of the sky is eerie
This is misery

We ask the whale! Help!
We ask the wind! Help!
We ask the waves! Help!
We ask the world! Help!

Never reason with nature

They have received a strange message
Their radio has told them a tale
They go gladly on this passage
They believe the whale

Seeing that beauty is dying
Braveness fills their hearts and limbs
Their senses feel the crying
Searching the edges and rims

In the soft embrace of nature
The dog gives the kiss of life
Where do we go from here?
We are dressed for eternity

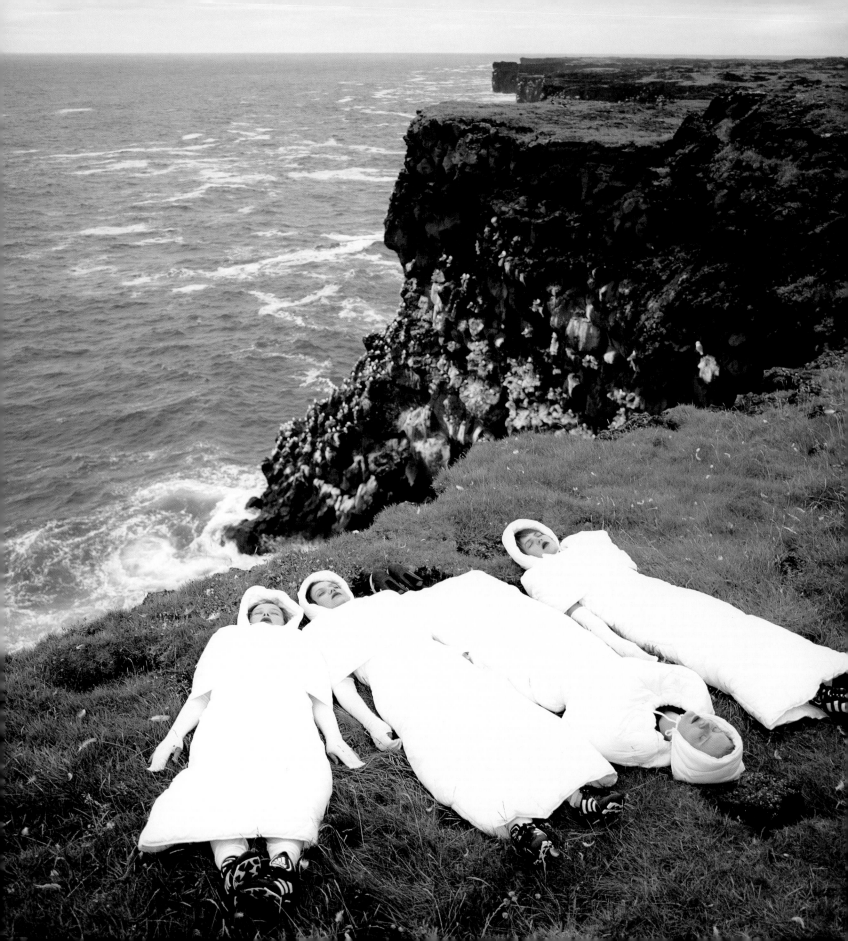

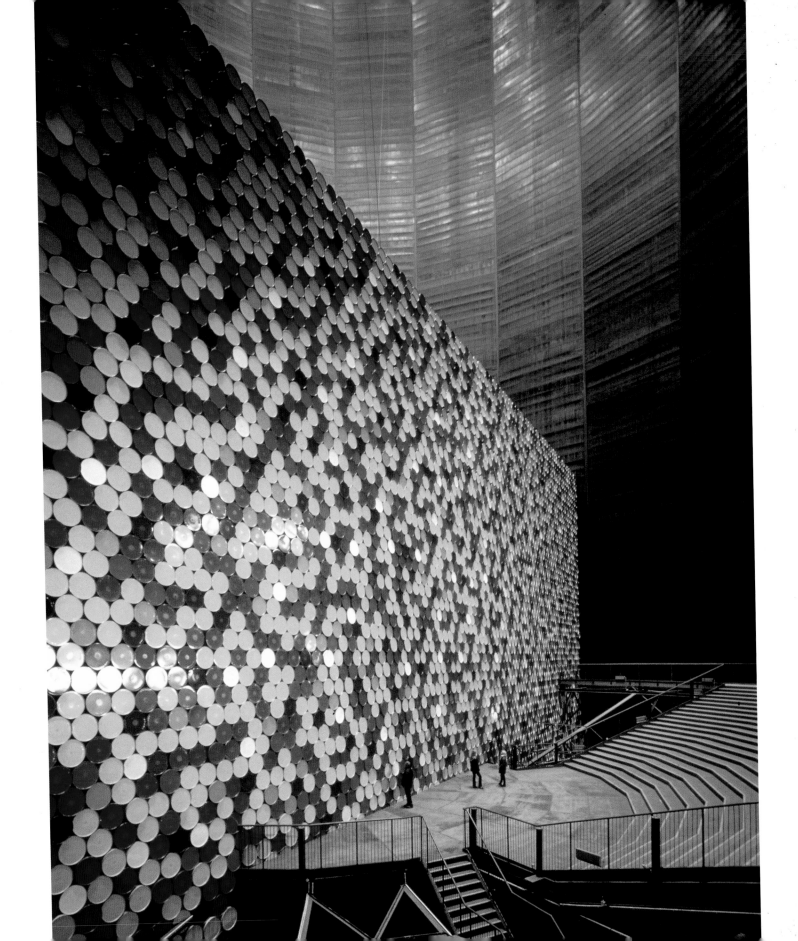

christo and jeanne-claude

CHRISTO AND JEANNE-CLAUDE have created art together as partners for more than four decades. Their works are entire environments, both urban and rural. Their temporal art singles out one part of the environment to astounding effect; the viewer perceives it with new eyes. Simple things like the wind blowing or the reflection of sunlight become monumental and magical. The effect often lasts much longer than the actual work of art. Years after the couple has removed every physical trace of an artwork and the materials recycled, original visitors can still see and feel them in their minds when they return to the site.

In 1999, Christo and Jeanne-Claude created *The Wall*, an installation of 13,000 oil barrels, inside the Gasometer in Oberhausen, Germany. At 360 feet high and 223 feet in diameter, the Gasometer is one of the largest tank structures in the world. It was built in 1928 to store the gaseous by-products of iron ore processing. *The Wall* bisects the Gasometer into two halves. Christo and Jeanne-Claude have a tradition of using oil barrels that began in some of their earliest works such as their 1962 installation *Wall of Oil Barrels - The Iron Curtain*, which blocked one of Paris's narrowest streets, Rue Visconti, for one night. Their most ambitious oil barrel project is yet to be completed. They began

work on the Mastaba Of Abu Dhabi in the United Arab Emirates in 1979. Four hundred thousand oil barrels painted in hundreds of bright colors, as brilliant as Islamic mosaics, will form a grand structure 492 feet high, with a base of 984 feet by 738 feet. The Mastaba interior will be constructed of materials connected to its immediate environment; natural aggregates and cement forming a concrete structure with a sand core. The colors of the exterior barrels will constantly change with the shifts of natural light throughout the days and nights.

Even seeing the words "oil barrels" and "the Middle East," printed on a page brings to mind a number of political and ecological issues, but Christo and Jean-Claude are not proselytizing. They make no didactic political statements, they simply create awesome artworks in and around urban and rural environments that have been managed by humans for humans. Then, after some time, after throngs of people have come and have been duly awed, the artists completely and thoroughly remove all traces of their work and move on.

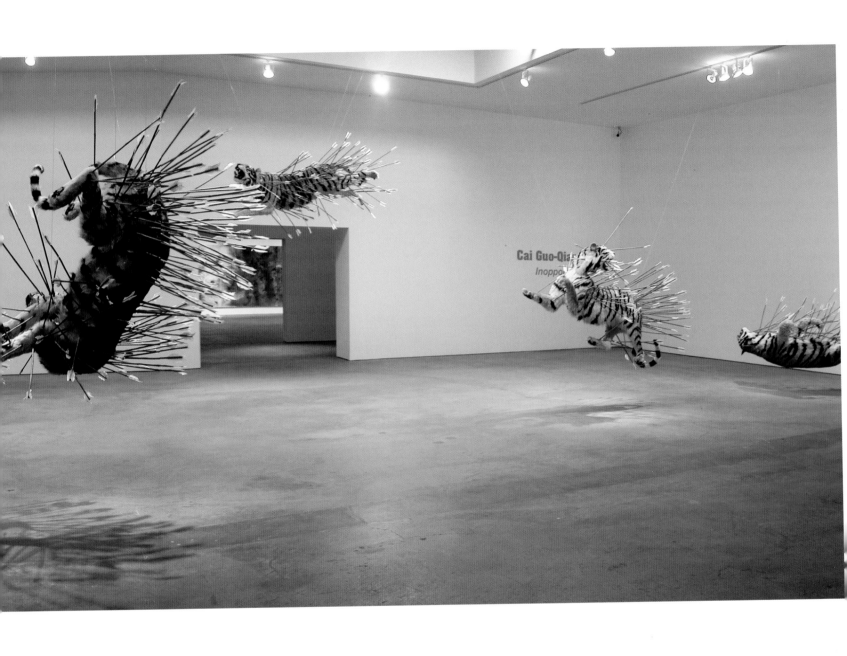

INOPPORTUNE: STAGE TWO, 2004
Tiger: paper mache, plaster, fiberglass, resin, & painted hide
Arrows: brass, bamboo, & feathers
Stage props: Styrofoam, wood, canvas, & acrylic paint
DIMENSIONS VARIABLE

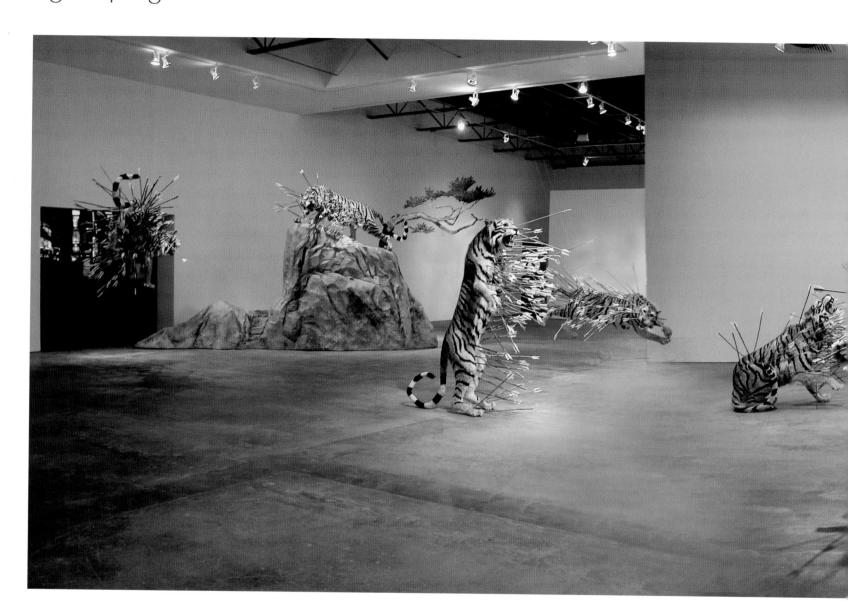

cai guo qiang

CAI GUO-QIANG is at ease with spectacle. His images are explosive even when they are static. The environments he creates have an electricity that encompasses the viewer like a bird on a wire.

For *Clear Sky Black Cloud*, at New York's Metropolitan Museum of Art, Cai invites visitors to climb out of the museum's historical labyrinth of world civilizations and up to its roof garden. They emerge to breathe in the open sky, enjoy the natural scenery of Central Park and gaze at the Manhattan skyline—all products of our modern civilization. From this vantage point, history lies behind while the present lies ahead. At precisely noon, a dense black cloud appears over the roof garden, accompanied by a sharp thunderclap. Resembling an inkblot splashed onto the sky, *Clear Sky Black Cloud* is an ephemeral sculpture that contrasts with the otherwise corporeal works that a museum visitor might expect. While the cloud is relatively small and the explosion is not particularly loud, the ominously low altitude of the cloud creates a powerful presence for the viewer, who witnesses the explosion as it is occurring directly overhead. As a site-specific, recurring event, the work provides a focal point and a daily attraction for the museum. It also symbolically sets the the city's clock.

Cai's impressive 2005 *Inopportune* installations unfurl like a Chinese scroll painting across Mass MoCA's 300-foot-long main gallery. The spectacular four-part sequence begins with a car crash depicted by nine full-size cars positioned in a sort of suspended timeline. Cai uses light rods to effect the movement and explosion of the crash. The final sequence is a room full of tigers leaping through the air and in many ways mimicking the cars, but instead of crashing, the tigers are shot full of arrows. "My work is sometimes like the poppy flower," says Cai. "It has this almost romantic side, but yet it also represents a poison. Behind all this is a very earnest and frank look at our society today."

opposite: CLEAR SKY BLACK CLOUD, 2006
Black smoke shells
DIMENSIONS VARIABLE

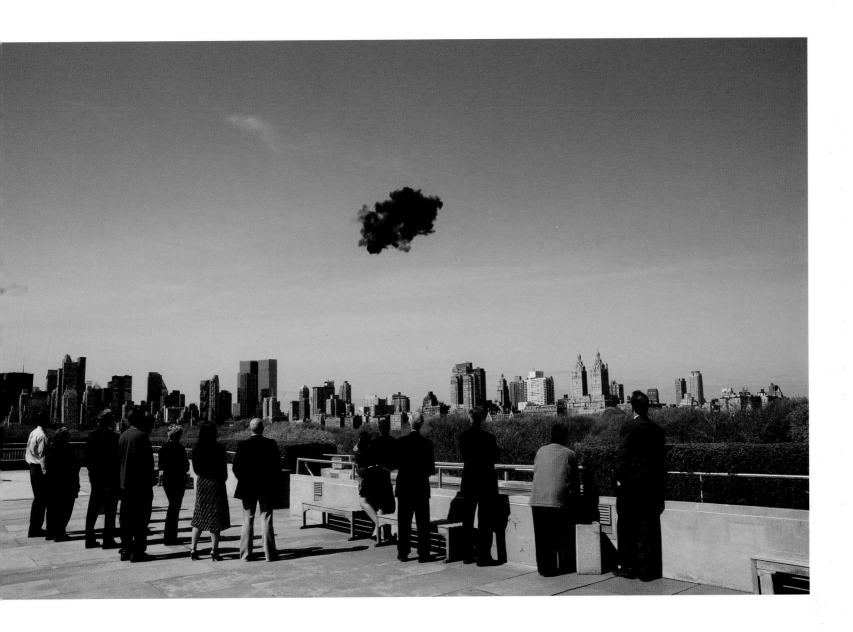

amy youngs

T HE CYCLE of satisfying appetite—consuming and digesting a meal—is a microcosm of a much greater system of consumerism that is shaping the planet. The simple domestic activity of sitting down to dinner with the family relies on a rapidly increasing set of natural and man-made systems. A complex global network of geophysics, agriculture, advertising, economics, communications, research and development, shipping, roads and railways is working around the clock to feed mankind. The cost of a simple plate of pasta is not merely the dollar and change one spends at the grocery store. Petroleum used to ship products, sometimes thousands of miles, and the pollution that shipping generates should also be taken into consideration, as well as the energy and materials used for packaging and the cost of waste management.

It is at the table that artist Amy Youngs and her partner Ken Rinaldo conceive many of their projects. "A lot of our work arises out of conversations we have over dinner," says Youngs. Their *Hydroponic Garden* began with an acknowledgment of their role in a living system and led to an exploration of the systems that support their survival. "We started thinking about the petroleum dollars involved in transporting our food and postulating about what we,

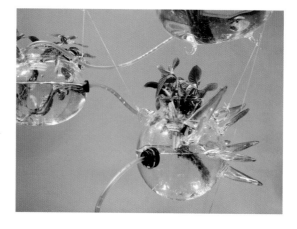

as artists, could do or make that might help remediate waste." The *Hydroponic Garden* produces only a handful of herbs and tomatoes, hardly enough to feed a household, but because it is an art piece it can have the greater impact of starting a dialogue. Youngs says that this "conversation piece" is a form of personal protest that might encourage others to consider what they are putting on their tables.

She also designed a sculpture in the form of a multifunctional table and stool set containing a built-in ecosystem. Scraps of food and shredded junk mail can be placed in a portal in the top of the table where they will be met by earthworms that compost the waste in an enclosed fabric cone. Rich, fertile dirt is excreted at the base of the cone, where it is fed to several potted plants. "It pushes the system of eating and waste processing together into one piece," says Youngs. She imagines the table could be made on a grander scale and used in offices or cafeterias. "I am always amazed that such low-tech solutions aren't explored. Through my work I am trying to increase awareness and acceptance of these already viable options."

above: detail shot of opposite

opposite: HYDROPONIC SOLAR GARDEN, 2005
Hand-blown glass vessels, live plants, water, and solar powered pump
2 x 1 x .6 M

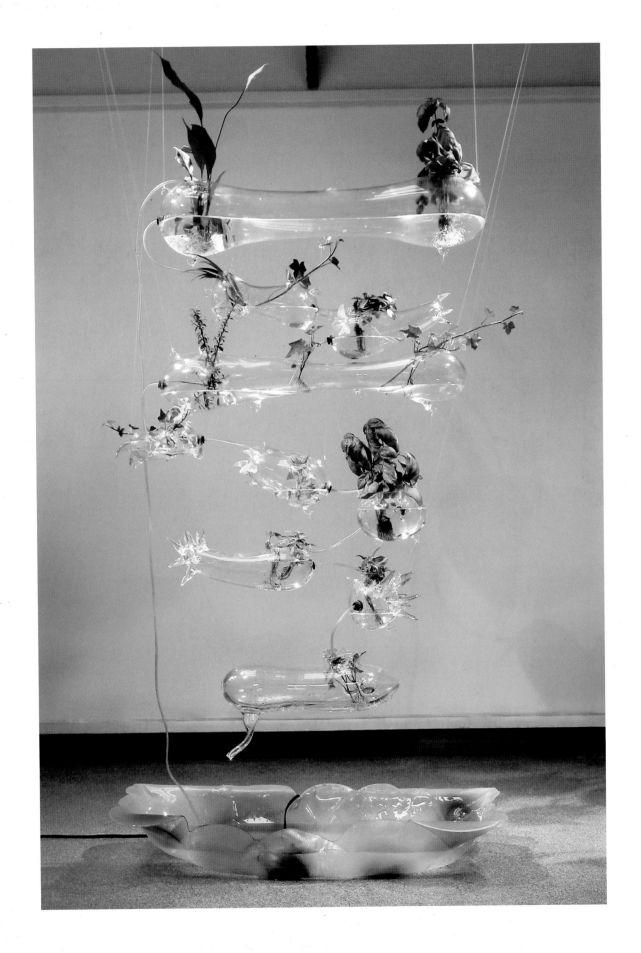

el anatsui

FRESH EYES and an original perspective can render the world a much richer place. A bottle cap, for example, can become a jewel. Master artist El Anatsui sees jewels all around him and skillfully arranges them in such a way that we can share in his vision.

Bottles of liquor were once the units of currency preferred by European traders seeking to acquire slaves and ivory on the West African coast while rum, a byproduct of the Caribbean sugar plantations for which Africa had supplied the labor, was exchanged at great advantage to the European traders. This history was not lost on El Anatsui. When modern distilleries in Nigeria recycle bottles, they discard the screw caps in the process. By collecting them and meticulously sewing them together with copper wire, El Anatsui aims to "subvert the stereotype of metal as a stiff, rigid medium and rather show it as a soft, pliable, almost sensuous

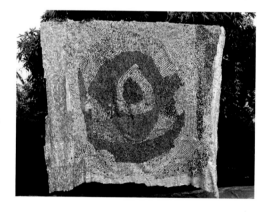

material capable of attaining immense dimensions and being adapted to specific spaces." At the same time, he transforms everyday objects into glittering tapestries that would be no more beautiful if they had really been made of so-called precious metals. What is more precious than something that has been rescued, revived and reimagined?

From Ghana, El Anatsui has lived in Nigeria since 1975. As one of Africa's most powerful contemporary artists, he dwells on the continent's history, but draws simultaneously on traditional African idioms and the motifs of contemporary Western art. Whether it is made of bottle caps, driftwood or other found objects, his work serves as a commentary on culture, history and society. El Anatsui weaves references to generosity and materialism, tradition and modernity into sumptuous cloths and other items that have no footprint.

above: DZENSI, 2006
aluminum and copper wire tapestry
3.5 x 4 M
opposite: detail shot of above

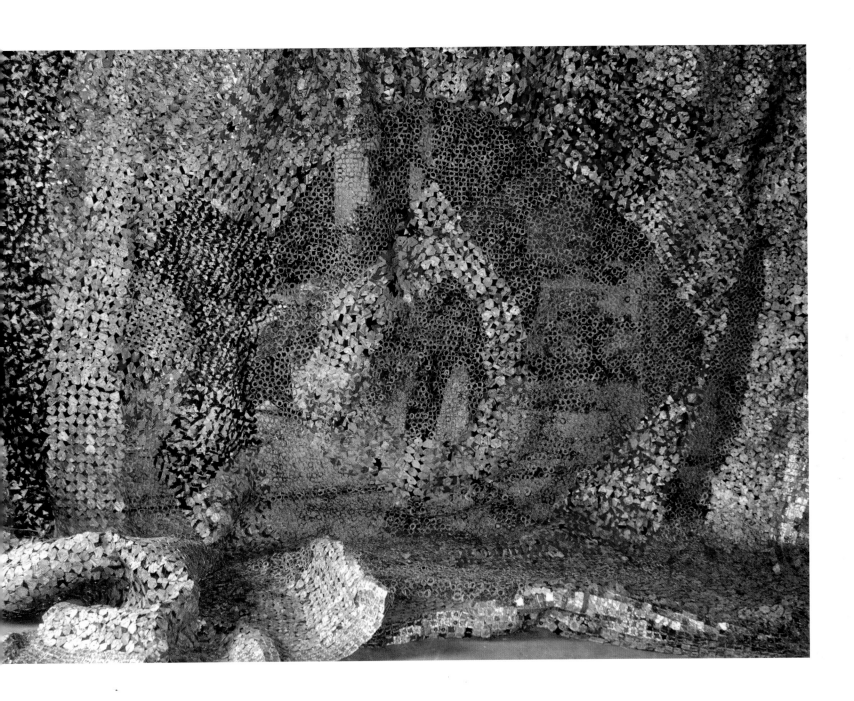

masaru emoto

MASARU EMOTO was moved by the story of a famous fourteenth-century Japanese warrior, Takeda Shingen, who was asked to settle a village dispute over water that flowed from the Sanbu-ichi Yusui spring. According to the story, Shingen created three channels from the spring to distribute the water equally, and peace was brought to the village. Emoto went to the Yusui spring and took a sample, as he often does when he learns of a water source that is particularly charged with either positive or negative energy. He uses the samples to test his theory that water physically "changes its expression" depending on the emotional environment that surrounds it.

Emoto presents his somewhat controversial research data in the form of beautiful photographs of microscopic water crystals. His assistants test the theory by exposing common tap water to a variety of "focused intentions" through images, spoken words and music. For example, Emoto often exposes water to positive phrases, such as "love and thanks." He also exposes water to negative phrases, such as "I hate you—I will kill you," which, he says, "many Japanese children picked up at a time when bullying was becoming a problem in the society." Tap water is placed in a glass, then spoken to or set beside music or images that are labeled positive or negative. The water is then divided into petri dishes and frozen for three hours. The ice is examined under a microscope and photographed.

Some people believe that Emoto's research could lead to new ways of positively impacting the earth and one's personal health, and even world politics. "I have been told that the dispute

between Israel and Palestine started with a dispute over water in the River Jordan," says Emoto. "We can learn from this beautiful crystal that the action and thought of sharing is important for a harmonious life. I think because the human race hasn't given enough thanks these days, there is so much destruction in the world." By focusing positive intentions toward this most essential element, we could affect a self-affirmation on a global scale.

above: YOU MAKE ME SICK, 2002–2003
microscopic water crystals
DIMENSIONS VARIABLE

below: LOVE AND THANKS, 2002–2003
microscopic water crystals
DIMENSIONS VARIABLE

siobhán hapaska

'If you try to combine something that has a shell of technology with a more organic core or foundation, it's almost repulsive. Like mixing petrol with milk. It's a modern tendency, and I find that interesting. I don't like being alone with a natural landscape. It makes me feel depressed and claustrophobic. It's as if the landscape were watching and saying, 'Go on, do what you will, you irritating tick on my surface. You're ineffectual and synthetic.' It's as if the landscape were smug in its rightness. It compounds my sense of my fleeting life span, a race against time, a certain politeness. The city is my defense against the landscape: its bars, its cinemas, its shops, its decadence."

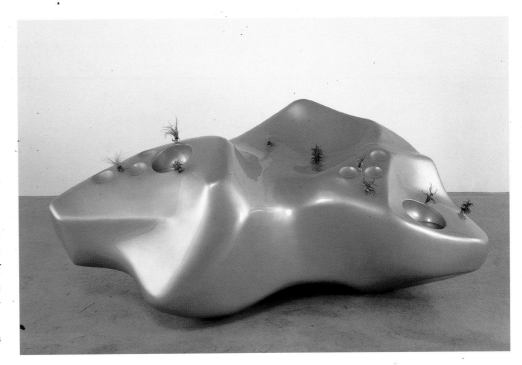

LAND, 1998
fiberglas, acrylic paint, two-pack acrylic lacquer, magnets and air plants
132 x 238 x 94 CM

janine benyus

THE ABALONE'S mother-of-pearl coating is a masterpiece of design—lightweight, durable and fracture resistant. Similarly, the tough skin of dolphins and sharks flexibly bends and bows to shrug off water and air pressure. Industrial designers would profit greatly if they could duplicate these qualities in a man-made material for manufacturing airplanes, submarines and automobiles. Janine Benyus sees the human capacity to replicate nature's brilliant designs as potentially limitless. She is an expert in the field of "biomimicry," a term she coined to define a new science that "studies nature's models and then imitates or takes inspiration from these designs and processes to solve human problems." She says, "Doing it nature's way has the potential to change the way we grow food, make materials, harness energy, heal ourselves, store information and conduct business. In each case, nature would be our model, measure and mentor. We would manufacture many things the way animals and plants do, using the sun and simple compounds to produce totally biodegradable fibers, ceramics, plastics and chemicals. Our farms, modeled on prairies, would be self-fertilizing and pest-resistant. To find new drugs or crops, we would consult animals and insects, which have used plants to keep themselves healthy and nourished for millions of years. Even computing would take its cue from nature, with software that 'evolves' solutions, and hardware that uses the lock-and-key paradigm to compute by touch.

"In each case, nature would provide the models: solar cells copied from leaves, steely fibers woven spider-style, shatterproof ceramics drawn from mother-of-pearl, cancer cures compliments of chimpanzees, perennial grains inspired by the tallgrass prairie, computers that signal like cells, and a closed-loop economy that takes its lessons from redwoods, coral reefs, and oak-hickory forests. When we view nature as a source of ideas instead of goods, the rationale for protecting wild species and their habitats becomes self-evident. To have more people realize this is my fondest hope. In the end, I think biomimicry's greatest legacy will be more than a stronger fiber or a new drug. It will be gratitude and, from this, an ardent desire to protect the genius that surrounds us."

above: "ZEN" NAUTILUS, 2005
x-rayography by Alfred C. Koetsier

opposite: PAXFAN, 2006
imagery © PAX Scientific, Inc.

francis baker

FRANCIS BAKER'S *Everyday Garden* is the sculptural documentation of a concentrated five-year engagement with nature. The idea was born when Baker found himself engrossed in repotting a neglected houseplant that had outgrown its confines. The roots curled in upon themselves, tangled and bound. "I had been feeling confined by my environment and my thoughts, and in that moment the plant appeared as a metaphor. It suggested that we are contained by our thoughts and emotions, by patterns set up from concepts that arise from fundamental structures such as societal living, or the notion of prosperity, or beauty."

This observation led Baker to ask himself, "What are some of the things that contain me?" Our body image, relationships, ambitions, emotions and environments are molds from which we all could break out. "To create meditative pieces, I began the process of casting everyday objects I saw as representing these notions of confinement." He experimented with casting objects in rubber because of the material's forgiving qualities. "The casting changes over time in the damp, fungus-prone environment, and it gives and distorts from the force of the roots finding weaknesses in the container. This gives the process a degree of freedom—separating me a little more from the result. By using the cast negative as a container in which to grow a plant, then recording its life and ultimate suffocation under the conditions of being root-bound, I am able to connect to a life-and-death struggle with physical confinement." He cast, among other objects, a Barbie doll, a Buddha and a baby's hand, into which the roots grew and took shape.

Baker believes that art provides a unique means of acquiring information. "You've heard the slogans before, but art really gets into another center of knowledge. For external change to take effect, the inner world has to be ready." This explains his use of the Buddha in this series: The first step is to free the mind. "I believe in art," he says, "so I believe art can promote positive social change. You just might change your usual habits. Not that everyone needs to change, but it works for me personally. You can see these images, reflect upon them, and then maybe come to some of the same conclusions. Slow down. See things fresh. When the direction we are pointed in is not a direction best suited to our health, we can then use the awareness that we are being confined by thoughts and emotions as a tool to find a different action."

EVERYDAY GARDEN: INTERMENT 3, 2005
acrylic box, organic matter
64 x 30 x 30 CM

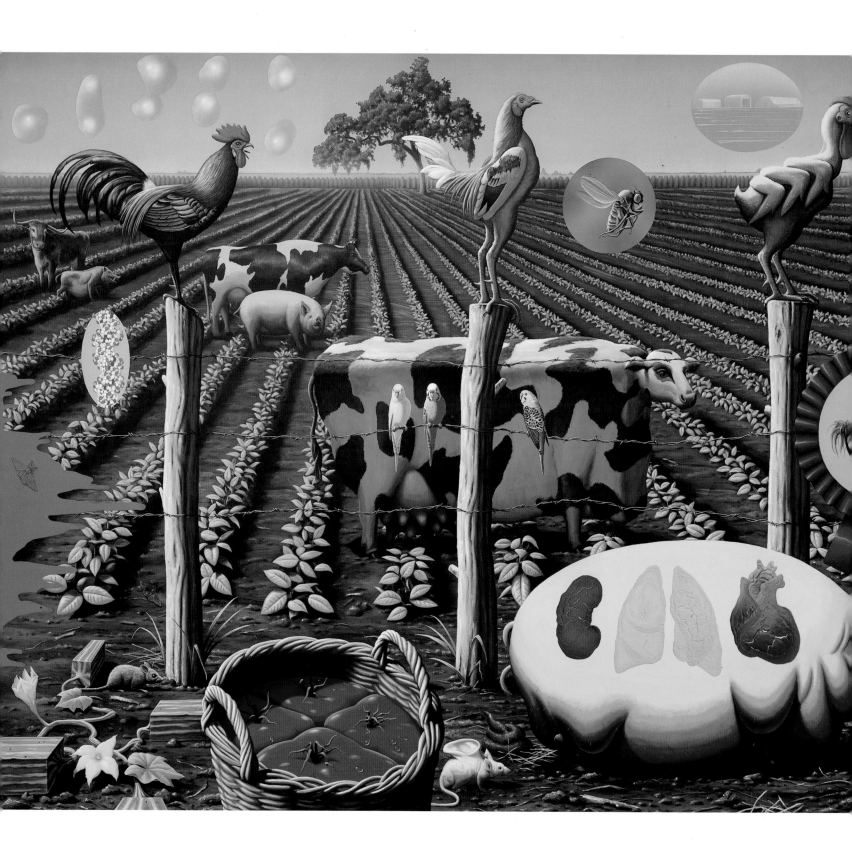

alexis rockman

ALEXIS ROCKMAN'S depiction of the effects of global climate change on the Brooklyn waterfront is not merely a work of the imagination. The artist consulted with climatologists James Hanson and Cynthia Rosenzweig, as well as with other authorities from the private and public sector, to develop a sophisticated, if disheartening, blueprint for our future. He applied similar criteria to his painting *The Farm*, which contextualizes the biotech industry's explosive advances in genetic engineering within the history of agriculture, breeding and artificial selection.

His paintings fortell a bleak future, but not total extinction. "There have been greater extinctions than we could ever provide. The Permian, for example. There have always been survivors—humans and cockroaches, for example—and there always will be. The likely winners, in terms of the global ecosystem, are the invasive species of plants and animals that do well around humans." His image of minimized biodiversity is not a pretty picture. "We'll have some rats and whitetail deer, and certainly cats and feral pigs. Geographically specific biodiversity will be a thing of the past."

Rockman sees no need to hide the axe he is grinding. "I am not ambivalent about it at all. I am infuriated. I find the situation almost unbearable," he says. "I am very conscious of how fragile civilizations have been, and are, and will continue to be. But there is a diabolical disconnect between consciousness and action stemming from humans' ability to go into denial. There's been a profound transformation in our climate over the past 150 years, yet if people are made aware of it, or allow it into their consciousness in any way, they tend to explain it away, as if it weren't happening to them or it couldn't happen in their lifetime. I find that particularly bizarre, if one has children. I can't imagine what parents like Karl Rove are thinking." He says people are operating with the psychology of a frog in a pot of water on the stove. Lulled by the warmth, it doesn't realize it is in trouble until the pot is boiling and it is too late to jump out.

Is it the artist's job to wake the lulled masses? "People don't want to think about the information I deliver because it has to do with their own mortality," he says. But it is hard to look away from Rockman's balance act, hovering between poetic composition and factual nightmare.

THE FARM, 2000
oil & acrylic on wood panel
2 x 3 M

patricia piccinini

IN *WE ARE FAMILY*, her Venice Biennale 2003 Australia exhibition, Patricia Piccinini presented a number of disturbing tableaux featuring fleshy creatures that exist just beyond the realm of the natural world. She used silicone, acrylic and human hair to fabricate these all too realistic sculptures. In *Still Life with Stem Cells*, a young girl sits playing with bulging pouches of wriggling flesh in the shape of knees and belly fat. And in *The Leather Landscape*, uncanny critters sit on a modern-architectural piece of furniture. Marsupial, ratlike, yet somehow unfamiliar, they blur the boundaries between the animal and the human.

These works explore the idea of our changing relationship with the natural world—particularly, our increasingly intrusive interventions. Cloning, crossbreeding, gene therapy and stem cell research are no longer the stuff of science fiction. Playing with the idea of doing the wrong thing for all the right reasons, Piccinini presents us with a series of curious solutions for a number of environmental problems. However, her interest is not so much in environmental correctness as it is in the stories that emerge when new beings are added to—and begin to interact with—the natural world. Her assumption is that while we might have the ability to create new forms, we will never have the power to contain them. Piccinini revels in the probability that her creations might be set loose and begin to create their own worlds, beyond our control and expectations.

STILL LIFE WITH STEM CELLS, 2002
silicone, acrylic, human hair, clothing, carpet
DIMENSIONS VARIABLE

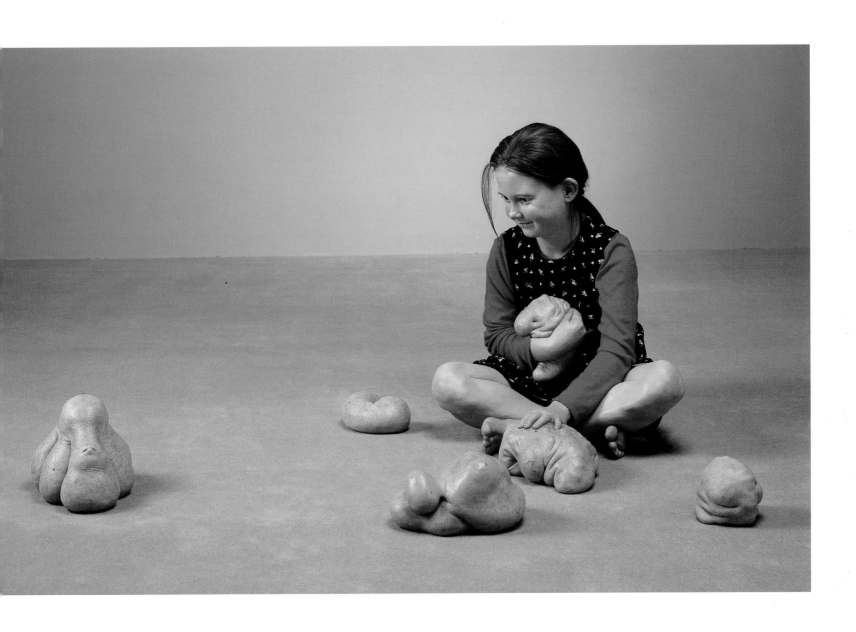

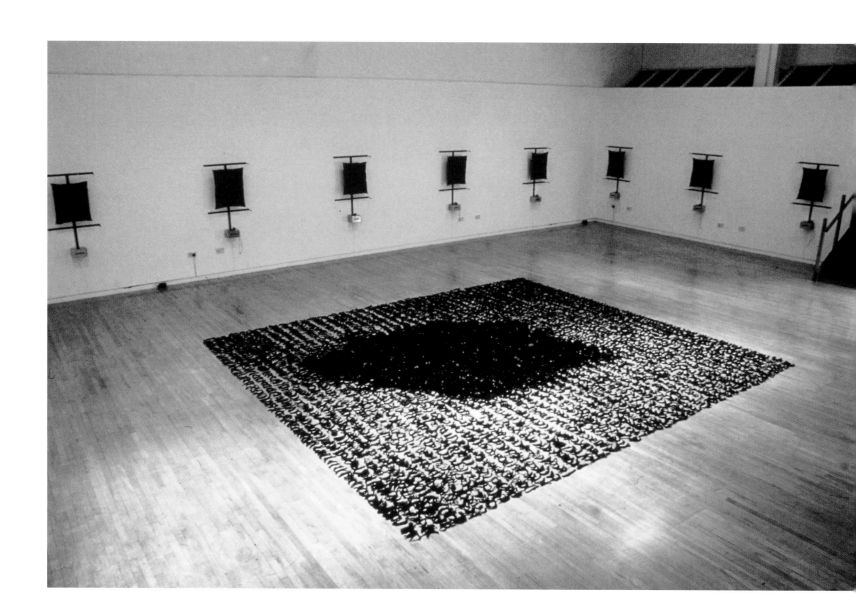

shelley sacks

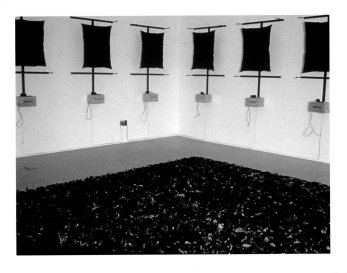

As global free trade and the agricultural–industrial complex expand, people are increasingly removed from their sources of sustenance. We have become dissociated from the processes that generate and deliver food to our table as the sacrifices made along the way are obscured by the tidy marketing and packaging of the final product. Shelley Sacks confronts the consumer by closing this gap and presenting the product and the producer side by side—the banana and the voice of the banana grower, together. For her social sculpture presentation *Exchange Values: Images of Invisible Lives*, Sacks stitched sheets of banana peels from twenty randomly selected boxes of bananas that had been shipped to Europe from the Caribbean Lesser Antilles. Each sheet is accompanied by a voice recording of the farmer or the family that grew that particular box of bananas.

The presentation required extensive detective work and an international network of collaborators. Each banana was traced back to its grower by the coding on the shipping crate. For twenty-four days, Sacks traveled through the volcanic mountains and valleys of St. Lucia attempting to identify and interview the farmers. She often spent hours four-wheeling through difficult terrain to find a single farmer. "We would hoot and wait on the track, in the blistering heat, or in tropical winds and pelting rain, for the grower to emerge out of the dense banana plantations that stretch up the mountains and deep into the valleys." But each interaction was like uncovering a hidden gem. Sacks engaged in long conversations with the field officers and farmers, reflecting on Britain's relationship with St. Lucia from the days of slavery to the present, discussing their struggle with the United States and with multinational corporations and pondering the concepts of ownership and value. "How is the worth of this fruit, once known as green gold, measured? What is this fruit, the world's fifth largest food crop, really worth?" They also contemplated the consumer's changing role. "When consumers have money in their pockets, is their only responsibility to themselves? Should they seek to buy the cheapest banana, the cheapest pair of shoes? Or should they, having informed themselves, consider the social and environmental costs, and other criteria?"

Before taking a meal, Buddhists pause to generate awareness of the interdependence of the universe and the hard work of individuals that is contained within each morsel of food. Nearly every culture has such a custom; Christians, Jews, Muslims, Hindus and countless others have long shared a tradition of bowing their heads and giving thanks to the creators and the many human hands upon which they depend. But there seem to be fewer opportunities to pause for such simple grace in these accelerating times. Sacks's work asks us not to forget.

above: detail shot of opposite

opposite: EXCHANGE VALUES: IMAGES OF INVISIBLE LIVES, 1998
20 stitched sheets of skin from 20 randomly selected boxes of bananas
DIMENSIONS VARIABLE

ken rinaldo

ON A FLIGHT over the middle of America, Ken Rinaldo peers out the airplane window to observe highways bisecting prairie lands. "Roads are a necessary means for us to transport our matter, energy and food. At the same time, they cut up the land and block the free migration of certain creatures." This superimposition of an artificial system on a natural one is central to Rinaldo's exploration of intelligent robotics. "Through my work, I am questioning how machines, or any of the technological systems we humans have created, impact the natural living systems that surround us." In particular, he is interested in the lessons that can be learned from those natural systems.

Evolution has been successful for 3.7 billion years, he says, so it must be doing something right. Rinaldo studies the "evolved and intertwined wisdom of natural living systems," searching for models of success to replicate as he manufactures his own highly evolved inventions, such as the personable *Autotelematic Spiderbots*. "A cockroach has 30,000 hairs on each leg and antennae-like protrusions called the cerci, so it can sense air currents. Before it can see you it can feel you, and it scurries away," he says. "Robots are being designed in the same way. We are creating massively parallel sensor networks that recognize the environment. It's not just computing and software anymore." Rinaldo has formulated a programming technique he calls "biosumption"

that allows robots to communicate and collaborate. "They have an embodied understanding of the world around them and how they can best interact with that world by using infrared eyes and ultrasonic ears."

Rinaldo thinks that biodegradation is another "beautiful lesson" we can learn from nature, and he hopes to see it replicated in the world of technology. "When something dies in a natural system, all the parts can be digested and used by the other creatures that are part of a very complex, intertwined food web." So, he asks, why not develop a technological food chain? "Developers should look beyond merely recycling or reusing, to create products that can feed or be fed off of." As an example, he has already seen car manufacturers thinking in terms of reintegrating parts, and he imagines one day we will see computers that "dissolve into the earth, or can be eaten after a certain amount of time."

Meanwhile, computer products are still being shipped across the globe and across our transportation systems, heading for superstores in one direction and landfills in the other. But Rinaldo notes that, over time, if conductive plastics can be manufactured to biodegrade and fill with water, a new system of insects and microbes may move in, transforming old circuit boards and broken screens into healthy green habitats.

AUTOTELEMATIC SPIDER BOTS, 2006
10 spider-like robots
DIMENSIONS VARIABLE

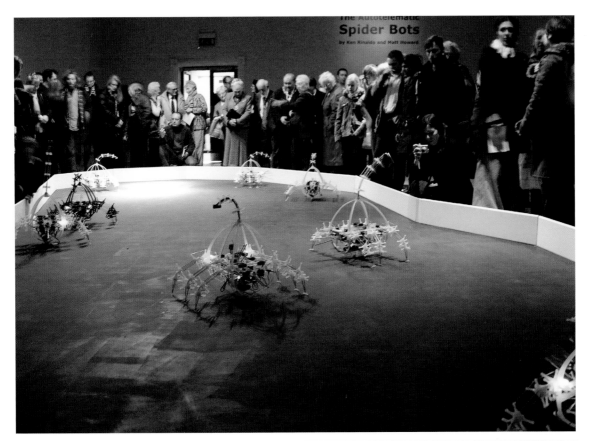
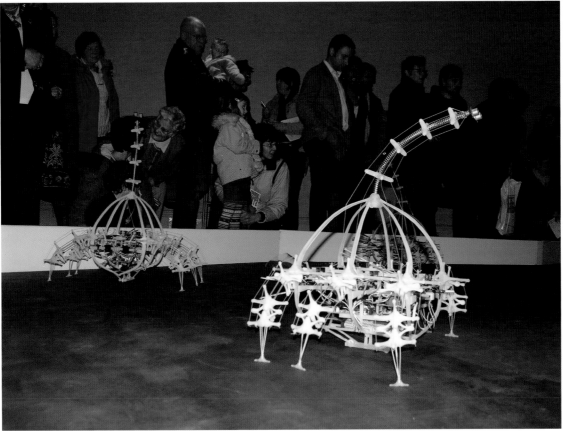

dustin shuler

IT IS DUSK on a cloudless summer day outside Dustin Shuler's Los Angeles studio. But inside, a flash of lightning and a clap of thunder give way to a cool rain. The storm is contained in a 144-cubic-foot, clear polycarbonate "life pod," part of a three-pod mobile rain forest habitat. It rouses the inhabitants—finches, frogs and other pet store specimens that have been selected to live out their lives in artistic captivity. It doesn't rain every day in the rain forest. The system requires three complex time-control units to manage its daily activity—lights set on timers mimic the passage of the sun and the moon, a sound system amplifies the chatter of the forest, the temperature is regulated with sensors and a huge mechanical filter mimics a watershed. These elaborate mechanical devices are contained in the two pods positioned on either side of the miniature ecosystem.

Shuler has been experimenting with *The Rainforest* since the 1990s. "Instead of having my studio in the woods, I've got my woods in the studio," says the Pennsylvania

native. "I've got those animals caged in my rain forest and they don't have to worry about predators coming and getting them." He takes his role of creator seriously. "If you are controlling a creature's environment and getting enjoyment from that, you have to be symbiotic and give that creature a healthy life, take care of it. I believe in responsibility. Symbiosis is the best relationship. Like humans and dogs."

The juxtaposition of the lush ecosystem and its highly mechanized support system recalls the science fiction images of a future where nature cannot exist on its own. But Shuler has taken care not to name the animals in the ecosystem, and he limits his interactions with them to a bare minimum. "They're living life and I'm just observing. The thing is that we are all caged. We are caged within our cities and our homes and such. There are boundaries put up in our culture and there are boundaries in nature."

above: detail shot of oppposite

opposite: THE RAINFOREST: A LANDSCAPE IN THE SHOWER, 1990–2005
ventilation fans, speakers, ballasts for color-Arc Lamps, fiberglass bathtub/shower, various plants, live animals, air vents

2 x 4 x 1 M

art in action

sam easterson

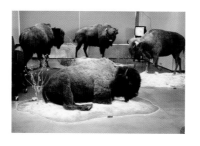

WE WALK in the footsteps of bison, the largest terrestrial mammals in North America and Europe. These nomadic grazers once numbered in the hundreds of millions. For centuries, the gigantic herds meandered through the plains and mountains, instinctively cutting paths that tribal warriors later used for their own purposes. During the nineteenth and twentieth centuries, the bison were hunted to near extinction, but their trails remained, and many have become the roadways and railways that we use today.

Sam Easterson takes us a step closer to our trailblazers by placing us at a voyeur's vantage point, atop a bison's head. Easterson designs helmet-mounted video cameras that attach onto bison and many other animals and plants, to capture moments of their experience. There is something raw and unsettling about the footage. It is not a smooth ride, and we are not truly seeing the world through the animals' eyes. Instead, we are sent on shaky trips, clinging on, trying to get a taste of life in the wild. "I think my footage helps disarm people," says the thirty-three-year-old Easterson. "Once their guard is down, then you can get them to start thinking about more serious environmental issues. I do believe that if people can see the world from the perspective of animals and plants, then they will be far less likely to harm them or their habitats."

By attaching his lightweight cameras to a variety of plants and animals, Easterson has amassed a collection of footage shot from the perspective of about fifty organisms, including a chicken, a goat, a pig, a cow, a frog, a whitetail deer, a bat, a box turtle, a tarantula, a slug and even a tumbleweed.

ANIMAL VEGETABLE VIDEO: WHERE THE BUFFALO ROAM, 2005
video stills

reuben lorch-miller

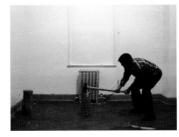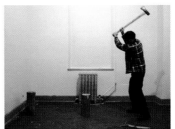

'The natural can be used to recontextualize us as humans. It rescales us, knocks us down, diminishes our hubris by placing us in a small part of a powerful system that can destroy us. It can also be used to heroicize our image of ourselves through our perceived mastery of it. Our self-awareness and self-image, both collective and individual, has often been measured through either a contrast against or an integration with the natural. Nature is tricky because it is largely a socially constructed idea. It is in this context that I usually consider it. It is a symbolic device through which we place and present ourselves. The other side of this is that nature, or rather everything, is also deceptively self-evident. It simply is and we are part of it.

"For this piece, my inability to easily chop the logs was purely accidental. This beautiful act of unplanned failure caused the piece to become far more interesting and successful than I had anticipated. In hindsight, the piece addresses an illusion of heroics. We witness a failure of physical competency and an ineptitude in an iconic male activity of survival and skill. The absurdity and futility of the action can be applied to many ideas and behaviors—dull, stubborn desire pounds against immovable fact.

"Both pieces are unified by the corruption, disruption and failure of idealized forms. In *Chopping*, the central form is me, or a man, or a human. In *Logs*, it is the log itself, the inert and severed part of the tree. They both express defeat, stunted power and lost hope. Logs are severed remains. They are dismantled parts of a larger system. They are also consumable fuel, power cells and a constructive material born of destruction. They are symbolically American, evoking the pioneer's rustic log cabin and the woodpile out back. They are the ordered and useful results of a victory over chaos. The safe reorganization of darkness. An escape from death through work."

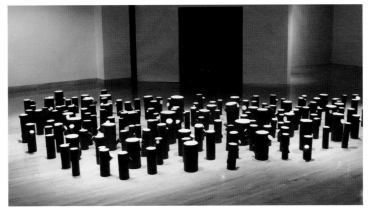

above, left and right: CHOPPING, 2001
video still
20 SECONDS

below: LOGS, 2002
papier-mâché, cardboard, paint
DIMENSIONS VARIABLE

alfio bonanno

JULY 1, 2003, RUDKØBING, DENMARK

'CREATING A site-specific work demands investigation, contemplation, understanding and often collaboration. When I saw the shoreline of Ontario's Lake Simcoe surrounding the city of Barrie, and in particular a sandy slope between land and water on Kempenfelt Bay, I knew immediately that this would be the site for my project. This sunlit space overlooking the city skyline is accessible by an established path that is regularly used by many walkers, runners and cyclists. The shoreline is framed by many species of trees and is populated by kingfishers, ducks and other nesting birds.

"I needed to find a connection, an idea that could be identified with this area, something that would make me feel that I was not intruding but instead creating a dialogue with this specific site. I took notice of the indigenous milkweed plant and its magnificent pods growing everywhere. Their shape, two halves coming together with delicate seeds bursting out from the center, reminded me of the nonindigenous zebra mussels that pose an ecological threat to the lake, and with that I had found the connection that I had been searching for.

"The common milkweed is toxic but has medicinal properties. It has been used by indigenous peoples for centuries to cure stomach ailments and for warts and bee stings. The monarch butterfly, which migrates to Canada from its winter in Mexico, is dependent on the milkweed for the survival of its chrysalis. When we take this common plant or weed for granted and build our houses, shopping malls and roads on top of its natural habitat, we may carelessly cause the extinction of these butterflies. Nature has taken millions of years of evolution to achieve a very delicate balance; preserving that balance demands our care and attention.

"With the help of an army of volunteers, I gathered huge amounts of sticks from different sites around Barrie that were slated for development. There were maples, birch, willow, poplar, red dogwood and various other species. For

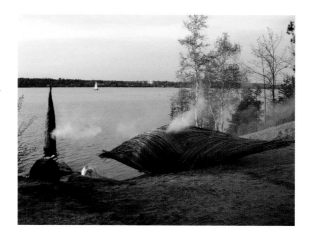

five weeks we wove these sticks into giant representations of the milkweed pods. The forms were then carefully placed along the shoreline, as if strewn there by a violent wind or a master hand. The forms cling to the site, creating a new visual experience and, hopefully, sharpening our sense of awareness and responsibility for this endangered species and its environment."

above: SHORELINES PROJECT, BARRIE CANADA: BETWEEN LAND AND WATER (AT DUSK), 2004
woven branches
DIMENSIONS VARIABLE

opposite: SKETCH FOR BETWEEN LAND AND WATER, 2003
watercolor and ink on photograph of project site
11 x 27 CM

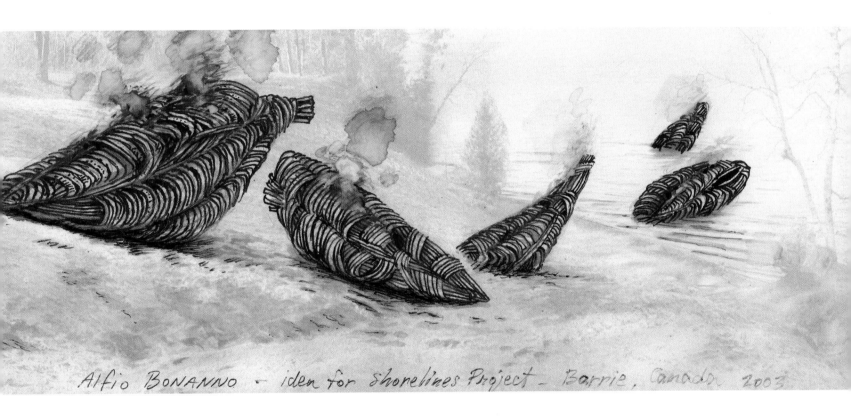

Alfio BONANNO — idea for Shorelines Project — Barrie, Canada 2003

lezli rubin-kunda

A woman contemplates an old olive tree situated in a suburban backyard on the outskirts of Tel Aviv. She has an overwhelming desire to connect with nature and be part of the place, not just an observer. She longs to feel at home in her immediate surroundings, as well as in the world at large. She begins by relating to this olive tree, making offerings to it as a mother might—giving it conventional powdered soup mix and knitting it sweaters.

Through her performance, Lezli Rubin-Kunda asks, "Am I domesticating the tree to make it more contained and familiar? Am I taking possession of it by leaving my painted mark on every leaf, anthropomorphizing it to protect it from the elements, eroticizing it by exploring its hidden cavities?"

Rubin-Kunda's physical entanglement with Israel, a place loaded with symbolic and political implications, complements her inner dialogue about history, property, justice, womanhood, ecology and suburbia. "I am trying to find a way to be comfortable in this environmentally and politically problematic place. Does any of it even belong to me? The idea of having a yard in the Middle East seems so wasteful." By applying a sense of childlike curiosity and wonder to the details of her landscape—an olive branch, a thorny thistle—she circumvents the current warring ideologues. She does so without taking a position. Rubin-Kunda's truth is not a matter of "us versus them." There are layers upon layers of truths, many buried in the land itself. "I am questioning if there is even something here that we can call original," she says. The ancient Arab olive grove swallowed up by the modern Israeli suburb is no exception. "Even an olive grove was once an intrusion in the landscape of the past."

left: OLIVE TREE COVERED WITH CHICKEN SOUP POWDER
(DOCUMENTATION FROM 'BACKYARD WITH OLIVE GROVE,' 2000-2001), 2001
photograph
70 x 50 CM

right: IMPRINT (DOCUMENTATION FROM 'BACKYARD WITH OLIVE GROVE,' 2000-2001), 2001
photograph
70 x 50 CM

philippe pastor

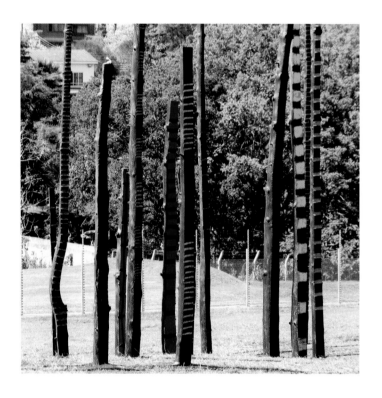

'THESE SCULPTURES were created from the calcified tree trunks of the Garde Freinet forest in the south of France, which was devastated by fire during the summer of 2003. The fires were started by arson and negligence. When I saw the fire burning down the mountain, I could not resign myself to such destruction. I don't want the trees to fade into memory. Looking at such mutilated nature, I am horrified and have a deep feeling of resentment toward the authors of this disfigurement. Through this work, I shout my anger at those who start forest fires, either on purpose or by carelessly throwing a cigarette into the woods. This scene of desolation is nothing but a mirror of our society—full of sap and beauty, it can easily fall into artifice and self-destruction. The trees symbolize the tension between the desire to live and the threat of self-destruction.

"My work is meant to give new life to these large trees, some of which are more than a century old. Through the universal language of art, I wish to alert the world to the damage caused by forest fires and the need to preserve our natural resources."

opposite: FORÊT DE LA GARDE FREINET, 2003
calcified tree trunks
DIMENSIONS VARIABLE

above: SIÈGE DES NATIONS UNIES, 2006
calcified tree trunks
DIMENSIONS VARIABLE

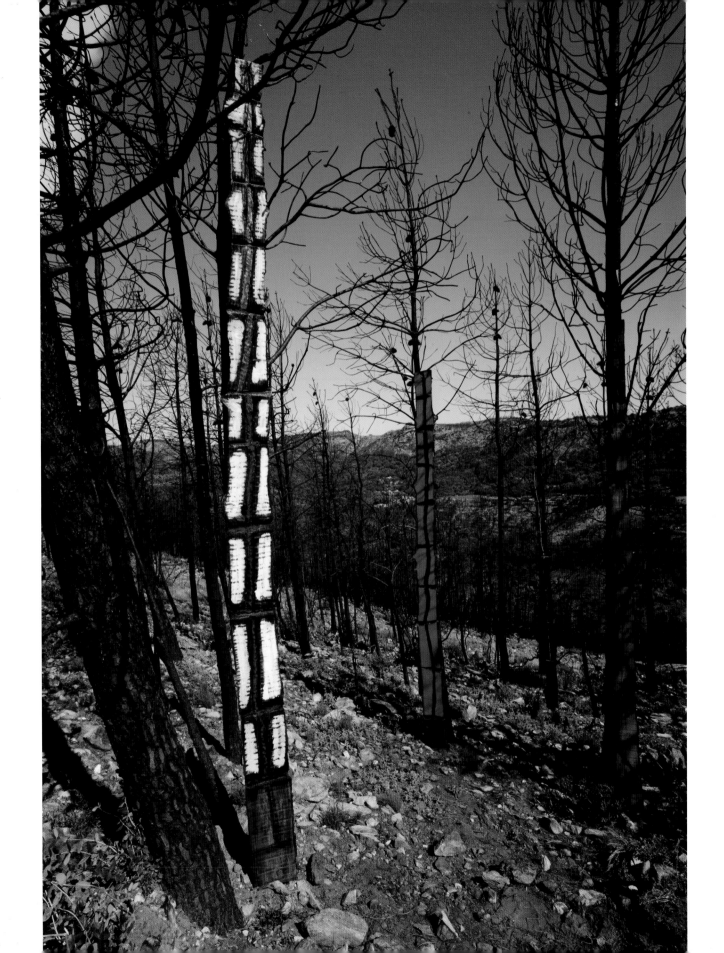

christian kerrigan

SOMETIME IN the not too distant future, a ship will come into being from the limbs of the newly planted trees in the last remaining yew forest—Kingley Vale. It is a replica of the ship from the *Rime of the Ancient Mariner*. The vessel is not being built with broadaxes, pit saws and sweat. Absent are the shipwrights of the present or the past. It is being constructed by means of the symbiotic relationship between two separate systems of organization—technology and nature. Refined armatures, calibrating devices and corsets have been designed to pace the growth of the ship to the growth and maturation of the forest. The construction will develop over a period of two hundred years and exist as a hidden architecture inside the trees. For the production to last without human intervention, an artificial system will harvest resin from the trees to measure the passage of time. When a two-hundred-year hourglass is filled with resin from the trees, the clock will jam, signaling the completion of the project.

Christian Kerrigan's renderings of his theoretical architecture asks a question: Why a ship with no one to sail it? Is it an indication that nature can move on without man? Or that nature can unite with technology, redefining the act of creation? Kerrigan is more interested in the cultivation of the ship than in its utility. "I don't decide what happens. It could feasibly be removed from the tree, but I propose that the work should remain within the body of the forest, to grow and develop. Ultimately it would die. It would become a ruin, the space within the forest becoming like an ancient burial."

Kerrigan's *Growing a Ship in a Yew Forest* is an exercise in defining new ways of creating architecture using both the natural and the artificial world. "We have an incredible ability as humans to affect our environment," he says. "The majority of our world has been modified, through farming or even through genetic alterations." He points to the art of bonsai as an early example of such manipulation, but encourages us to think far into the future. "We have the ability to alter our surroundings, and we need to realize the potential of what we can do and what we want to do."

above: detail shot of opposite

opposite: GROWING A HIDDEN ARCHITECTURE, 2006
digital print
1.5 x 1 M

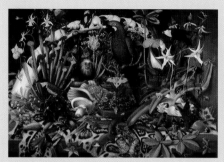 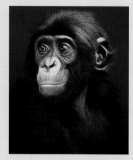

joseph beuys

robert glenn ketchum

shana & robert parkeharrison

isabella kirkland

charles alexander

amy franceschini

j.c. didier

ichi ikeda

mel chin

subhankar banerjee

wyland

agnes denes

free range studios

brandon ballengée

marjetica potrč

soledad salamé

newton and helen mayer harrison

mierle laderman ukeles

jackie brookner

protect

4

When we see the interconnectedness of all life, when we realize that our survival is linked to the survival of all beings, our protective instincts are roused. Planting a tree or reducing our consumption of fossil fuel become investments in ourselves. Those who hunt endangered animals and dump toxins in watersheds become our personal adversaries. And when it becomes personal, our resourcefulness and creativity kick in. The incredible ingenuity and technology we have used to alter the surface of the planet can be turned to its defense. If we were to attack environmental crises at the same rate that we are currently running from them, a sustainable future could be there for us all to enjoy. The resources are available. Some may find themselves in the trenches with weapons; others will find themselves armed with words and numbers. Artists wield the world back upon itself with imagery and sounds. Many of those included in this section incorporate community participation and activism as a component of their artistic pursuits.

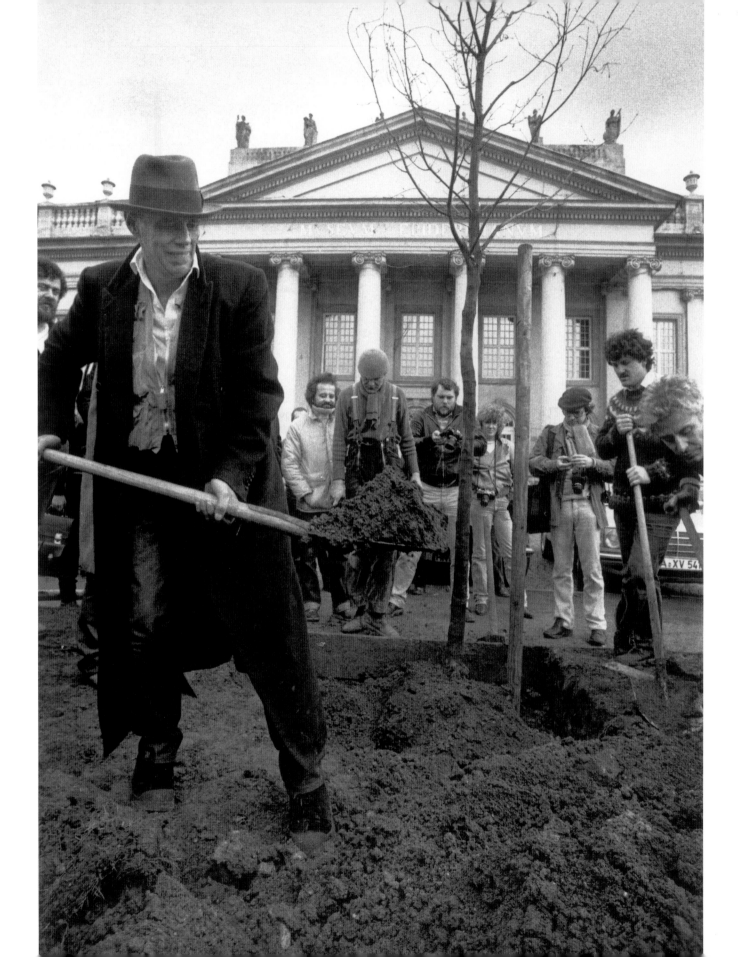

joseph beuys

GERMAN CONCEPTUAL artist Joseph Beuys (1921–1986) is widely regarded as one of the most influential European artists of the twentieth century. His work often recontextualized objects and materials to startling effect, particularly when his attentions were directed at the natural world. Though Beuys' incorporation of dead rabbits, buckets of fat, and fur in his pieces shocked some viewers, he asserted a deep respect for nature and animals, which he believed possess superior intelligence and intuition. In 1974 Beuys presented the performance piece *I Like America and America Likes Me*, for which he wrapped himself in felt and stayed in a room with a coyote for five days.

In 1982, Beuys began his *7000 Oaks* project in Kassel, Germany. Over the course of the next five years, he planted seven thousand trees, each paired with a columnar basalt stone approximately four feet high, throughout the city of Kassel. The last tree was planted in 1987. Beuys intended the Kassel project to be the first part of an ongoing tree-planting scheme that would extend across the world as part of a global mission to effect environmental and social change.

About that project he has said, "I believe that planting these oaks is necessary not only in biospheric terms, that is to say, in the context of matter and ecology, but in that it will raise ecological consciousness—raise it increasingly in the course of the years to come, because we shall never stop planting. The tree is an element of regeneration which in itself is a concept of time. The oak is especially so because it is a slowly growing tree with a kind of really solid heartwood. It has always been a form of sculpture, a symbol for this planet. The planting of seven thousand oak trees is thus only a symbolic beginning. And such a symbolic beginning requires a marker, in this instance a basalt column. The intention of such a tree-planting event is to point out the transformation of all of life, of society, and of the whole ecological system. My point with these seven thousand trees is that each would be a monument consisting of a living part, the live tree changing all the time, and a crystalline mass maintaining its shape, size and weight. This stone can be transformed only by taking from it—when a piece splinters off, say—never by growing. By placing these two objects side by side, the proportionality of the monument's two parts will never be the same. So now we have six- and seven-year-old oaks, and the stone dominates them. In a few years' time, stone and tree will be in balance, and in twenty to thirty years' time we may see that gradually the stone has become an adjunct at the foot of the oak, or whatever tree it may be."

7,000 EICHEN, 1982
7,000 oak trees
DIMENSIONS VARIABLE

robert glenn ketchum

ALASKA IS an astonishingly vast and undeveloped land. The ecosystems remain relatively intact, the habitats are less disrupted and the chance to protect significant expanses of habitat is greater there than almost anywhere else on earth. "There is an opportunity to do things on a grand scale that has not been possible in the lower 48 since the 1800s," says photographer and activist Robert Glenn Ketchum. But despite the apparent opportunity, he says, "Alaska is home to many with a prodevelopment, antifederal mindset that puts the remarkable resources of the state at risk."

Alaska's Tongass Rain Forest is the largest unit of land in the entire national forest system and one of the rarest temperate rain forests in the world, but until recently it was known only as the Inside Passage. Thanks in large part to Ketchum's efforts, the ecological value of the Tongass is now widely recognized. "As a photographer taking a stridently environmental stance, my first mission was to put the Tongass on the map in everyone's mind." His comprehensive visual and written study of the area, *The Tongass: Alaska's Vanishing Rain Forest*, revealed an incredible tale of mismanagement that threatened this national treasure. "It was so much more than just a story of 'save the trees and save the eagles.' It was an in-depth analysis of economics, liars, payola." As a result, a number of corrupt players lost their jobs, and in 1980 the most significant timber reform bill in the history of the United States was passed. Ketchum's book was a major factor in this success, giving a voice to those who understood what was at stake but had no means to express themselves. But the battle rages on. The current administration in Alaska and the current federal government are decidedly prodevelopment. New battles between Congress and the Supreme Court are once again placing significant sections of the rain forest in jeopardy.

Ketchum is now focusing his lens on southwestern Alaska, a relatively undisturbed habitat about the size of Washington state with about a hundred miles of paved road and only two cities, each with a population of under 3,500. Within it lies the most productive commercial salmon fishery in the world. The state is in favor of developing two of the largest open-pit copper and cyanide gold leaching mines in the world, right at the headwaters of this territory's two most productive rivers. "Leach mining is one of the most lethal industrial projects known to man," says Ketchum. "No one has ever done it right, and its footprint is toxic in perpetuity."

Ketchum has produced a two-volume set of books about the situation and has curated a large photography exhibit that is touring museums around the nation. He hopes for a success similar to that of his Tongass campaign. "It's a media war at this point," he says. And Ketchum is on the front lines.

THE TONGASS: ALASKA'S VANISHING RAIN FOREST; KADASHAN II (BLACKWATER), 1986
Cibachrome print
76 X 102 CM

shana & robert parkeharrison

THE HUSBAND and wife team of Robert and Shana ParkeHarrison create realistic fictions that exist just outside our comfort zone. Their manipulated photographs have a documentary quality and enough familiar elements to render them believable, which makes the content all the more striking and often unsettling. They have created a protagonist, an everyman who has appeared throughout the body of their work, *The Architect's Brother,* over the past fifteen years. The protagonist, embodied by Robert ParkeHarrison, is a shapeshifter who lives in a world reminiscent of the nineteenth-century preindustrial age and yet seems ambiguously postapocalyptic. "His presence in the images works as a theatrical tool for pulling people into the space that we create," says Shana ParkeHarrison. The protagonist is able to manifest as a scientist, a shaman or a clerk. Sometimes he appears nurturing and sometimes he appears destructive because, above all, he is human.

In one image, the protagonist earnestly attempts to pull a carpet of fertile lawn over a desolate planet. In another, he peeks out of a cardboard box to find that he is just one of an endless landscape of identical men stuffed into identical boxes. "We are addressing the spiritual disconnection that has occurred over the last hundred years between humans and the earth," says Shana ParkeHarrison. "People take the earth for granted. They don't see how essential it is to their daily lives. Some people don't even have a clue that there are limited resources and that the earth is overburdened. When people don't have that consciousness, they don't have a relationship that they feel is worth saving. We try to remind people of that relationship." She admires people who investigate and delve into their personal psychologies. "The deeper they dig within themselves, the more they connect universally," she says.

There is always a hopeful quality within the ParkeHarrisons' images. Over the course of fifteen years, the protagonist has continued to be earnest. He is never shown dead or even defeated. The artists are ultimately optimistic, says Shana ParkeHarrison. "The earth will work with us as long as we don't work against it."

RECLAMATION, 2003
photogravure
53 x 48 CM

isabella kirkland

DRAWING INSPIRATION from sixteenth- and seventeenth-century Dutch still lifes, Isabella Kirkland has created a series of seductive ruminations on wealth, biological diversity and our voracious and often fetishistic relationship with the natural world. *Taxa* (from the Greek *taxis,* meaning order) comprises six sumptuous arrangements of meticulously rendered, anatomically accurate, life-size plants and animals set aglow by rich dark backgrounds. With their luscious colors and high-gloss finishes, these elaborate oil paintings celebrate decorative beauty while at the same time delivering a disturbing narrative of environmental degradation and homogenization.

Descendant is a *memento mori* to some of the many species that have been endangered by human activity. In the painting's counterpoint, *Ascendant,* a perfectly ordinary orange house cat stares confidently out from beneath a large array of flora and fauna, all of which are species that have overtaken the habitats into which they've been introduced. On the left, a delicate feather drops from a mongoose's mouth, alluding to that animal's disastrous introduction to Hawaii, where it was meant to kill off rats brought ashore by foreign ships. The diurnal mongoose rarely crossed paths with the nocturnal rat; instead, it feasted on the indigenous ne-ne bird until that species neared the point of extinction. *Trade* and *Collection* address the effects of commerce and scientific study on the natural world. In *Trade,* a large tusk carved with a parade of elephants arcs across the canvas; perched nearby is a Lear's macaw, a black market rarity whose sparse population is threatened by deforestation and the caged bird trade. *Collection* features plants and animals that excite our desire to possess—the horn of a black rhino, which is used to make dagger handles; the jaws of a great white shark, which can bring up to $10,000 on the black market. These works are true *natures mortes,* showing lives endangered or cut short in pursuit of precisely the kind of drawing room luxury that this style of genre painting originally typified. In resurrecting this style, Kirkland also draws a sly parallel between our own intoxicatingly prosperous era, with its bursting speculative bubbles, and a time—some three and a half centuries before the term "biodiversity" was coined—when a frenzy for rare varieties of tulip turned the Dutch economy upside down."

—Commentary on Isabella Kirkland by Susan Emerling
(originally published in *Grand Street 71*)

TRADE (FROM THE TAXA SERIES), 2001
oil and alkyd on canvas
91 x 122 CM

charles alexander

'SINCE EARLY 2005, I have been painting the bonobo orphans of Lola ya Bonobo, a 75-acre oasis of lush jungle situated on the outskirts of Kinshasa, Democratic Republic of Congo (DRC). Founded in 1994 by Mme. Claudine André, the Lola sanctuary is now home to more than fifty bonobos, each with a harrowing survival story to tell.

"The rarest of the great apes, the bonobo (*Pan paniscus*) is found only in three provinces of a single nation: the DRC. Isolated from other ape populations by the horseshoe-shaped bend of the Congo River, the bonobo has evolved into a species distinct from the chimpanzee, the only other member of the genus Pan. The bonobo is slim, black-faced and gracefully proportioned, with long legs that give the species a low center of gravity, which allows it to walk upright with ease. Living in groups of fifty to one hundred individuals, bonobos do not practice infanticide or warfare—as do chimps and humans—but instead prefer to diffuse social tensions and potential conflict through the creative use of sex.

"Tragically, this complex and intelligent species—one that shares with us more than 98 percent of our human DNA—is meeting a rapid and violent end in its war-torn and poverty-stricken home nation. Bush meat hunting with snares and guns has decimated the bonobo population, which has plunged from an estimated 100,000 in 1980 to between 10,000 and 20,000 today, though no one knows for sure just how many bonobos remain in their remote forest habitat.

"Each of my Lola portraits represents an individual bonobo that has witnessed the violent death of its family to bush meat hunters. Like all bonobo orphans that end up in the pet trade, each was ripped from the security of its dead mother's arms, then remained ill-fed and unloved for days and even weeks until it was sold. Bonobo infants are fragile creatures, and only one orphan in twelve survives the trauma of this first, brutal contact with humans. My portraits offer clues to the long journey that each orphan has made: the haunted gaze of Maniema; Kindu's malnutrition-induced baldness; and the bright, resolute eyes of Mabali, determined to beat the odds and survive.

"Ultimately, each Lola portrait that I paint also tells the story of an entire African rain forest world at risk. Bush meat hunting, facilitated by the construction of logging roads, is systematically eliminating wildlife populations in the Congo Basin, leaving in its wake empty forests where uneaten fruit falls into piles at the base of the trees. Without wildlife to disperse the seeds, the forest cannot renew itself, which sets into motion an empty-forest syndrome that could spell an end to its very existence. The expansion of agriculture, mining and uncontrolled logging also threatens to fragment and destroy this fragile and beautiful hotbed of biological diversity—a catastrophe with global implications. In recent years, 50 percent of the Congo Basin's forests has been allocated for logging. At present, 23-percent of the bonobo's habitat—some 37,000 square miles of forest—remains relatively intact. By 2030 it is estimated that that number will have shrunk to a mere four percent if human disturbance continues at its current levels."

ORPHANS OF LOLA YA BONOBO: PORTRAIT OF LOMAMI, 2006
pastel
25 x 20 CM

amy franceschini

RED DOTS blemish a map of the United States, each representing one of more than 1,200 hazardous waste sites identified by the Environmental Protection Agency as threatening to human health and the environment. These Superfund sites are contaminated with heavy metals, pesticides, chlorinated solvents, polychlorinated biphenyls (PCBs) and a number of other pollutants. They have spread like a rash, from the country's underbelly to its mountains and from coast to coast. An especially concentrated cluster appears in the otherwise beautiful Silicon Valley, home of the high-tech industry. Many residents still do not realize that their local semiconductor and microchip manufacturing companies use hundreds of gallons of solvents every day to maintain the ultraclean conditions necessary for their delicate equipment to function. Originally, the chemical runoff was to be stored in underground tanks; but as time passed, huge amounts of toxic fluids were spilled or dumped into the soil and the underlying groundwater. In 1981 a routine water sampling by the California Department of Health Services showed that these spills had polluted the aquifer and contaminated 30,000 homes. High rates of birth defects and liver problems were reported. In all, 179 groundwater contamination sites have been found in Santa Clara County.

Artist and designer Amy Franceschini wants to remind people of this toxic legacy. Invited to participate in a festival celebrating electronic arts, she proposed a biodiesel bus tour of Superfund sites in Silicon Valley, to bring awareness of the environmental costs of the high-tech industry. Franceschini says that while the sites remain off-limits to the public, the industry continues to generate untold volumes of electronic waste and toxins. She wanted to introduce a level of criticism to the "elite group of smart people" who would be attending the festival.

Her project *Gardening Superfund Sites* involved the mass participation of students, scientists, activists and other community groups. Clay figurines modeled after the women in China who work separating wires in the mountains of electronic waste were inscribed with messages to the industry leaders. Native plant seeds were embedded in the figurines, which were then parachuted in to various Superfund sites. The seeds took root and flowers bloomed, attracting butterflies to the landscape.

Francheschini gets excited when people ask "Why is this art?" "I'm of the school of thought that anything can be art once it is contextualized as such," she says. While she contemplates notions of community, sustainable environments and the conflicting rituals of humans and nature, her output takes on many forms—from direct action to beautifully designed, interactive, computer-based displays. Though she has no science background, she has an affinity with scientists and is similarly rigorous with her process and research. "We all conduct tiny experiments, and those that don't fail we continue to explore. The distinction is that artists have freedom to create imagined universes that don't have to be based on a particular reality. But I enjoy collaborating with scientists because a lot of their research is locked up in labs and would otherwise not be made public. They are excited to share their work." And Franceschini is happy to usher science into the realm of art. "Science is as much a reflection of our culture as anything in an art museum."

above: PROTESORS, SUPERFUND PROJECT, 2005
native plant seeds, clay
DIMENSIONS VARIABLE

opposite: SILICON VALLEY SUPERFUND SITES MAP
maps, wood, newspaper, plant
1 x 1.2 M

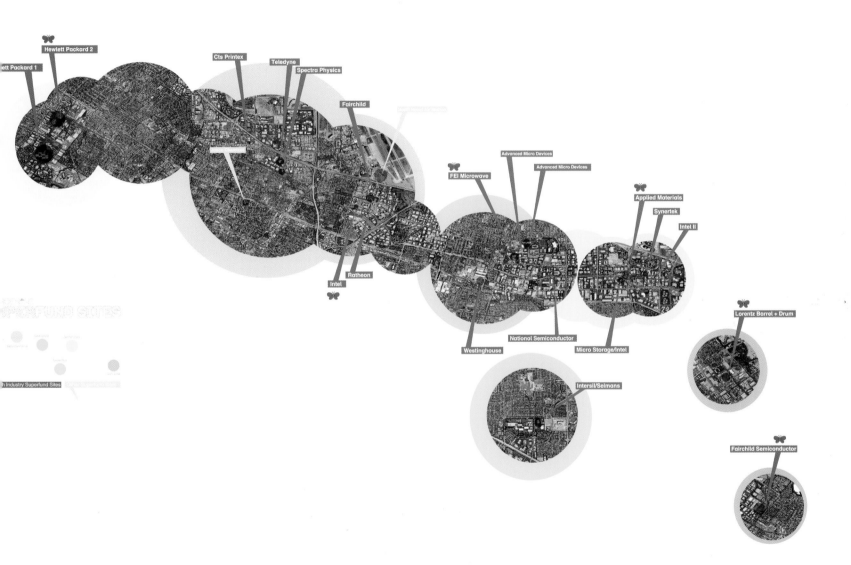

Hewlett Packard 2

ett Packard 1

Cts Printex

Teledyne

Spectra Physics

Fairchild

FEI Microwave

Advanced Micro Devices

Advanced Micro Devices

Applied Materials

Synertek

Intel II

Lorentz Barrel + Drum

Intel

Ratheon

Westinghouse

National Semiconductor

Micro Storage/Intel

Intersil/Selmans

Fairchild Semiconductor

FUND SITES

h Industry Superfund Sites

j. c. didier

SCIENCE FICTION often correctly predicts the not-too-distant future. We may not yet be ready to teleport to Mars, but we are already equipped with handheld devices that are not unlike those used by the crew of the *Enterprise*, and crowded metropolises around the world seem to re-create the set of the film *Blade Runner*. Contained nature, separate and rarified, is a recurring image in these imagined futures. J. C. Didier's installation *Trapped Inside* presents an endangered native tree with its roots exposed, its body on life support. Dozens of clear feeding tubes sustain an organism that once was capable of supporting itself.

"*Trapped Inside* symbolizes both destruction and regeneration," says Didier. "It gives us a glimpse of the future and puts us in a close relationship to nature in jeopardy and nature at a crossroads. We need to step carefully as we walk into the future. For the sake of future generations we need to use our wisdom now." The installation, situated at the headquarters of the United Nations Environmental Programme (UNEP) in Nairobi, is an atmosphere-controlled, life-support system for a single, solitary tree. The viewer can step inside the tree's "intensive care unit" as a guest might visit a patient. And like a sick patient, the tree must depend on human care for its survival.

Didier created the installation with the idea that it can be sustained for the long term, so that it will exist even after the species it contains has become extinct. For that reason he found the UNEP location apt. "I feel that UNEP is here to last forever," he says. "As we evolve into a world where 11 billion people will have to live together, we will one day have a common goal of protecting our earth for the simple motive of surviving."

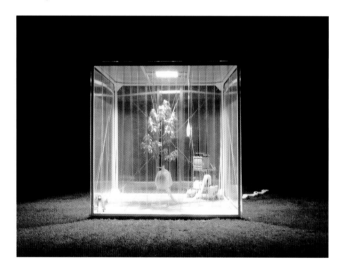

above: TRAPPED INSIDE, 2006 (NIGHT VIEW)

opposite: TRAPPED INSIDE, 2006
plastic, metal, electronics, African Greenhart tree
4 x 4 x 4 M

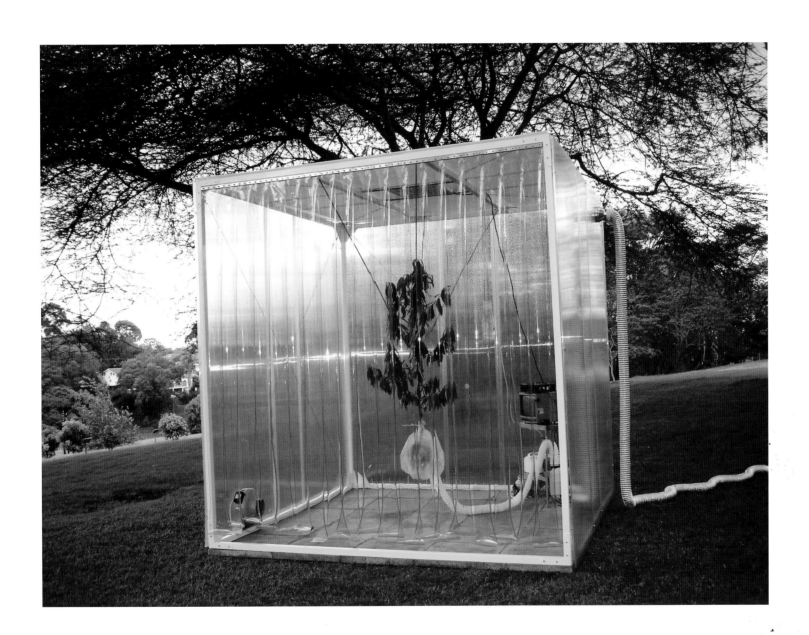

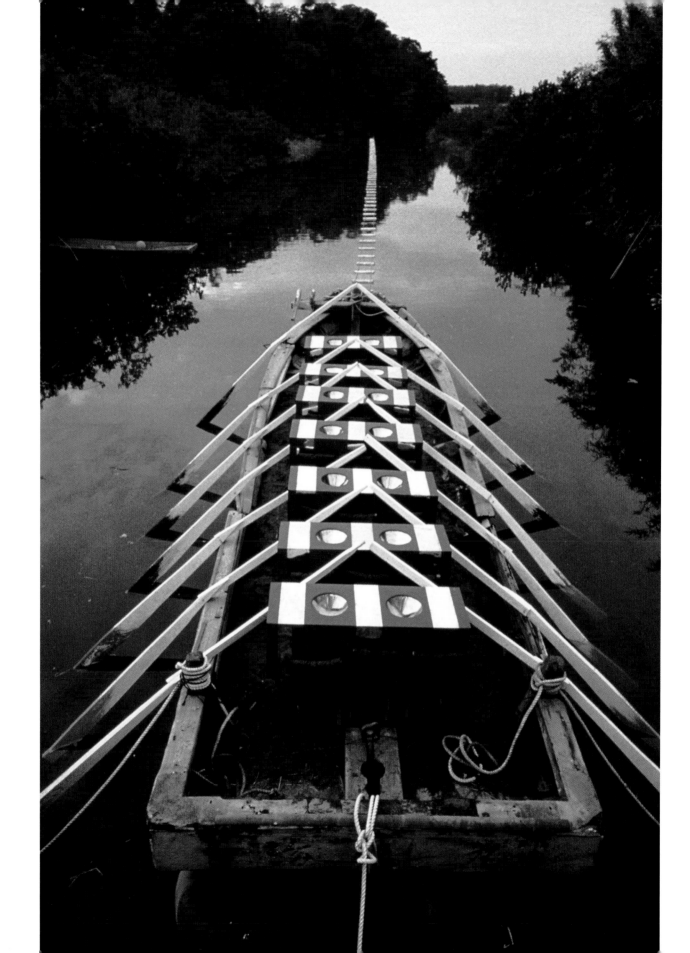

ichi ikeda

"WHAT SORT of water are you transferring to the future earth?" asks Ichi Ikeda. Ikeda's work investigates the movement of water and how the flow of water reflects the flow of time, how its currents connect people of different cultures and geographies. Kaseda, Japan, and Taipei, Taiwan, are situated on opposite ends of the Ryukyu Arc, a chain of islands. Kaseda, on the Manosegawa River, and Taipei, on the Tamsui River, had once been two of the most important and prosperous ports in the East China Sea, enabling trade among East Asian countries. As a result of the rapid development of transportation, as well as ecological neglect, the ports have fallen into decline. Gradually, sand and gravel have collected, constricting the flow of both the Manosegawa and the Tamsui rivers. Similarly, there has been less interaction among the people who live on the shores of these rivers.

Ikeda's public installations in and around Kaseda and Taipei required the involvement of local populations. He asked them to treat the water with a new reverence, to transport it, purify it and recognize the environmental conditions that the two cities share. Ikeda urged participants to create a new flow among their different cultures and geographies.

Ikeda's installations have since expanded to include the cities of Hong Kong, Manila, Bangkok and Yogyakarta. Water is at the center of all Ikeda's work. His other projects include a supper for people affected by the construction of Sagami Dam, situated about thirty miles west of Tokyo. Its construction in 1946 created Lake Sagamiko, which has become an important source of water for the surrounding homes, industries and farms. Ikeda collaborated with the Lake Sagamiko Cultural Communication Center to create *The First Supper*. Entering into the gallery at the center, visitors encountered a long banquet table and the disembodied voices of individuals whose lives are closely tied to the lake. Ikea had collected these recordings through interviews with the locals. "The shape of the river was altered too artificially," says one voice. Another grieves, "The river has already died." And a young person insists, "Therefore the dam must be just a checkpoint."

above: ARCING ARK: WATER CIRCULATING, 1997
bamboo, wooden boards, wooden boxes, plastic sheets, wires, plastic bottles, water
14 x 2.5 x 2.8 M

opposite: ARCING ARK: WATER REJUVENATING, 1997
wooden fishing boat, sand, blue boxes, chairs, ropes, logs, cloth
3 x 2.5 x 160 M

mel chin

MOST OFTEN the beauty of a piece of art is in its final presentation, but the methods and means that bring Mel Chin's work to life are in themselves spectacles to behold. From concept to completion, Chin weaves a complex web of ideas that often requires many hands and many minds from the worlds of art, science and sociopolitics. Chin recalls that Michelangelo worked with chisels and marble to create his famous *David*, but says his own sculptures are carved out of the material of society. Referring to his work *Revival Field*, he says, "Now we live in a world of pollution, with heavy metals saturating the soil. If that pollution could be carved away, and life could return to that soil, creating a diverse and ecologically balanced wildlife, then that would be a wonderful sculpture. I think there is a profound aesthetic in there and it's really simple. But we have to create the chisels, we have to create the tools, and we have to isolate the problem before we can carve it away." Chin's chief collaborator on this project is the USDA agronomist Dr. Rufus Chaney.

In 1991 Chin commissioned Kurdish weavers to create a 9-by-23-foot carpet with patterns based on satellite telemetry. The carpet became part of his artwork *Degrees of Paradise*, and was installed on the ceiling of a triangular room at the Storefront for Art and Architecture in New York City. In a second triangular room, a suspended bank of video monitors played a multidimensional, fractal-modeling program that appeared as cloudlike images. The hand-woven Turkish carpet juxtaposed with the video monitors continued Chin's commentary on the traditional arts and the arts of the digital world by paying homage to both. *Degrees of Paradise* was a precursor to a larger project called *State of Heaven*, a proposed 66-foot-square carpet that represents the entire atmospheric envelope, with each knot equaling five square miles. The carpet is to be destroyed and rewoven in a constant process according to the depletion or accretion of the ozone layer. Although *State of Heaven* has not yet been realized, Chin says, "This was an attempt to make visible a phenomenon that we normally cannot see." Chin worked with Dr. Shaun Lovejoy, a mathematician from McGill University, as his collaborator on the mathematics program.

above: MEL CHIN WORKING WITH CUSTOM-DESIGNED KURDISH CARPET INCLUDED IN DEGREES OF PARADISE

opposite: DEGREES OF PARADISE, 1991
installation with video monitors
DIMENSIONS VARIABLE

subhankar banerjee

NAMED AFTER the Porcupine River in northeastern Alaska and northwestern Canada, the porcupine caribou, whose population is 120,000 strong, migrates across the Arctic National Wildlife Refuge each year during calving season. But the females coming to the coastal plain are finding it increasingly difficult to make the journey. Thinning and receding sea ice has led to greater expanses of open water in the Arctic Ocean, which in turn creates more moisture in the air and therefore greater levels of snowfall. Such upsetting evidence of the environment's decline surfaces every day, but words often fail to communicate its severity. Subhankar Banerjee has proven that where words fail, photography can succeed, and it is the porcupine caribou's good fortune that he has focused his lens on their arctic home, drawing attention to their plight and influencing legislation.

A native of the crowded, tropical city of Kolkata, India, where temperatures regularly hover in the triple digits (*above* zero, it should be said), the photographer nevertheless found himself drawn to the icy mystique of the northern lands. "Opposites attract," says Banerjee, who now spends much of his time in the Alaskan and the Canadian Arctic, camera in hand, kayaking through the glacial waters, flying over snowfields and getting hit by temperatures in the double digits *below* zero. "I wanted to explore a place far removed from humanity, one that had not been impacted by tourism or industry. I was captivated by the notion of a pristine land. Now I see there is no such thing. Every place known to man has been debased in one way or another by development, global warming and toxicity."

Banerjee has been working on his series *Terra Incognita: Communities and Resource Wars* since 2001. While *terra incognita* means "unknown land," he has found that the Arctic is one of most interconnected places on the planet. Of the hundreds of millions of birds that migrate to the Arctic every year, Banerjee says, "It is a celebration of epic scale that connects the Arctic to every continent on the planet." But just as the birds migrate, so do toxins, he says. "Toxins emitted twenty to thirty years ago are showing up now in the Arctic food chain because of wind and currents. Even the breast milk of High Arctic women has been found to be toxic."

The photographer has developed a close relationship with the Inupiat and Gwich'in people. In addition to the threat of pollution, these native tribes are facing major threats from onshore and offshore drilling, coal development and global warming. "The Gwich'in have depended on the caribou for 10,000 years, but their habitat is exactly where Congress is preparing to allow oil drilling." Will the people allow drilling? "In the United States, we are really not willing to admit what is happening," says Banerjee. "Every time I return to the States I feel like I am back in Oz. Life is so comfortable here, and comfort disallows you to be engaged and informed. Why should we care, unless it affects us directly?" He also attributes apathy to a system of doubt. "Once you create even a little doubt, an issue is killed. But the evidence is piling up so high, it is hard to sustain doubt anymore." Banerjee's photographs serve as both evidence and art; they leave no place for doubt.

CARIBOU MIGRATION I (FROM THE OIL & THE CARIBOU SERIES), 2002
photograph
2 x 1.7 M

wyland

VISUALIZATION AND positive affirmation techniques reportedly bring great benefit to those who are seeking to effect change. When the goal is made clear, it is that much easier to achieve. The Wyland Foundation—led by the marine life artist Wyland—aims to give people something to dream about. As part of its mission to promote the ongoing conservation of American water habitats, a series of mammoth representations of an idealized natural environment is appearing on buildings around the country. Rather than simply talking about clean water, the foundation will help thousands of people in nine states "picture" healthy rivers through this series of large murals. "We're using art as a gateway to conservation," says Wyland. "For a lot of people, that's where the concept of a healthy environment really sinks in—by visualizing how to protect our rivers, lakes and streams and the animals that live in and around them."

In 1998, water quality in the United States began to decline for the first time since the 1970s. During the same year, Wyland launched the Wyland Ocean Challenge, an ambitious national tour of fifty states in fifty days, to raise awareness about healthy oceans. The foundation hopes to encourage people to reduce water waste by 10,000,000 gallons over the next year. A supplemental classroom education program devoted to protecting water-based ecosystems is also planned in select cities.

THE WINDY WHALES, 1997
painting on exterior of Hotel Inter-Continental, Chicago
61 x 27 M

art in action

agnes denes

ALTHOUGH AGNES DENES began her career as a poet, she gave it up in favor of the visual arts, saying, "I lost my language." In doing so she has created a new language within the art world. As one of the pioneers of ecological environmental art, she has planted tens of thousands of trees in Australia and Finland, fields of grain in Manhattan's financial district and rice on the U.S.–Canadian border. She has spent eight days and nights perched inches from the torrent of Niagara Falls, has built time capsules and glass fortresses and has undertaken numerous other projects, with people from all walks of life, that call attention to a variety of social concerns.

"These works are intended to help the environment and endow future generations with a meaningful legacy," she says. "As difficult as they are to realize, it is absolutely necessary to create them and to do so in the nervous tension of cities, to give people a chance to stay in touch with nature wherever they are in the world." She says her works set an example of what can be done on an even grander scale "to restore landfills and barren lands where resource extraction has taken its toll, to stop erosion on deforested soil, to purify the air and protect fresh groundwater, and to provide a home for wildlife."

Although Denes is first and foremost an artist, her large-scale environmental work requires a knowledge of architecture, landscaping, design, urban planning, soil science, mathematics, forestry, the social sciences and philosophy. Denes believes that art must change as the world changes. Early on, she found herself wanting to break out of what she perceived to be an elitist, self-involved artistic establishment and to enter into the landscape. "I left the ivory tower of my studio and entered the world of concerns. Ecological environmental art goes beyond the self and the ego without being selfless. It assumes the difficult task of maintaining a delicate balance between thinking globally and acting independently, for the ego must remain intact to allow the self to act fearlessly, while the ego must be relinquished in order to think universally and for the good of others."

Denes is a woman who does not let traditional boundaries get in the way, even within her own being. "Designing space is complicated. We can go inward, into inner space, and outward, into the universe. The distance is about the same. For me, both of these journeys are necessary. Some of my work deals with this inner space, visualizing invisible processes such as time, mathematics, logic, thought, evolution, and so on. Other works are dealing with very large spaces—large by necessity in order to rebuild our environment and make a difference."

TREE MOUNTAIN–A LIVING TIME CAPSULE–
11,000 TREES–11,000 PEOPLE–400 YEARS, 1992–1996
11,000 Trees
28 x 270 x 420 M

free range studios

Free Range Studios is an award-winning design firm founded by Jonah Sachs and Louis Fox, who work exclusively for nonprofits and other organizations that promote social change. "The way we've built our company is an expression of our values and it's our creative outlet. The business is our art," says Fox. Their short animation *The Meatrix* uses parody to address a common fantasy about family farms that gives peace of mind to carnivorous consumers. By taking a red pill, the protagonist (Leo the pig) chooses to see the ugly truth of meat production in America's factory-farming industry, with its cruel conditions, pollution, growth hormones and grisly deaths. But the video doesn't end in doom. "A lot of activists stop at the point of waking people up, as if the public only needs to have more information in order for conditions to change," says Fox. "But if people know about issues and still feel there is nothing they can do about them, they are going to shut off, and then when you mention the environment or endangered species, they will turn away. You need to take it to the next stage—wake them up gently and then present an alternative, or a way to make sense of it."

Free Range's pseudodocumentary *Climate—A Crisis Averted*, made for its client Renew US, promotes clean-energy solutions by presenting a postrevolution future in which sustainable energy has overtaken dirty fuels. McDonalds reinvents itself as a biodiesel provider, and the McCain/Obama ticket wins the White House. "It's like drawing a storyboard for the future," says Fox. "One of our tenets is to not just point out the problems and jeer at those who make them, but to illustrate attractive, realistic solutions. If you can frame the issues and paint a positive picture, you have a much, much better chance of getting people to realize that picture."

The Meatrix, 2003
flash animation movie
3 min 30 sec

brandon ballengée

BRANDON BALLENGÉE grew up in central Ohio surrounded by cornfields and twenty five acres of woods. "As a kid I was out every day catching things and studying them." He started to selectively breed certain species of fish and amphibians. Ballengée is a bit of an academic hybrid himself. Despite his proclivity for science, he pursued degrees in art and art history. "I thought if I went with art, I could do both," he says.

Ballengée's research drew him to the amphibian version of canaries in a coal mine. "Frogs are extremely sensitive environmental indictors because they exist as aquatic-born embryos and land-based organisms in a single lifetime. They are like sponges, absorbing anything that comes into contact with their sensitive membrane. Changes to the environment and pollutants are expressed in deformities, declines and other anomalies in amphibians." His ongoing amphibian breeding project involves selectively breeding a type of African frog back to its original, pre-domesticated phenotype. Ballengée calls it "sculpting though breeding."

"Instead of using a chisel to carve stone, I am using scientific techniques to sculpt a species back. It's a very plastic phenotype. I have changed the way they look as well as their behaviors." But Ballengée is not trying to play God; he combines art and science almost exclusively for the sake of education and to increase our appreciation of the natural world. When people enter the exhibit, they are greeted by hundreds of curious, tiny frogs in a succession of tanks at various stages of domestication. "The human-to-frog interaction is fun to watch. The frogs swim right up to the glass. They are adorable living sculptures. There is always a visual component to my installations that is attempting to seduce the viewers, so they leave inspired to learn more."

Ballengée sees his work as "contemporary storytelling," an extension of the landscape paintings of the Hudson River School, artists who used their medium to describe how perceptions of the environment were changing in their day. At times he leans further toward the artistic realm and at times more to the didactic and scientific, as with his multilingual text panels explaining which fish are sustainable and which to avoid at the fish market.

What started out as artistic curiosity turned into a "mind-boggling" research project. Exploring the fish markets in Queens, New York, he encountered hundreds of species of aquatic organisms from all over the globe. "Live fish from Vietnam, sharks from New Zealand . . . every day there would be something new. It's like a dead zoo," he says. "It can be very emotional, especially when you see a 40-square-foot tray of orange roughy, each only a couple inches long, and you realize that they are the young of the year. Unless something changes, they are the last of their kind . . . being sold for 99 cents a pound. These beautiful creatures have been sculpted by evolution for tens of thousands—in some cases millions—of years. They are incredible expressions of this world and the environment we live in." Ballengée spent a year cataloguing fish market species for the Queens Museum of Art and generating awareness campaigns that will be translated into a multilingual online database. "If we make information available, it will make a huge difference."

CLEARED AND STAINED HYMENOCHIRUS FAMILY FROG, 2001
digital imaging of various frogs sculpted through breeding
DIMENSIONS VARIOUS

marjetica potrč

IF THERE were an environmental superhero who had the powers of great foresight, empathy and stealthy prowess, she might work like Slovenian artist-architect Marjetic Potrč. Potrč takes on massive ecological issues like sustainable energy, poverty and globalization by tactically homing in on a few very important details. Instead of partially tackling an entire infrastructure on a global level, she thoroughly, perfectly accomplishes small strategic projects on a local level. For example, in the city of Caracas, Venezuela, where about half the population has access to water no more than two days a week, Potrč and her partner, Liyat Esakov, built a single dry, ecologically safe toilet in La Vega barrio, a district in the city that is without access to the municipal water grid. For another project, she installed a wind turbine on the fourteenth floor balcony of a single high-rise apartment in Liverpool, England. The apartment is in a building situated in a public housing block that had once been an integral part of a social movement but is now being privatized. She has also cultivated a hydroponic vegetable garden on the roof of a privately owned building in Siena, Italy.

Each of these projects is an isolated instance of success. It can be overwhelming to consider all the ecological challenges we face. But by providing concrete examples of innovation and initiative, Potrč helps us take baby steps in the long march toward creating a more sustainable society.

DRY TOILET, 2003
building materials and sanitation infrastructure
DIMENSIONS VARIABLE

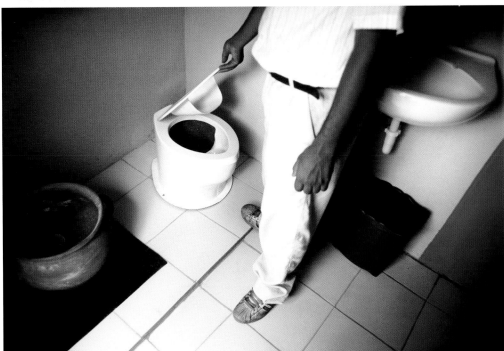
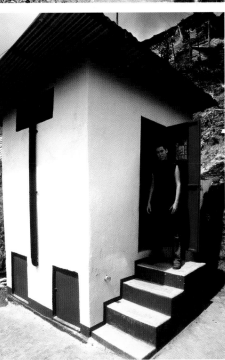

soledad salamé

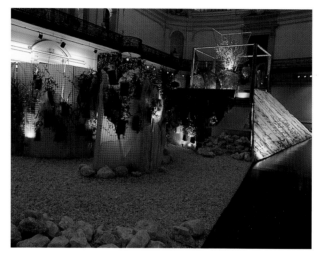

IN 2002, a series of studies found alarmingly high levels of mercury contamination among newborns in hospitals in the Brazilian Amazon. Of the 1,666 babies born that year, 1,000 of them had mercury poisoning. The mercury was a by-product of a popular gold mining process employed in the rivers of the region during the 1980s. The National Department for Mineral Production estimates that 600 tons of mercury was thrown into the Tapajós River, one of the biggest tributaries of the Amazon, over a ten-year period. This mercury entered the ecosystem through small species like algae and vegetarian fish, and quickly moved up the food chain into humans, birds and other animals. Ingested mercury is accumulated, not excreted, and can easily pass from mother to child.

Soledad Salamé's inspiration is in part a response to this contamination. To a greater extent it is a meditation on water, the element that unifies all of us and is in such peril. "I think water is going to be the gold of the twenty-first century," she says. Salamé feels that while we should all voice our concerns, art can deliver her message more elegantly. "It is like an ambassador." Her installations are mini environments and use hay, resin, insects, geodes and other natural materials. "The more I immerse myself in the elements I use in my work, the more conscious I become of the ecological issues that surround them," she says. Her concern for the environment strengthens her relationship to the natural world and her understanding of it. Her recent *Living Water* exhibition is more than a call to arms; it is a commentary about the changing geographies of our continents as the climate warms and the oceans rise.

In her work *In the Labyrinth of Solitude*, installed in the atrium of the National Museum of Fine Arts in Santiago, Chile, Salamé imagines a world that increasingly insulates itself in a labyrinth built upon the ground of exponential production and consumption. The sculptures, consisting of sheets of translucent poured resin embedded with organic materials, are an extension of her ongoing experimentation with media and materials, particularly resins, amber and pigments. They evoke the passage of time as it is tracked by geological deposits— bits of history suspended and encapsulated in slabs of earth and slowly buried beneath the world we unremittingly fabricate above ground.

above: detail shot of opposite

opposite: IN THE LABYRINTH OF SOLITUDE, 2001
installation
DIMENSIONS VARIABLE

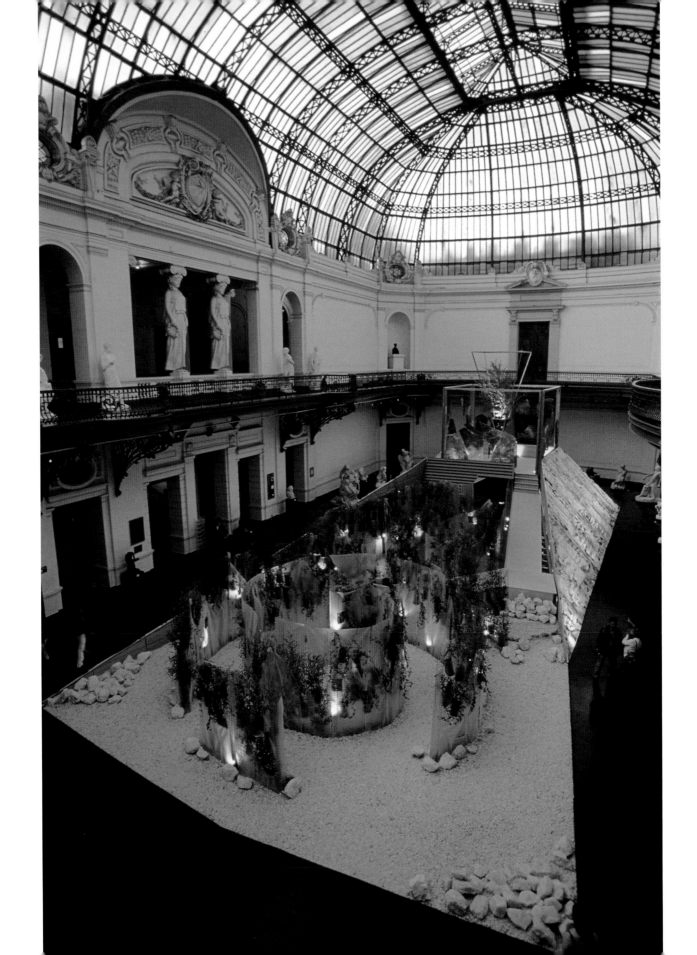

newton and helen mayer harrison

Newton and Helen mayer Harrison see the ocean as a great draftsman that traces the shores of the world, and they see themselves as storytellers who foretell the future that is written on those shores. Their collaboration began in the mid-1960s when, alarmed by the very early signs of global warming, they pledged to put the environment at the center of their life's work. At the time, global warming was a novel theory. Now it is almost certain that the oceans will rise and, sooner rather than later, millions of people will be displaced and several hundred thousands of miles of land will go under. "We are being told that in fifty years it will be warmer that it was three million years ago, when the ocean was more than forty feet higher," says Newton. "Do you know what that means? If you live in New York, get a canoe or move to the fiftieth floor."

In the text accompanying their 1978 work *Lagoon Cycle*, the Harrisons ask, "Will you feed me when my lands can no longer produce, and will I house you when your lands are covered with water?" Clearly and artistically prophesying a future that few others seemed equipped or prepared to acknowledge, they created a map of the world, imagining the land loss that would occur if all the icecaps melted. Based on their best unscientific calculations, they estimated that the oceans would rise 300 feet. The images of a shrunken landmass are shocking. "Twenty-five years later, the scientific figures came out," says Newton. "We were within thirteen feet of the best satellite calculations now available."

Thirty years later, the Harrisons are still reflecting on global warming, but instead of fighting against the inevitable, the Harrisons are thinking ahead, exploring creative and compassionate methods of dealing with the remapping of the world. "We have to start planning to move people uphill, feed people in new ways and build roads that go under," says Helen. "The question is, how can we withdraw gracefully?"

Their 1999 book *Green Landscape: Vision of the World as a Garden* presents a detailed vision of the unification of Europe through environmental crisis. It has been translated into five languages and made available to European Union officials. Its success led to a commission from the British government for their most recent work, *Greenhouse Britain*, a master plan for the United Kingdom's withdrawal to higher ground. It is essentially a storyboard for the future. With their maps, diagrams and exit strategies, they are introducing a new narrative not dictated by the power elite. "Capitalism allows the marketplace to rule. It doesn't mind if a couple hundred million people go under, here and there. As storytellers we try to develop a new history, a new story that is beneficial to all life." The master plan, and all the Harrisons' work, is made more plausible because they have gathered their information from the world's top ecologists, biologists, paleobotanists and climatologists. "You have to be informed to do this work," says Newton. The picture they paint is heartbreaking—no more Riviera, no more Indonesia—but their solutions offer hope. Their prophecies are not fairy tales, nor are they nightmares.

And the Waters Will Rise Gracefully
(from the Book of the Lagoons), 1981
oil, graphite, photography
51 x 122 CM

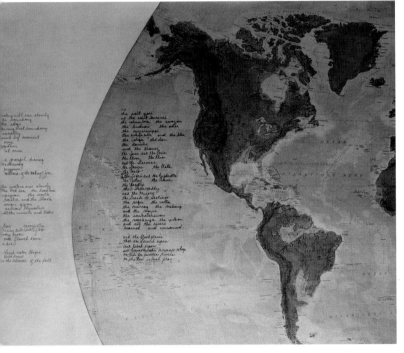
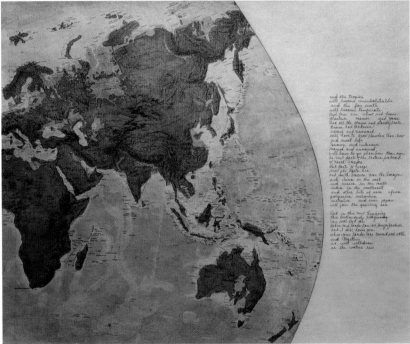

mierle laderman ukeles

IERLE LADERMAN UKELES doesn't think of those who work for the New York City Sanitation Department as "garbage men." Instead, she thinks of Sanitation as employing great experts in "the urban material information, mapping, tracking and relocation system." The designation shows her deep understanding and respect for an aspect of life that most people choose to avoid. For more than fifty years, the waste of New Yorkers was sent to the Fresh Kills Landfill in Staten Island, one of the largest landfills in the world. The landfill's intake peaked in 1986–87, with 29,000 tons of solid waste being dumped there every day. In May 1996, Mayor Giuliani and Governor Pataki announced that Fresh Kills would cease to be a landfill and would be reclaimed as a public park. The final shipment of waste arrived on March 22, 2001. It was re-opened briefly to accommodate debris from the World Trade Center.

Ukeles has been studying Fresh Kills since she was appointed the official and unsalaried artist-in-residence of the New York City Department of Sanitation in 1977. She says, "What draws me to Fresh Kills is its enormity and diversity." Of its 2,200 acres, 45 percent is covered by four mounds of household waste; the mounds range in height from 90 to 225 feet. Fresh Kills is sandwiched between the largest shopping center in the Northeast and the oil wells of New Jersey. "But crisscrossing all of that are creeks and wetlands. Nature charges right through," says Ukeles. "When you go to the top of the mounds and look around, you get a sense of what drives our culture. You see cause and effect converging in one place."

From that vantage point, Ukeles drew inspiration for her ambitious *Public Offerings Made by All Redeemed by All*, one of a number of proposals she has presented to the City of New York as part of her commission as Percent for Art artist of Fresh Kills. *Public*

HOW DOES A PLACE SWITCH ITS MEANING AND BECOME SOMETHING ELSE?

THE CITIZEN DONOR'S HAND THAT POSSESSES RELEASES THE OFFERING

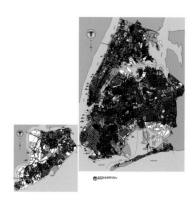

NYC DEPARTMENT OF SANITATION MAP OF ALL THE STREETS TO PICK UP

Offerings may be among the projects chosen by the governing body when their *End-Use Master Plan* for the transformation of Fresh Kills is finalized. She appreciates that the architects and planners want to develop a pleasant recreation area, but, she says, "I don't want to erase what happened here over the past fifty years."

Ukeles's plan is to lay a fine layer of love on top of the waste that created Fresh Kills. "More than 150 million tons of waste is sitting inside those mounds. They represent billions of individual acts of rejection. When we chuck something, we strip away the identity of the material and it becomes 'garbage.' My feeling is that there is a kind of bad karma that lingers from all those acts of rejection. I am inviting people to acknowledge their part in that and participate in consciously trying to shift the deep meaning of this place through their own powers of creativity."

That layer of love would consist of precious items donated by New Yorkers. "This was the largest municipal garbage landfill in the world, and it calls for very ambitious artwork. It would be pitiful if the cultural response to the site were puny, so I am asking one million people to make or select something of great value to them—something not monetarily but personally valuable—and to release it." Each item will be placed in a transparent glass block, which will then be used to pave the miles of pathways in the park.

Letting something go at this site once meant rejection, says Ukeles. "Now, to release something will be to share it with the community. Value will be expanded rather than stripped away. There is a lot to criticize in our culture, but by using all our levels of creativity we can transform what we have done. Fresh Kills is a public landscape that can become a living museum, a symbol of our power to create transformation."

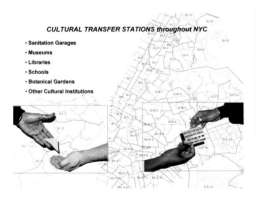

A NETWORK OF CITYWIDE CULTURAL TRANSFER
STATIONS RECEIVES THE OFFERINGS

MAP OF CULTURAL TRANSFER STATIONS

EXAMPLE OF AN EMBEDDED OFFERING

jackie brookner

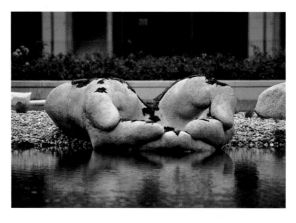

SEVERAL YEARS AGO, Jackie Brookner was invited to design a piece of public art for the small town of Grossenhain, about 20 miles west of Dresden, Germany. Her sculpture was included in a larger plan to build a new public swimming complex in which the water would be completely chemical-free, filtered entirely by a constructed wetland, and incorporating Brookner's Biosculpture. The artist's Biosculptures are living works of art that function ecologically as well as aesthetically and metaphorically. The vegetated sculptures are based on the use of mosses and the bacteria that live in plant roots, transforming toxins in the water into nutrients for their own metabolism. Fish, snails and other organisms living in the water complete the ecosystem when their excretions provide nutrients for the plants. "As in all wetlands and, in fact, in all healthy natural systems, there is no waste," says Brookner.

Brookner made this sculpture in the image of two enormous hands reaching from the banks into the water, cupping the water and the wetland plants. When it came time to find the rare mosses needed for the Biosculpture, Brookner was taken to a site on the outskirts of Grossenhain, an area where the Russians had practiced military exercises throughout the cold war. Over the years, the weight of the tanks had compressed the soil. Soon after the fall of the Berlin Wall, the Russians withdrew and the site was set aside as an ecological reserve. It soon became apparent that many unique species, unable to grow elsewhere, were thriving at the tank site. Among them were rare sun-loving mosses. "What a delicious irony that fields dedicated to such destructive power would become home to these delicate and ancient plants, that a new intimate habitation would grow to take the shape of human hands as they transform toxins into food to yield clean water," says Brookner.

Brookner does not offer interpretations of her work, but prefers instead to pose questions:

What might it mean to see huge hands holding water?

What does it suggest that these hands are
 immersed in water?

What does it suggest to see plants growing over the hands?

Are these hands a part or a whole?

What is your relationship with water?

What is your relationship with plants?

above: detail shot of opposite

opposite: DIE GABE DES WASSERS (THE GIFT OF WATER), 2001
concrete, moss, mist
89 x 251 x 155 CM

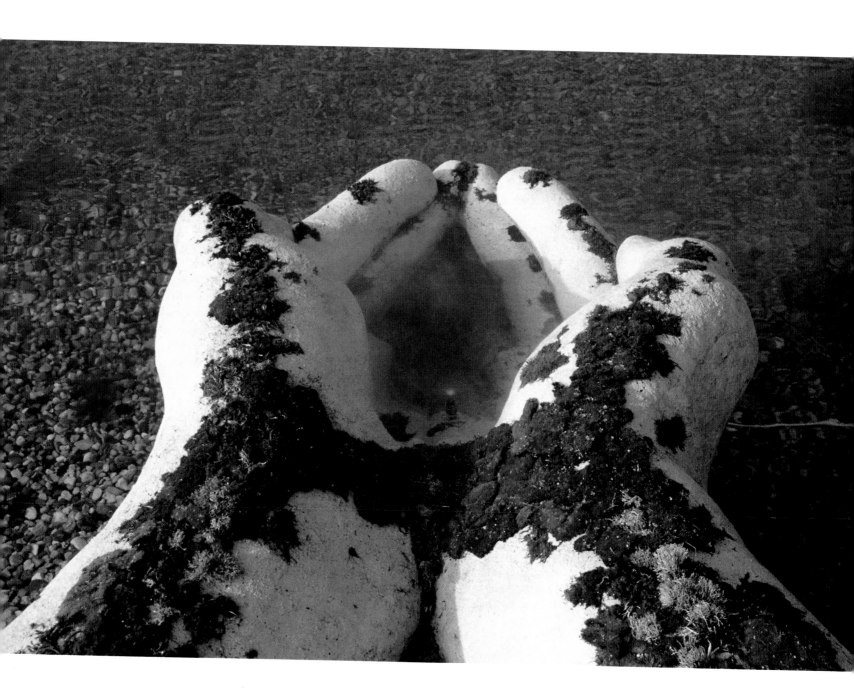

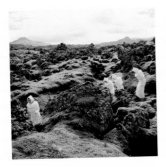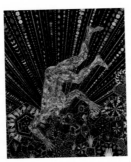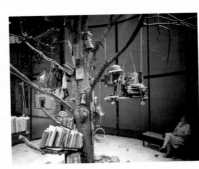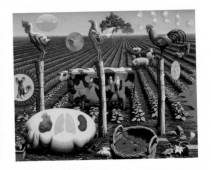

act 5

What inspires a person to take action? What paralyzes a person into nonaction? Apathy is a by-product of fear, which is a by-product of ignorance. Inundated by media messages that spell doom, many people are succumbing to this fear, withdrawing into ignorance. As the atmosphere warms and biodiversity shrinks, good intentions seem no match for the juggernaut of global development. But this cycle is a flimsy illusion made vulnerable by the immense power of another cycle—the cycle of awareness. Awareness begins when we take off the blinders, opening our eyes and developing curiosity instead of detachment. With a sense of wonder, we are drawn from behind closed doors and out into the big, mysterious, life-giving world. Outside, communing with trees, animals and even cityscapes, the dividing line between ourselves and nature blurs. There is nothing left to do but to act in the best interest of all beings. The enormous challenge of environmentalism is to keep finding inspiration without falling into the extremes of nihilism or eternalism. Taking the very broadest perspective, we can see that everything, including the planet, is impermanent, but that life as we know it is still worth protecting. Where fear starves the spirit, art feeds it. Artists ask us to step out of whatever routine we have fallen into and interact with the world with freshness and originality. By inspiring us to celebrate, reflect, interact and protect, art naturally leads us to act.

afterword

Unprecedented change is taking place on a global scale, and its consequences are not fully understood. Ever-mounting pressures from human activity on the Earth's ecosystems threaten our future as a species. But while uncontrolled development is taking a devastating toll on our planet and natural resources, many people remain unconvinced of the urgency of these issues. This indifference is born of a lack of inspiration and of knowledge. The twenty-first century is at a critical turning point in human history. It is up to us to determine whether this is to be the century of our imminent downfall, or the moment when we take action, start making progressive socio-cultural decisions and begin to show respect for the natural world.

In 2001 a team of museum experts, conservationists and artists heeded this call to action. They came together to create a cultural institution that would use art to emphasize the value of the natural world and to communicate messages surrounding environmental issues. The team was not acting on its own whims but rather responding to the zeitgeist of these times, to people's desire for illumination and understanding. That institution came to be known as the Natural World Museum.

The word "environment" is very broad and the definition of "art" even more so. When these terms are closely examined, it becomes difficult to draw a sharp distinction between the science of nature and the realm of art. Art has the power to communicate ideas and concepts across cultures and beyond spoken language; like science, it is universal. The intermingling of art and the environmental is a phenomenon with roots in some of the earliest known human works.

It is in human nature to contemplate our existence in the natural world. Where do we come from? Why do we exist? What is our relationship to the world and all that exists in it? What are the forces of nature that drive this world? These questions must be similar to those asked by early humans, confronted with our seemingly infinite world. The scientific mind is a feat of evolution. The creative mind has emerged from a primitive quest for understanding. This book weaves together the way humans from past to present try to capture their experience with the natural world through creative expressions.

We are on the verge of a global upheaval. Every year an estimated 40,000 square miles of earth are deforested. There are 40,000 pieces of plastic for every square mile of ocean. There are almost 5,000 mammal species in the world and currently one out of four are considered threatened and at risk of extinction. Carbon dioxide emissions by the United States are equivalent to the total emissions of East Asia, Latin America and Sub-Saharan Africa, and global warming is already a reality. By 2025, two-thirds of the world's inhabitants are likely to be living in areas of acute water stress. Hazardous chemicals are now found in newborn babies, and an estimated one in four people worldwide are exposed to unhealthy concentrations of air pollutants.

The time has come for raising awareness of our impact on the planet, changing our behavior and reversing the negative trends. Education is an essential tool to shift the paradigm. The old paradigm of power equals profit can't last forever. The real power lies in nature itself. It is imperative for our own survival that we embrace an environmentally inclined lifestyle.

Artists can help awaken us. They can recall to us our place on this planet, remind us that we breathe the same air the hummingbird breathes, the same air that contains oxygen released by our trees and the same air the dolphin inhales before traveling the deep seas. The sacred aspect of our relationship to nature has to be accessed, enriched and expressed, enlivening our senses and intellect. Artists help us change the way we see.

Deepening our understanding can open our minds and inspire us to protect the fragile beauty of our world. Witnessing the mighty fjords and glaciers, the deep green forests and jungles teeming with wildlife, the expansive ocean's mysterious abyss and the migratory crossroads of the sky, we are given the gift of inspiration. Transforming these experiences into creative expression integrates that experience into our very being and serves as a reminder of both nature's beauty and its threatened existence.

Creativity is rooted in the struggle to survive. Humans, animals and nature have all evolved in fantastic ways to adapt to their surroundings. Certain animals attract mates by flaunting their bodies with elaborate plumes and dances, other animals design utensils for scooping ants from hives for food, flowers shimmer in radiant colors to attract insects to pollinate their stems, humans have used trees to create fire and shelter. The universal language that crosses all boundaries is creativity.

Throughout human history, cultures have developed traditions that honor the creative source, Mother Nature. Prehistoric cave painters depicted their relationship with the natural world. Temples were built to worship gods that personified once inexplicable natural forces. Costumes, song and dance were created to celebrate and honor the wonders of nature through elaborate rituals. Theaters have been created to preserve the performing arts. Mixed pigments spread on canvas with bristles of a brush expressed reflections of human experiences. Museums have been built to collect and exhibit these visual masterpieces. The feather plume dipped in ink brought poetry and prose to paper, recording human thought. Libraries have been established to preserve and protect these literary works.

Whether it takes the form of visual arts, music, performance, film, poetry, literature or fashion, the essence of creativity goes back to the beginning: it is rooted in the struggle to survive. The survival of humankind depends on our actions to preserve and protect the world that keeps us alive, the air we breathe, the water we drink, the food we eat and the ecosystems that make it all possible.

Art In Action: Nature, Creativity and Our Collective Future is a visual document that chronicles the movement and works of artists combined with personal essays and critical dialogue by some of the world's most influential visionaries. The Natural World Museum joined forces with the United Nations Environment Programme and Earth Aware Editions to present a collection of art from seventy-nine international artists. Works in this book range from glorifications of nature to political critiques to explorations of contemporary issues such as pollution, endangered species, global warming or sustainable energy. But all serve to raise awareness of the peril our environment is facing. We hope this compilation of artwork and the stories that bring each piece alive inspire you to celebrate the creative power of nature.

MIA HANAK, Founding Executive Director
Natural World Museum

In 2001, Mia Hanak founded the nonprofit organization, the Natural World Museum, in collaboration with Founding Benefactor, Richard Vencill Smith. NWM is now the world's premier cultural institution producing global environmentally based curatorial programs in partnership with the United Nations Environment Programme (UNEP). She leads the team that produces annual world-class international art exhibitions for United Nations World Environment Day, which is hosted by a different country each year. Nominated by the American Association of Museums as a Museum Leader of the Next Generation, Hanak was recognized for her groundbreaking work by Senator Barbara Boxer and Speaker of the House Nancy Pelosi. She is a native San Franciscan.

resources

Natural World Museum *www.artintoaction.org*
The Natural World Museum utilizes the universal language of art as a catalyst to empower individuals, communities, and leaders to focus on environmental values across all sectors of society.

United Nations Environment Programme *www.unep.org*
The United Nations Programme inspires, informs and enables nations and people to improve their quality of life without compromising the environment.

Autodesk *www.autodesk.com/green*
The global leader in 2D and 3D design software, Autodesk supports sustainable design to promote a cleaner and healthier environment.

An Inconvenient Truth *www.climatecrisis.net*
With wit, smarts and hope, the Academy Award-winning documentary *An Inconvenient Truth* brings home Al Gore's persuasive argument that we can no longer afford to view global warming as a political issue – rather, it is the biggest moral challenge facing our world.

Conservation International *www.conservation.org*
Conservation International believes that Earth's natural heritage must be maintained if future generations are to thrive spiritually, culturally and economically. Its mission is to conserve the Earth's living heritage, our global biodiversity, and to demonstrate that human societies are able to live harmoniously with nature.

Fauna & Flora International *www.fauna-flora.org*
Founded in 1903, FFI is the world's longest established international conservation body. Its goal is to protect the entire spectrum of endangered plant and animal species on the planet. The organization provides support to conservation initiatives throughout the world in the form of partnerships, technical assistance, direct funding and consultancy.

Global Trees Campaign *www.globaltrees.org*
The Global Trees Campaign aims to save the world's most threatened trees and habitats through provision of information, conservation action and support for sustainable use. The campaign focuses on trees as flagship species for conservation of ecosystems and landscapes, and enables local people to carry out rescue and sustainable use operations.

Global Green *www.globalgreen.org*
Global Green USA is a national environmental organization addressing three of the greatest challenges facing humanity: stemming global climate change by creating green buildings and cities, eliminating weapons of mass destruction that threaten lives and the environment and providing clean, safe drinking water for the 2.4 billion people who lack access to clean water.

Green Belt Movement *www.greenbeltmovement.org*
Founded by the 2004 Nobel Peace Prize Laureate Professor Wangari Maathai, the Green Belt Movement International empowers individuals worldwide to protect the environment and to promote good governance and cultures of peace.

Green Cross International *www.greencrossinternational.net*
Green Cross International (GCI), created and launched by Mikhail Gorbachev, works to build leadership, financial management, volunteer networks and technical capabilities. GCI's mission is to prevent and resolve conflicts arising from environmental degradation and provide assistance to people affected by the environmental consequences of wars and conflicts.

Intergovernmental Panel on Climate Change *www.ipcc.ch*
The Intergovernmental Panel on Climate Change (IPCC) has been established by WMO and UNEP to assess on a comprehensive, objective and open basis the scientific, technical and socio-economic information relevant to understanding the risk of human-induced climate change, its potential impacts and options for adaptation and mitigation.

IUCN Red List of Threatened Species *www.iucnredlist.org*
The World Conservation Union, through its Species Su Commission (SSC), has for more than four decades assessing the conservation status of species, subspecies, var and even selected subpopulations on a global scale to hig organisms threatened with extinction and to promote conservation.

Natural Resources Defense Council *www.nrdc.org*
The Natural Resources Defense Council's purpose safeguard the Earth: its people, its plants and animals an natural systems on which all life depends. They strive to create a new way of life for humankind, one that can be susta indefinitely without fouling or depleting the resources support all life on Earth.

Nobel Peace Center *www.nobelpeacecenter.org*
The Nobel Peace Center is a center where you can exper and learn about the various Peace Prize Laureates and activities as well as the remarkable history of Alfred Nob also serves as voice and meeting place where exhibits, discus and reflections related to war, peace and conflict resolutio in focus.

Ocean Conservancy *www.oceanconservancy.org*
The Ocean Conservancy promotes healthy and diverse ecosystems and opposes practices that threaten ocean life human life. Through research, education and science-l advocacy, The Ocean Conservancy informs, inspires empowers people to speak and act on behalf of the oceans.

UNESCO *www.unesco.org*
The United Nations Educational, Scientific and Cu Organization (UNESCO) seeks to encourage the identifica protection and preservation of cultural and natural he around the world considered to be of outstanding val humanity.

Wildlife Conservation Network *www.wildnet.org*
The Wildlife Conservation Network is dedicated to prote endangered species and preserving their natural habita partners with independent conservationists around the v who live and work with local communities and are explorin ways to resolve the conflicts between people and wildlife.

World Environmental Organization *www.world.org*
The World Environmental Organization is devoted to preservation of the natural diversity of plant and animal sp and their habitats through the prevention of environm degradation and destruction. World.Org develops implements scientific strategies for decreasing fossil fuel preventing climate change and preserving natural habitats.

credits

biographies

CHARLES ALEXANDER (P.140)

www.natureartists.com/charles_alexander.asp

Wildlife painter and naturalist Charles Alexander is dedicated to the conservation of endangered animals and their vanishing habitats. He is particularly interested in raising awareness and generating funds for projects focusing on lesser-known endangered species, such as the bonobo ape and the Sumatran rhino. His work has appeared in such publications as *Birder's World* and *Wildlife Art*. A signature member of the Worldwide Nature Artists Group, he resides in Memphis, Tennessee.

EL ANATSUI (P.102)

www.jackshainman.com

Inspired by the beliefs and crafts of his native Ghana, Nigerian sculptor El Anatsui developed his artistic abilities at the College of Art at the University of Science and Technology in Kumasi, Ghana, from 1965 to 1969. He represented Nigeria at the Venice Biennial of 1990. Focusing on themes of tradition and change, El Anatsui uses the power of modern tools, particularly the chain saw, to create original works in wood. His work serves as a reminder of our post-use consumerism as he weaves the debris of thousands of discarded aluminum liquor bottle caps and labels into monumental walls. His art has been, and continues to be, showcased internationally in such countries as Brazil, Japan, Germany, England, South Africa and the United States.

CHESTER ARNOLD (P.76)

Chester Arnold is an American painter who was raised in Germany. At the age of sixteen, he was inspired to pursue a career as an artist when he discovered the work of Max Beckmann. Initially studying the fundamentals of technique through correspondence courses with the Famous Artists School, Arnold went on to earn to his MFA from the San Francisco Art Institute in 1987. His detailed oil-on-linen works and his black-and-white drawings depict natural and urban settings. He has had several solo exhibitions in the United States: at the Catharine Clark Gallery in San Francisco, the San Jose Museum of Art in San Jose, the Tacoma Art Museum in Washington and the George Adams Gallery in New York. In 2005 he also participated in *ECO: Art About the Environment*, a group exhibition for the Fine Arts Gallery at San Francisco State University.

FRANCIS BAKER (P.108)

www.francisbaker.com

San Francisco–based photographer Francis Baker earned a BS in physics from the University of Wisconsin at Madison in 1990. His conceptual series of sculptures, paintings, and drawings utilize a range of natural and man-made materials, from the roots of plants to Barbie dolls and plastic hangtags, which his camera lens ultimately captures. The galleries where he has had solo exhibitions include the Togonon Gallery and the Yerba Buena Center for the Arts in San Francisco, the Oakland Airport Museum and galleries in Seattle, Santa Fe and Paris. His art has been reviewed by many publications, including the *Seattle Post-Intelligencer*, the *Seattle Times* and *Artweek* magazine.

BRANDON BALLENGÉE (P.157)

New York–based artist and researcher Brandon Ballengée creates mixed-media installations that reveal the threatened state or abnormal development of biodiversity worldwide. Ballengée's collaborative studies and experiments most often deal with amphibians and fish. He has worked with several renowned organizations, including the Peabody Museum at Yale University, the American Museum of Natural History, the Natural History Museum in London and the Museum of Vertebrate Zoology at UC Berkeley. In 2004 he participated in the Geumgang Nature Art Biennale in South Korea, and in 2005 his work was showcased at the Venice Biennale in the Waterways Project. He is currently working toward a dual Ph.d. in art and science at the University of Applied Sciences and Art, Hochschule für Gestaltung und Kunst, in Zürich, Switzerland.

SUBHANKAR BANERJEE (P.150)

www.wwbphoto.com

Indian-born artist-activist Subhankar Banerjee lives in Santa Fe, New Mexico. His ongoing photography project, *Terra Incognita: Communities and Resource Wars*, which started in 2000, explores how the Arctic has connected us all across the planet—through its celebratory and tragic manifestations. Banerjee sees the Arctic not as a last frontier but as a mirror on which our human cultures are reflected. He holds a

bachelor's degree in engineering and master's degrees in physics and computer science. For his work in the Arctic National Wildlife Refuge in Alaska he received many awards, including, in 2003, the inaugural Cultural Freedom Fellowship from the Lannan Foundation and, in 2005, the Green Leaf Artist Award for Photography from the United Nations Environment Programme. His work has been reviewed by Roberta Smith, art critic of the *New York Times*; by Ingrid Sischy, the editor-in-chief of *Interview* magazine; and by the art historian Finis Dunaway, assistant professor of history at Trent University, Ontario. Banerjee's photographs have been exhibited in numerous solo museum and gallery shows, including at the Hood Museum of Art at Dartmouth College, where his work is in the permanent collection.

ROBERT BATEMAN (P.22)

www.robertbateman.ca

Considered one of the foremost wilderness artists of our time, avid naturalist Robert Bateman has been working to change the way we think and live for more than thirty years. A native of Toronto, Canada, Bateman has garnered a lengthy list of honors, including Officer of the Order of Canada in 1984, the Rachel Carson Award in 1996 and the Golden Plate from the American Academy of Achievement in 1998. He was also named one of the Twentieth Century's Champions of Conservation by the U.S. National Audubon Society in 1998. His paintings have been exhibited internationally, most notably at the Smithsonian Institution's National Museum of Natural History in Washington, D.C., in 1987. His work is also held in several public collections, including the Denver Art Museum; the Leigh Yawkey Woodson Art Museum in Wausau, Wisconsin; the National Museum of Wildlife Art in Jackson, Wyoming; the Art Gallery of Greater Victoria in British Columbia; and in the private collections of the late Princess Grace of Monaco and Prince Philip and Prince Charles of Great Britian. Bateman is a board member of many organizations in Canada and the United States and supports many conservation organizations.

JANINE BENYUS (P.106)

www.biomimicry.net

Janine Benyus is the face and name behind "biomimicry," a term she coined to emphasize the lasting environmental benefits that are realized when the human world learns from and functions like the natural world. As a life sciences writer, educator and lecturer, Benyus presents her work in many nonfiction books and through her consulting organization, the Biomimicry Guild (a department within the Biomimicry Institute). She co-founded the Institute in 1998 to support designers at companies such as Nike, Novell, Patagonia, and Proctor & Gamble. She is a member of the Women of Discovery Series and sits on the advisory board of the engineering research and development firm Pax Scientific, with other major environmentalists of our time. A graduate of Rutgers University in New Jersey, Benyus earned dual degrees in natural resource management and English literature.

JOSEPH BEUYS (P.132)

Influential twentieth-century German conceptual artist Joseph Beuys pioneered art as a movement—a form integral to, rather than separate from, everyday life. He believed in the transformative powers of art and over time increasingly turned his attention away from the traditional gallery setting and toward community-based artwork. He worked in painting, sculpture, installation, video and performance art. He trained at the German art academy Kunstakademie Düsseldorf from 1947 to 1951 and taught sculpture there from 1961 to 1972. After he left the academy, Beuys founded the Free International University for Creativity and Interdisciplinary Research in 1973, where he laid the framework for his social sculpture theory. Beuys represented Germany at the Venice Biennale in 1976 and 1980. In 1979 a retrospective of his work was held at the Guggenheim Museum in New York and in 1980 he was made a member of the Royal Academy of Fine Arts in Stockholm. Prior to his death in January 1986, Beuys was awarded the Wilhelm Lehmbruck Prize in Duisburg, Germany.

ALFIO BONANNO (P.122)

www.alfiobonanno.dk

A pioneer in environmental art, Alfio Bonanno is a site-specific outdoor-installation artist who has been creating large-scale sculptures within select natural environments for the past thirty-five years. Bonanno collects natural materials that come directly from the site he has chosen, including the Cedarhurst Sculpture Park in Mount Vernon, Illinois, and Nome Beach in Telemark, Norway, to crea

inform his work. Born in Italy and raised in Australia, Bonanno ... influenced by Arte Povera, a term coined by the Italian art critic ...mano Celant to describe the nonconformist, anti-institutional art ...ement of the 1960s and '70s. Bonanno's 1985 installation at the ...o Museum in Barcelona, a collaboration with the Danish composer ...nar Moller Pedersen, was seen as a breakthrough in environmen... ...rt. As founder of TICKON (Tranekaer International Center for ...and Nature), Bonanno has worked with Andy Goldsworthy, David ...n, Karen McCoy, Chris Drury, Alan Sonfist, Lance Bélanger, ...-Udo, and Lars Vilks. He lives in Langeland, Denmark, and has ...ked extensively in Europe, Asia and North America.

KIE BROOKNER (P.166)
.jackiebrookner.net
...ironmental artist Jackie Brookner works collaboratively with ecolo-..., design professionals, communities and policy makers on water re-...liation and public art projects for wetlands, rivers and storm water ...off. Her projects range from Biosculptures™ (vegetated water-fil-...on systems) to municipal planning, in which local water resources ...mote community revitalization. Her current and recent projects ...near Dresden, Germany, and in West Palm Beach, Florida, San ..., California and Cincinnati and Toledo, Ohio; her community-...d planning projects are in Germany, Pennsylvania and the Pacific ...thwest. She is the recipient of awards from numerous institutions, ...uding the National Endowment for the Arts, the New York Founda-... for the Arts, the Nancy Gray Foundation for Art in the Environ-...t and the Trust for Mutual Understanding. She received her BA ...n Wellesley College and her MA from Harvard University. She lives ... works in New York, has taught at Harvard and the University of ...nsylvania and currently teaches at Parsons School of Design.

...WARD BURTYNSKY (P.50)
..edwardburtynsky.com
...more than twenty-five years, Canadian photographer Edward Bur-...sky has explored the links between industry and nature in his large-...e color prints, which eloquently correlate human progress with the ...nging shape of the earth's surface. Burtynsky's inspiration dates ...k to his youth and his work experiences in the mining industry and ...he General Motors plant in his birthplace, St. Catharines, Ontario. ...received his undergraduate degree in photographic art at Ryerson ...versity, Toronto. In 1985, as a young entrepreneur, Burtynsky ...nded Toronto Image Works—a darkroom rental facility, custom ...to laboratory and digital imaging and new media computer-train-... center. Today his prints are housed in the collections of sixteen ...or museums around the world, including the National Gallery of ...nada, the Bibliotèque Nationale in Paris and both the Museum of ...dern Art and the Guggenheim Museum in New York. In 2004 he ... a recipient of the prestigious TED (Technology, Entertainment ... Design) Award. In 2006 Burtynsky earned the title Officer of the ...der of Canada—the country's highest civil award—and was given an ...norary doctor of laws degree from Queen's University, Kingston, ...tario.

...DY CAO (P.34)
..landscape2go.com
... childhood memories of growing up in Vietnam have influenced ...rd-winning garden designer Andy Cao, who studied landscape ...hitecture at California State Polytechnic University before he and ... business partner, Stephen Jerrom, completed their first Glass ...den project in 1998. Made of 45 tons of recycled glass pebbles, this ... became the backbone for Cao and Jerrom's joint venture Glass ...rden, Inc—a company dedicated to manufacturing alternative mate-...s for landscape applications. Cao has received two full fellowships to ... Pilchuck Glass School in Seattle and was a participant in the 2001 ...ernational Garden Festival at Chaumont-sur-Loire, in France. In ...02 he was the recipient of the prestigious Rome Prize. Based in Los ...geles and New York City, Cao is regularly commissioned to design ... hotels, private residences, stores and museums.

...L CHIN (P.148)
..frederieketaylorgallery.com
...ological artist Mel Chin uses his multidisciplinary work to address ...ues involving habitat devastation, restoration, sustainability and bio-...ersity. He has participated in individual and group shows world-...le, including the Fifth Havana Biennial in Cuba; the Seventh Archi-...tural Biennial in Venice, Italy; and the Kwangju Biennale in Korea.

His work has also been exhibited at several leading art museums and galleries, including the Hirshhorn Museum in Washington, D.C., the Museum of Contemporary Art in Los Angeles and the Whitney Museum of American Art in New York. Chin is the recipient of various awards and grants from the National Endowment for the Arts, the Penny McCall Foundation, the Pollock-Krasner Foundation, the Rockefeller Foundation and the Louis Comfort Tiffany Foundation, among other established art organizations. A native of Houston, Texas, Chin earned his BA from Peabody College in Nashville, Tennessee, in 1975.

NANCY CHUNN (P.56)
www.feldmangallery.com
Painter and mixed-media artist Nancy Chunn received her BFA from the California Institute of the Arts in 1969. She has had solo exhibitions of her work at the Carnegie Mellon College of Fine Arts in Pittsburgh, the Corcoran Museum of Art in Washington, D.C. and the Museum of Contemporary Art in Chicago. Since 1987 she has had six solo shows at the Ronald Feldman Gallery in New York City. Chunn's art is also part of many public collections, including the Museum of Contemporary Art in Chicago. In 1985 and 1995 Chunn received a National Endowment for the Arts Fellowship. In 1997 her Front Pages, 1996 series was compiled into a book of the same name and published by Rizzoli International Publications, Inc. Chunn lives in New York City, where she teaches art at the School of Visual Arts.

CHRISTO AND JEANNE-CLAUDE (P.94)
www.christojeanneclaude.net
Husband-and-wife team Christo and Jeannne-Claude have been creating large-scale installation pieces in locations around the world since the 1960s. Their well-known projects include Pont-Neuf Wrapped (the veiling of the Parisian bridge) in 1985, Wrapped Reichstag (the veiling of the Parliamentary building in Germany) in 1995, and The Gates in New York City's Central Park in 2005. Their work is also held in collections worldwide: at the Whitney Museum of American Art in New York, the Tate Gallery in London, the Museum of Modern Art in Paris, and the National Museum of Art in Osaka, Japan, among many other renowned museums and galleries. Christo was born in Gabrovo, Bulgaria, on June 13, 1935; Jeanne-Claude was born in Casablanca, Morocco, on the same day in the same year.

VERNE DAWSON (P.72)
Painter Verne Dawson studied art at The Cooper Union School of Art in New York prior to participating in solo and group exhibitions worldwide. His work has been showcased at the Camden Art Centre in London; Le Consortium in Dijon, France; the Douglas Hyde Gallery in Dublin; and Gavin Brown's Enterprise in New York City, among other distinguished venues. He has been reviewed several times in the New York Times, Flash Art, CIRCA Art Magazine, and Artforum over the course of his career. He is a native of Meridianville, Alabama, and currently lives and works in New York and Pennsylvania.

AGNES DENES (P.154)
American environmental artist Agnes Denes creates large-scale site-specific installations. For her 1982 project, Wheatfield—A Confrontation, she was able to plant and harvest a two-acre lot in downtown Manhattan. She has also participated in reforestation, reclamation and earthwork projects worldwide. She is the recipient of several prestigious awards and fellowships: the Watson Award for Transdisciplinary Achievement in the Arts from Carnegie Mellon University in 1999, the Rome Prize from the American Academy in Rome in 1997 and an honorary doctorate in fine arts from Ripon College in 1994, among others. Commissioned by organizations throughout Europe and the United States, Denes has produced work for the First National Bank of Chicago; the Department of Cultural Affairs & Artemesia in Genoa, Italy; the Public Art Fund in New York City; and the Museum of Contemporary Art in Helsinki, Finland.

MARK DION (P.66)
www.tanyabonakdargallery.com
Mixed-media installation artist Mark Dion is a native of New Bedford, Massachusetts. His projects have been presented at the Museum of Modern Art in New York, the Academy of Fine Arts in Vienna, the Fabric Workshop and Museum in Philadelphia, the University of Tokyo Museum in Tokyo and the Tate Gallery in London, among other institutions. From 1982 to '84, he studied at the School of Visual Arts

in New York, and in 2003 he earned his Ph.d. from the University of Hartford's School of Art in Connecticut. In 2001 he was the recipient of ninth annual Larry Aldrich Foundation Award. Dion also participated in the Whitney Museum of American Art Independent Study Program from 1984 to '85.

LEONARDO DREW (P.88)
www.leonardodrew.com
Leonardo Drew was born in Tallahassee, Florida, and grew up in Bridgeport, Connecticut. He attended The Cooper Union for the Advancement of Science and Art and Parsons School of Design in New York. His art has been collected internationally by the Metropolitan Museum of Art in New York, the Guggenheim Museum in Bilbao, Spain, the Hirshhorn Museum and Sculpture Garden in Washington, D.C. and ArtPace in San Antonio, Texas. He has received several awards over the last fifteen years, including a residency at the Studio Museum of Harlem in 1991 and one of the first Joan Mitchell Foundation grants, in 1994. He is known for his large-scale sculptural installations created from materials such as paper, cotton, rope and wood, in addition to discarded objects. He currently resides in Brooklyn, New York.

CHRIS DRURY (P.43)
www.chrisdrury.co.uk
Chris Drury is a site-specific outdoor-installation artist who also produces works to be exhibited indoors, at museums and galleries. Some of his notable commissions include his temporary 2005 Redwood Vortex at Villa Montalvo in Saratoga, California, Rhythms of the Heart for Conquest Hospital in Hastings, England and Cloud Chamber for the Trees and Sky for the North Carolina Museum of Art in Raleigh. He is the recipient of a Pollock-Krasner Award, the Scottish Environmental Award, the Natures Prize and the University College London's Arts in Health Award. Drury has also participated in several artist-in-residence programs, including the British Antarctic Survey, as part of the 2006 Artists and Writers in Antarctica Fellowship. His work has been collected by several public institutions; among them are the Victoria & Albert Museum and the Leeds City Art Gallery in England and the Henry Art Gallery in Seattle, Washington.

SAM EASTERSON (P.120)
www.anivegvideo.com
The work of video artist Sam Easterson has been showcased at several distinguished museums throughout the United States, including the Whitney Museum of American Art in New York, the Walker Art Center in Minneapolis, the International Center for Photography in New York and the Massachusetts Museum of Contemporary Art in North Adams. Easterson is the founder and director of Animal, Vegetable, Video, a comprehensive library of video footage taken from the animals' and plants' point of view. Clips from this video series have been presented at several venues, including the Natural History Museum of Los Angeles, the Exploratorium in San Francisco, the Te Papa Museum in Wellington, New Zealand and the Center for Land Use Interpretation in Los Angeles. His work has been reviewed in the New York Times, the Village Voice and Flash Art International, among other publications. He has garnered awards from the Louis Comfort Tiffany Foundation in New York, the Creative Capital Foundation in New York and the Peter S. Reed Foundation in New York.

OLAFUR ELIASSON (P.16)
www.olafureliasson.net
Olafur Eliasson is an Icelandic-Danish artist well known for his 2003 exhibit The Weather Project at the Tate Modern in London. His re-creations of natural phenomena, such as fog and rainbows, are grounded in the basic elements of weather—water, light, temperature and pressure—and aim to challenge human perceptions of the physical world. Eliasson's work is in the permanent collections of a number of private and public institutions, including the Guggenheim Museum in New York, the Museum of Contemporary Art in Los Angeles and the Deste Foundation in Athens. He has had solo exhibitions at, among others, the Kunsthaus Bregenz in Austria and the Museum of Modern Art in Paris. In 2003 Eliasson also represented Denmark at the Venice Biennale. He lives and works in Berlin.

MASARU EMOTO (P.104)
www.masaru-emoto.net
Born in Yokohama, Japan, in 1943, Masaru Emoto is a graduate of the Yokohama Municipal University, where he studied international relations within the Department of Humanities and Sciences. In 1992 he received certification as a doctor of alternative medicine from the Open International University for Alternative Medicine in India. As an artist, Emoto is interested in the effect of the environment on the molecular structure of water. Expanding upon his theories and applications surrounding various forms and states of water, Emoto established the International Hado Membership (I.H.M.) Corporation in Tokyo in 1986. By 2004 the I.H.M Corporation had a second location in Liechtenstein, under the name Hado Life Europe. Today, Emoto continues to work as a scientist, a theorist, a lecturer and an author.

RUUD VAN EMPEL (P.46)
www.ruudvanempel.nl
The digitally manipulated photography of Dutch artist Ruud van Empel is seamlessly collaged into lush tropical forests, where he decides which plants can grow and which animals can inhabit this imaginary environment. His work has been included in exhibitions at the Groninger Museum and the Frisia Museum in the Netherlands, as well as in the Arad Collection in London and the Sir Elton John Collection in Atlanta, Georgia. His photo-collage works, video and graphic design have earned him several awards, including a St. Joost Prize in 1981, a Charlotte Kohler Award in 1993 and an H. N. Werkman Award in 2001. He resides in Amsterdam.

FREE RANGE STUDIOS (P.156)
www.freerangestudios.com
Louis Fox is co-founder of the creative arts organization Free Range Studios, which produces films, Web sites, graphic design and animation, in addition to consulting on brand identity and strategic communications. Free Range Studios is dedicated to promoting sustainable business models, particularly for the agriculture industry. Its clients include charitable organizations and for-profit entities alike. Its clients also range from the globally recognized activist organizations to local, independently owned outfits. Fox's movies, specifically *Grocery Store Wars* and *The Meatrix*, have earned numerous honors at film festivals worldwide, including SXSW, Media That Matters, Annecy International, Rezfest, the Holland Animation Festival and the Environmental Media Awards. In 2001, Fox and cofounder Jonah Sachs were listed among "The Thirty People Saving the Earth" by *Shift* magazine.

AMY FRANCESCHINI (P.142)
www.futurefarmers.com
A new-media artist and Web designer, Amy Franceschini focuses on notions of community and sustainable environments in her work. In 1995 she founded Futurefarmers, a print and electronic design group inspired by biodynamic farming as a model and a philosophy. She is also the cofounder of *Atlas* magazine, an online source for photography, multimedia, design and illustration. Futurefarmers' Web calendars, showcased at the San Francisco Museum of Modern Art in 1996 and 1997, were some of the first Web sites to be collected by a museum. Franceschini teaches media courses at Stanford University, where she earned her MFA, and at the San Francisco Art Institute. She won a 2006 SECA Art award from the San Francisco Museum of Modern Art. Presented annually, the award recognizes five local artists of exceptional promise.

ROBERT GLENN KETCHUM (P.134)
www.robertglennketchum.com
Prolific American photographer and writer Robert Glenn Ketchum is a Fellow of the International League of Conservation Photographers. He is the recipient of the United Nations Outstanding Environmental Achievement Award, the Ansel Adams Award for Conservation Photography and the Robert O. Easton Award for Environmental Stewardship. A lifetime trustee of the Alaska Conservation Foundation, Ketchum continues to promote habitat protection, natural resource management and the preservation of wild lands. He earned a BA in design from UCLA and an MFA in photography from the California Institute of the Arts.

CAI GUO-QIANG (P.96)
www.caiguoqiang.com
Installation artist Cai Guo-Qiang was born and raised in Fujian Province, China, before moving to Tokyo, Japan, where he became internationally known for his use of gunpowder in his explosive art series *Projects for Extraterrestrials*. Educated in stage design at the Shanghai Drama Institute from 1981 to 1985, Guo-Qiang considers his grandiose conceptual works to be rooted both in theatrics and in his Chinese heritage. His art has been exhibited at the Shanghai Art Museum, at the Tate Modern in London and at the Museum of Modern Art and Metropolitan Museum of Art in New York, as well as at many other galleries and museums in Asia, Europe and the United States. In 1999, he was the recipient of the International Golden Lion Prize at the 48th Venice Biennial, and in 1993 he was awarded a grant from the prestigious Cartier Foundation for Contemporary Art in Paris. He divides his time between Tokyo and New York City.

SIOBHÁN HAPASKA (P.105)
www.tanyabonakdargallery.com
Installation artist Siobhan Hapaska was born in Belfast in 1963. From 1985 to '88 she studied at Middlesex Polytechnic in London, and continued her education at Goldsmiths College at the University of London from 1990 to '92. She has garnered several awards, including the Irish Museum of Modern Art's Glen Dimplex Award in 1998 and the Guinness Peat Aviation Award for Emerging Artists from the Gallagher Gallery in Dublin in 1990. In 2001 she represented Ireland at the 49th Venice Biennale in Italy. She has participated in solo and group exhibitions worldwide: at the Tanya Bonakdar Gallery in New York, the Museum of Contemporary Art, Kiasma in Helsinki and the Milton Keynes Gallery in London, to name a few.

NEWTON AND HELEN MAYER HARRISON (P.162)
www.feldmangallery.com
Among the leading pioneers of the eco-art movement, husband-and-wife team Newton and Helen Mayer Harrison have worked for more than thirty years with biologists, ecologists and urban planners to initiate collaborative dialogues about biodiversity and community development on a local and international scale. As historians, diplomats, environmentalists, investigators, emissaries and art activists, the Harrisons contribute significantly to the worlds of both art and urban planning. Their work has been exhibited at the Los Angeles County Museum of Art, Ronald Feldman Fine Arts in New York and the Pompidou Center in Paris, among other prestigious art institutions. Together they hold emeritus faculty positions at UC San Diego. They reside in Santa Cruz, California.

THE ICELANDIC LOVE CORPORATION (P.90)
www.ilc.is
In 1996 Sigrún Hrólfsdóttir, Jóní Jónsdóttir, Dóra Ísleifsdóttir and Eirún Sigurdardóttir formed the Icelandic Love Corporation (ILC) as a performance, video, photography and installation art collaborative. Prior to settling in their current location in Reykjavik, Iceland, the ILC worked and studied in New York, Copenhagen, and Berlin. The ILC is the recipient of several grants and awards, including a Visitors Choice Top Ten Award for their work at the 2001 Palazzo della Triennale in Milan and two Reykjavik Art Fund grants. The ILC's projects have been documented and captured for solo exhibitions at the Living Art Museum in Reykjavik, the Basel Art Fair in Switzerland and Jack the Pelican Presents Gallery in Brooklyn, New York. Several of the ILC's photographs, sculptures and video installation pieces are held in the permanent collection at the Reykjavik Art Museum and in other collections.

ICHI IKEDA (P.146)
www.33.ocn.ne.jp/~waters
Born in Osaka, Japan, Ichi Ikeda is dedicated to raising global awareness around water issues and conservation through international conferences, community activism, public performance and his interactive Water Art installations. He is specifically concerned about the ability of water to flow cleanly and accessibly all over the world. In Bangkok, at his 2002 Big Hands Conference, Ikeda orchestrated an educational symposium featuring an interactive gallery installation with images of large cupped hands holding water as well as a recording of the artist's poetry. Since 1984 his projects have been showcased collectively and individually throughout the United States and Southeast Asia.

YOKO INOUE (P.80)
Yoko Inoue graduated from Hunter College, N.Y., with an MFA in 2000. She was awarded a fellowship from the John Simon Guggenheim Memorial Foundation (2006) and from the Joan Mitchell Foundation Painters and Sculptors Grant Program (2005); she received the Franklin Furnace Archives Fund for Performance Art Award (2005), a NYFA Fellowship in Sculpture from the New York Foundation for the Arts (2003), and a Lambent Fellowship from the Tides Foundation (2004–6). Residencies include Skowhegan, Art Omi, the Atlantic Center for the Arts, and the European Ceramic Work Centre in Holland, among others. Her work has been shown at the Brooklyn Museum; at SculptureCenter in Long Island City; at the Lower Manhattan Cultural Council; at the Bronx Museum; and at Art in General, the Greene Naftali Gallery, and the Von Lintel Gallery in New York, among other venues. Currently she is a resident artist of the Workspace Program at the Lower Manhattan Cultural Council.

CHRIS JORDAN (P.54)
www.chrisjordan.com
Chris Jordan is a Seattle-based photographic artist whose work explores the detritus of American consumer society. His large-scale prints have been featured in solo and group exhibitions throughout the United States and Europe, and photo essays, interviews and reviews of his images have been published in more than one hundred magazines, newspapers and blogs all over the world. In 2006 Jordan collaborated with environmental writers Bill McKibben and Susan Zakin to produce the book *In Katrina's Wake: Portraits of Loss From an Unnatural Disaster* (Princeton Architectural Press, New York).

NICHOLAS KAHN AND RICHARD SELESNICK (P.26)
www.kahnselesnick.com
Nicholas Kahn and Richard Selesnick have been collaborators on a body of work that includes complex narrative photo-novellas, paintings and sculptural installations since their days as fellow BFA students at Washington University in St. Louis, Missouri. Their work is included in many public collections, including the National Portrait Gallery in Washington, D.C., the Brooklyn Museum of Art and the Philadelphia Museum of Art. They have been artists-in-residence with the Princeton Atelier at Princeton University, the Djerassi Foundation in Woodside, California and the Addison Gallery of American Art in Andover, Massachusetts. Kahn is a native New Yorker and Selesnick was born and raised in London. Both now reside in New York state.

WALANGARI KARNTAWARRA (P.18)
www.walangari.com.au
Aboriginal painter Walangari Karntawarra is of the Arrernte, Luritja, Walpiri, Yankuntjatjarra, Pintubi and Alyawarre peoples of the Central and Western Desert of Australia. In addition to his work as an artist, Karntawarra has held many executive positions on various Aboriginal councils, including chair of the Central Australian Aboriginal Media Association (CAAMA)—the first Aboriginal owned radio station—and director of the first Aboriginal television station, Imparja. His paintings are in the permanent collections of several prominent art institutions, including the Australian National Gallery, the Stuttgart Museum, the Costello Collection, the Kneed-McDaid Collection and the Jagamarra Collection in Sydney, Australia. Karntawarra has exhibited widely and participated in many artist-in-residence programs, including the program at the Museum of Sydney.

WILLIAM KENTRIDGE (P.62)
www.mariangoodman.com
William Kentridge is a South African artist who creates charcoal drawings, prints, collages, stop-animation, film and theater. He is perhaps best known for his distinctive short animation films and drawings. He has had solo exhibitions at the Marian Goodman galleries in New York and Paris, at the Deutsche Guggenheim in Berlin, and at both the Metropolitan Museum of Art and the Museum of Modern Art in New York, among other distinguished art venues. His 2004 retrospective exhibition, organized by Castello di Rivoli, Museo d'Arte Contemporanea, Rivoli, Italy, traveled to Germany, Australia, Canada and South Africa. In 2001–02, a survey of his work toured the United States, and was exhibited at the Hirshhorn Museum in Washington, D.C., the New Museum of Contemporary Art in New York, the Museum of Contemporary Art in Chicago, CAM Houston and the Los Angeles County Museum of Art. The exhibit concluded at the

h African National Gallery in Cape Town. In 2003 he was the
ient of the prestigious Goslar Kaiserring Award, and in 2000 he
warded the Carnegie Prize. From 1973 to '76 Kentridge studied
e University of the Witwatersrand, Johannesburg, South Africa,
from 1976-78 he studied fine art at the Johannesburg Art Foun-
n, where he later taught printmaking. In 1981-82 he completed a
se in mime and theatre at L'Ecole Jacques LeCoq in Paris. He lives
works in Johannesburg.

RISTIAN KERRIGAN (P.128)
interactivearchitecture.org
stian Kerrigan is a qualified architect originating from Greystones,
nd. He is a recent graduate of the Bartlett School of Architecture
e University College London, where he developed his final-year
is around ideas of architecture, art and philosophy. Kerrigan is
the editor of *The Space Between* magazine, which showcases emerg-
concepts of international creativity and progressive situationist
ure. He has worked for the renowned architects Jean Nouvel and
k Fisher and is writing a book about his architectural investigations.
rigan has won a number of awards, including the Fitzroy Robinson
ng Design Drawings of the Year Award, the Andrew Grant Design
folio Prize from the Edinburgh College of Art and the Hays Mon-
e Architectural Student of the Year Award from the Dublin In-
te of Technology. He has participated in exhibitions such as the
ME House Project in New York, the SECCA affordable housing
petition in North Carolina and the Architecture for Humanity's
ile HIV/AIDS Clinic competition in New York, among others. He
des in London.

IT KHALSA (P.78)
onal experiences and revelations initiate Khalsa's research into
y complex environmental and societal issues, including air quality,
r politics, deforestation and land use. As an installation artist and
tographer, Sant Khalsa is the recipient of prestigious grants and
rds from the National Endowment for the Arts, the California Arts
ncil, the California Council for the Humanities and the Center
Photographic Art in Carmel. Her artworks have been exhibited in
and group exhibitions at Exit Art in New York City, the Armory
ater for the Arts in Pasadena, the McKinney Avenue Contemporary
Dallas, the University Art Museum at UC Santa Barbara, the Scott-
e Museum of Contemporary Art and other distinguished galleries.
photographs are found in public and private collections, includ-
the Los Angeles County Museum of Art; the Center for Creative
tography at the University of Arizona, Tucson; and the Nevada
seum of Art, Reno. Khalsa resides in the Santa Ana Watershed and
rrently the chair of the Art Department at California State Uni-
ity, San Bernardino, where she is also one of the founding faculty
nbers of the Water Resources Institute (WRI).

BELLA KIRKLAND (P.138)
.isabellakirkland.com
rained taxidermist as well as an artist, Isabella Kirkland draws atten-
to hundreds of species of flora and fauna in detailed oil paintings
deled after sixteenth- and seventeenth-century Dutch still lifes. Her
-size depictions of plants and animals are precisely rendered and
tomically accurate, the result of extensive research at natural history
seums. Kirkland studied at the Worcester Museum School in Mas-
husetts in 1973 and at the Virginia Commonwealth University in
hmond in 1975 before moving west to study at the San Francisco Art
itute. Her work has been included in exhibitions at the Harvard
seum of Natural History, the Yerba Beuna Center for the Arts in
Francisco, Feature Inc. in New York, the Scottsdale Museum of
ntemporary Art in Arizona and other leading galleries and museums
the United States. She was featured in *ArtForum*'s "Best of 2002: II
Tens," and in 2004 she received an Individual Artist Grant from
Marin Arts Council. She resides in Sausalito, California.

GRID KOIVUKANGAS (P.36)
v.ingrid-koivukangas.com
rid Koivukangas is a Finnish-Canadian environmental artist. She
ates permanent and temporary site-specific sculptures as well as
d-based installations that include video, photography, sound and
Internet. Her multimedia works are made in response to her ex-
iences in nature. She received her MFA in sculpture from the Uni-
sity of Calgary, Alberta, Canada, in 2002. Her works have been ex-

hibited in Canada, the United States, Finland, Spain and Costa Rica.
Many of her exhibits include workshops on environmental art in which
participants learn firsthand how she works within a site. She lives in
Vancouver, British Columbia, where she teaches new media and design
in the Fine Arts Department at Langara College.

HIROKAZU KOSAKA (P.38)
Installation and performance artist Hirokazu Kosaka is a Buddhist
priest of the Shingon sect and a master Zen archer. Kosaka was born in
Japan and graduated from the Chouinard Art Institute, California In-
stitute of the Arts, in Los Angeles in 1970. Among Kosaka's awards are
grants and fellowships from the Rockefeller Foundation, the National
Endowment for the Arts, the Brody Foundation, the J. Paul Getty
Trust, the Pew Charitable Trusts and the California Arts Council. In
2003 he collaborated with architect Michael Rotondi and visual artist
Wolfgang Laib on an experimental installation at the Fowler Museum
for Cultural History at UCLA entitled *From the Verandah: Art, Buddhism,
Presence*. Kosaka is currently the artistic director at the Japanese Ameri-
can Cultural and Community Center in Los Angeles.

BERNIE KRAUSE (P.37)
www.wildsanctuary.com
Internationally recognized bioacoustic artist Dr. Bernie Krause has
been capturing the sounds of wild habitats around the world since
the late 1960s. Through his soundscapes, Krause is able to turn his
fieldwork into both music albums and dramatic sound installations for
public spaces such as museums, zoos and aquariums. Krause's work
demonstrates how our ability to listen is a key component in heighten-
ing our awareness of the natural world. From 1968 to 2004 Krause
was the president and CEO of Wild Sanctuary, Inc., a company he
founded as a resource for natural sound and media design. Krause
earned a Ph.d. in creative arts, with an internship in bioacoustics,
from the Union Institute in Cincinnati, Ohio, in 1981. His work has
been showcased at galleries throughout the United States, inlcuding
the Smithsonian Postal Museum in Washington, D.C., the Ameri-
can Museum of Natural History in New York City, and the California
Academy of Sciences in San Francisco, to name a few. He resides in
Glen Ellen, California.

MIERLE LADERMAN UKELES (P.164)
www.feldmangallery.com
As a basis of her work, artist Mierle Laderman Ukeles looks at the inter-
section between maintenance and detritus in the shaping of the public
domain. She has been the artist-in-residence for the New York City
Department of Sanitation since 1978 and is currently the artist of Fresh
Kills Park and an integral part of the transformation of Fresh Kills
Landfill in Staten Island. Manifested in the form of installation, work
ballets, video and performance art with, at times, thousands of people,
Ukeles's pieces reveal our limitless powers of transformation—from
changing the degraded identities of service workers, to the restoration
of ravaged landscapes, to individual and urban rebirth. Since earning
her MA in interrelated arts from New York University in 1974, Ukeles
has garnered numerous awards, including recent artist's fellowships
from the Guggenheim, Andy Warhol, Joan Mitchell and Anonymous
Was a Woman foundations and from the National Endowment for the
Arts. Her work has been displayed internationally at museums and
galleries in the Netherlands, Japan, Korea, Israel, England, Ireland,
Austria and France, and in the United States in Los Angeles; New
York; Cambridge; Portland, Maine; Pittsburgh; Denver; and Cincin-
nati. A Colorado native, Ukeles currently resides in New York City and
is represented by the Ronald Feldman Gallery.

REUBEN LORCH-MILLER (P.121)
www.lorch-miller.com
Multimedia artist Reuben Lorch-Miller works in video, text, sculp-
ture, photography, drawing and sound. He was raised in Washington
and says that his early influences include punk rock and the forests of
the Northwest. Solo exhibitions of his work have been displayed in the
United States at the Catharine Clark Gallery in San Francisco, the Greg
Kucera Gallery in Seattle, the San Francisco Arts Commission Gallery
and the Schroeder-Romero Gallery in New York, as well as in museums
and galleries internationally. His art is in the permanent collection of
the Brooklyn Museum of Art. In 2001 Lorch-Miller was the recipi-
ent of the Goldie Award from the *San Francisco Bay Guardian* and was an
artist-in-residence at the Headlands Center for the Arts in Sausalito,

California. He earned his MFA in new genres in 2001 from San Fran-
cisco State University.

JOHN LUNDBERG (P.82)
www.circlemakers.org
The British artist and documentary filmmaker John Lundberg is the
founder of the U.K.–based artist's collective Circlemakers, a group
that designs and creates crop circles as an art form. In 1995 Lundberg
developed circlemakers.org as a way to document the organization's
work and serve as a resource for the history and philosophy behind
crop circles. The Web site went on to receive many awards, including
The Guardian's "Site of the Year" prize in England. Although individual
projects remain authorless, Lundberg has commanded the attention
of companies like Nike, Microsoft and the BBC for their advertise-
ments. In 2004 Lundberg earned his MA from the National Film and
Television School, where he studied documentary direction. He has
been featured on the Discovery Channel and has been the subject of
articles in *National Geographic*, the *Washington Post* and the *Boston Globe*. With
Rob Irving and Mark Pilington he is the co-author of *The Field Guide: The
Art, History and Philosophy of Crop Circle Making*.

MARCI MACGUFFIE (P.32)
www.baumgartnergallery.com
Marci MacGuffie has had solo exhibitions at Baumgartner Gallery in
New York and in Connecticut at Real Art Ways in Hartford, ArtSpace
in New Haven and Fairfield University in Fairfield. She has participat-
ed in group exhibitions worldwide: at the Elam School of Fine Arts in
Auckland, New Zealand; Goff and Rosenthal in Berlin, Germany; Exit
Art in New York City; Smack Mellon and Rotunda galleries in Brook-
lyn, New York; Montserrat College of Art in Beverly, Massachusetts;
The Discovery Museum in Bridgeport, Connecticut; and the Hudson
D. Walker Gallery at the Fine Arts Work Center in Provincetown, Mas-
sachusetts. She holds a BFA from Cornell University and an MFA in
painting and printmaking from the Rhode Island School of Design.
She was the recipient of a Puffin Foundation Grant in 2004 and the
Exposure Award from the Discovery Museum in Bridgeport, Connect-
icut, in 2001. Her work was also selected for display at the Library of
Congress in 2001. She currently resides in Brooklyn, New York.

SUSAN MAGNUS (P.83)
www.susanmagnus.com
Susan Magnus explores symbolic aspects of collections and material
culture through installations, sculpture, photography and works on
paper. Her work has been included in exhibitions at the UC Berkeley
Art Museum, the Rena Bransten Gallery in San Francisco, the Paris
Gibson Square Museum in Great Falls, Montana and the Islip Museum
in East Islip, New York. Her work is held in many private and public
collections, including the San Francisco Museum of Modern Art, the
Oakland Museum of California, the UC Berkeley Art Museum, the
Microsoft Corporation and the Oracle Corporation. She is the recipi-
ent of a Visual Arts Award from the Wallace Alexander Gerbode Foun-
dation, a Regional Fellowship from the National Endowment for the
Arts and a Jack and Gertrude Murphy Fine Arts Fellowship from the
San Francisco Foundation.

JOE MANGRUM (P.64)
www.joemangrum.com
Upon earning his BFA from the School of the Art Institute of Chicago
in 1991, San Francisco–based artist Joe Mangrum began his career as a
oil painter. He continued his studies through world travel and eventu-
ally shifted his attention to ephemeral site-specific works. Interested
in texture and structure, Mangrum creates a dialogue between found
or fabricated objects and natural materials. In 2003 he was the recip-
ient of the Lorenzo de Medici award for his installation at the Florence
Biennale. His work has been included in exhibitions at the San Fran-
cisco Museum of Modern Art's Artist Gallery and the 2005 Bioneers
Conference in San Rafael, California. In 2006 his installation at Ch'I
Fine Art in Brooklyn was awarded "Best in Show" by the *Village Voice*. In
2005 he contributed to World Environment Day in San Francisco with
Detonation Earth, an installation showcasing a four-story-tall mushroom
cloud made from live wheatgrass. Mangrum was recently interviewed
for the PBS program *Spark*.

TAKAGI MASAKATSU (P.26)
www.takagimasakatsu.com
Japanese artist Takagi Masakatsu works in video, music and discography. Solo exhibitions of his work have been displayed at the Byblos Gallery in Verona, the Transplant Gallery in New York, the CAI Gallery in Hamburg and Pepper's Gallery in Tokyo. Two of his albums, *Eating (Karaoke)* and *Journal for People*, have been widely acclaimed. From 2002 to '05, Masakatsu was involved in several video and music commissions for record labels and cultural institutions in Tokyo, including Sony DefSTAR Records, Victor Speedstar Records and the Spiral Hall Art Center. He lives and works in Kyoto, Japan.

LAURA MCPHEE AND VIRGINIA BEAHAN (P.58)
www.lauramcphee.com
www.laurencemillergallery.com
Laura McPhee and Virginia Beahan collaborated for fourteen years, photographing diverse locations worldwide in an effort to document and investigate how human behavior and the natural world affect one another. Their work has been exhibited at the Museum of Fine Arts in Houston, Texas; the San Francisco Museum of Modern Art; the Art Museum at Princeton University; and the Los Angeles County Museum of Art. Together their photography is held in several public and private collections, including the Rose Art Museum at Brandeis University in Waltham, Massachusetts, the Polaroid Corporation Collection, and the Reader's Digest Corporate Collection in Cambridge, Massachusetts. They were the recipients of a John Simon Guggenheim Memorial Foundation Fellowship in 1994 and a Polaroid Artists Support Grant from the Polaroid Corporation in 1991. McPhee earned her MFA in photography from the Rhode Island School of Design in 1986; Beahan earned her MFA in photography from the Tyler School of Art at Temple University in 1984.

LORI NIX (P.48)
www.lorinix.net
Lori Nix is a photographer from Norton, Kansas, who has portrayed the natural disasters—floods, snow storms, tornadoes—that occur in the Midwest. Early influences on her work include the classic children's book *The Wizard of Oz* and Truman Capote's *In Cold Blood*, both of which take place in her home state. Nix now resides in Brooklyn, New York; her more recent compositions explore the boundaries between rural and city environments. In 2001 she was invited to be a Light Work Artist-in-Residence in Syracuse, New York, and in 2004, she was the recipient of an Individual Artist Grant from the New York Foundation for the Arts. She received her MFA in photography from Ohio University in Athens, Ohio, in 1995. She has had solo exhibitions at the Miller Block Gallery in Boston, the Alona Kagan Gallery in New York and the California Museum of Photography in Riverside.

SIMON NORFOLK (P.52)
www.simonnorfolk.com
Photojournalist turned landscape photographer Simon Norfolk has been capturing major world events and disasters through the lens of his cherrywood and brass field camera for more than fifteen years. However, it was not until after his book *For Most of It I Have No Words: Genocide, Landscape, Memory* was released in 1998 by Dewi Lewis Publishing that Norfolk began to showcase his work as art within museums and galleries. His images have been exhibited individually and collectively at numerous venues, including the Royal Photographic Society in Bath, England, the Holocaust Museum in Houston, the Griffin Center for Photography in Boston and the Thessaloniki Museum of Photography in Greece. He has participated in several art shows, among them the Tenth Turin Biennale in 2003 in Italy and the Hereford Photography Festival in 2002 in England. His work is also held in many private and public collections, including the Hayward Gallery in London, the British Council, the Houston Museum of Fine Arts, the Los Angeles County Museum of Art and the San Francisco Museum of Modern Art. A native of Lagos, Nigeria, Norfolk now resides in Brighton, England.

SVEN PÅHLSSON (P.74)
www.svenpahlsson.com
Digital video and photography artist Sven Påhlsson is a native of Lund, Norway, and currently divides his time between Oslo and New York. From 1985 to 1990 he studied at the National Academy of Fine Arts in Oslo, and from 1984 to 1985 he trained at the Oland Fine Art School in Sweden. He has received several fellowships and grants, including a

Vederlagsfondet grant in 2003 and a three-year Norwegian National Art Stipend from 1998 to 2000. He has participated in a number of art shows, including the 1993 European Media Art Festival in Osnabruck, Germany, and the 1991 Sao Paolo Bienal in Brazil. His work has been exhibited individually in museums and galleries in New York, Barcelona, Oslo, Tel Aviv, Milan and Paris, for more than ten years. Påhlsson's photography is held in several public and private collections, including the Stokel Collection, the Lillehammer Olympic Collection, the Levi Strauss Corporation and the National Museum of Contemporary Art in Oslo.

CECILIA PAREDES (P.86)
www.ceciliaparedes.com
Peruvian photo-performance, sculpture and installation artist Cecilia Paredes divides her time between art studios in San Jose, Costa Rica, and Philadelphia, Pennsylvania. She has participated in the Rockefeller Foundation Bellagio Residency, the Sixth and Seventh Havana Biennial, the Ev+a Project in Ireland, The Floating Land event in Australia, and the 51st Venice Biennial, among other programs. Highlighting the concept of metamorphosis throughout her work, Paredes uses her own body to inform the outcome of her art. She has had solo exhibitions at the Contemporary Museum of Art and Design in Costa Rica, and at the Museums of Modern Art in Guatemala and Panama.

ROBERT AND SHANA PARKEHARRISON (P.136)
www.parkeharrison.com
The husband-and-wife team of Robert and Shana ParkeHarrison have been collaborating on their photographic essays for more than a decade. Through the creation of an "Everyman" character who appears in each photograph, the artists fabricate and control entire scenes, freely manufacture metaphor and reexamine myths. Their work speaks to our sense of responsibility and connection to the earth, as well as to the need to find balance. They received a Guggenheim Fellowship in 1999, an Artist Grant in Photography from the Massachusetts Cultural Council in 1996 and 2001 and a number of other awards. Their monograph, *The Architect's Brother*, was published by Twin Palms Press in 2000; there was a second edition in 2002. Their works are included in numerous collections, including the Los Angeles County Museum of Art, the Whitney Museum of American Art, the Museum of Fine Arts in Houston and the International Museum of Photography at the George Eastman House.

PHILIPPE PASTOR (P.126)
www.philippe-pastor.com
Abstract expressionist Philippe Pastor finds inspiration from nature and observed human experience. For the past four years his works on paper have been included in exhibitions and shows throughout Western Europe, at venues such as the Fondation RIVA in Venice, the Monaco Modern Art Gallery (the site of Pastor's former atelier) in Monte Carlo, the Museum of Antiquities in Turin and the Contemporary Fine Art Gallery in Saint-Tropez. He will exhibit his work at The Venice Biennale in 2007. His sculpture series, *Burned Trees*, has been on permanent display at the headquarters of the United Nations Environmental Programme (UNEP) in Nairobi, Kenya, since March 2006, as part of the organization's art and environment initiative in collaboration with the Natural World Museum. Pastor lives and works in Monaco.

PATRICIA PICCININI (P.112)
www.patriciapiccinini.net
Patricia Piccinini is a native of Sierra Leone who currently resides in Melbourne, Australia. She works in a variety of media, including paint, sculpture, video, sound, installation and digital print, exploring ethical dilemmas of our time such as cloning and numerous forms of genetic manipulation. She earned a BA in painting from the Victorian College of the Arts in Melbourne. Her art has been exhibited internationally since 1991 at museums and galleries such as the Tokyo Metropolitan Museum of Photography, the Venice Biennale, the Center for Visual Arts in Lima, the Australia Centre in Manila and the Institute of Modern Art in Brisbane. She has garnered several awards, including a New Media Fellowship in 2000 from the Australia Council and an Arts Development grant in 1999 from Arts Victoria. Her work is also included in several public collections, including the Australian National Gallery and the National Gallery of Victoria.

SUSAN PLUM (P.24)
Artist and human rights activist Susan Plum has participated in exhibitions at the Station Museum in Houston; the Fowler Museum UCLA in Los Angeles; Museo de la Ciudad, Queretaro in Mexico; Meridian Gallery in San Francisco; Urban Glass in Brooklyn, New York; the Montalvo Historical Estate for the Arts in Saratoga and the Bedford Gallery in Walnut Creek, California; and the William Traver Gallery in Seattle. She is on the board of WEAD (Women Environmental Artists Directory). She has taught at the Pilchuck Glass School in Washington; the Penland School of Craft in North Carolina; the Studio at the Corning Museum of Glass in New York; and the California College of the Arts in San Francisco and Oakland. Plum was born in Houston, Texas, and raised in Mexico; her bicultural background is present throughout her work.

MARJETICA POTRČ (P.158)
www.potrc.org
Based in Ljubljana, Slovenia, Marjetica Potrč is an artist and architect. Her work has been exhibited throughout Europe and the Americas, including at the Sao Paolo Bienal and the Venice Biennial. She has had solo exhibitions at the Guggenheim Museum in New York, the Protetch Gallery in New York, the Nordenhake Gallery in Berlin, the Palm Beach Institute of Contemporary Art (PBICA) in Lake Worth, Florida, the List Visual Arts Center at the Massachusetts Institute of Technology in Boston and the De Appel Foundation for Contemporary Art in Amsterdam, among other places. She has been the recipient of numerous grants and awards, including the Hugo Boss Prize in 2000.

ALEX PUTNEY (P.20)
www.humanresonance.org
Alex Putney investigates the relationship between science and spirituality in his multimedia projects, which have included oil painting, glass, bronze casting, stone carving, welding, Web site design, digital print and film. Through his Web site and his two-disc DVD, *Eyes of the Inner world*, Putney presents technological data from renowned research laboratories and uses these findings to reveal links to ancient belief systems such as those expressed in ancient Sanskrit texts and Mayan prophecy. In 1998 and 2000 Putney received grants from the Elizabeth Greenshields Foundation, and in 2002 he was awarded a Brandeis-Hilde Traveling Fellowship. In addition to his research, Putney also finds outlets in meditation and visualization techniques—both of which he uses to achieve a higher consciousness rooted in the earth's natural systems.

JAUNE QUICK-TO-SEE SMITH (P.42)
The painter Jaune Quick-to-See Smith was born in 1940 in St. Ignatius, Montana, and raised on the Flathead Reservation. She is of Salish-French-Cree and Shoshone heritage. She became an artist in her thirties, and received her MFA degree from the University of New Mexico. Smith has had more than eighty solo exhibitions in the past thirty years. Over that time, she has organized or curated more than thirty Native exhibitions and lectured at more than 175 universities, museums and conferences internationally. Smith has completed several collaborative public art works, such as the floor design in the Great Hall of the new Denver Airport, an on-site sculpture in Yerba Buena Park in San Francisco and a mile-long sidewalk history trail in West Seattle, Washington.

KEN RINALDO (P.116)
www.kenrinaldo.com
Ken Rinaldo is an electronic installation artist and theorist who explores the intersection of biology and technology and the interdependence between the earth and humanity. He has participated in exhibitions at the World Ocean Museum in Russia; the Biennale of Electronic Arts in Perth, Australia; the Exit Festival in France; and ARCO Arts Festival in Madrid, Spain. The Kiasma Museum of Contemporary Art in Helsinki, Finland, the AV Festival England 2006 and Lille 2004 European Capital of Culture have commissioned installations. Rinaldo received an Award of Distinction in 2004 at Electronica Austria and first prize at Vida 3.0 Madrid for his work *topoiesis*. His works has been reviewed in publications including *NY* magazine, *Circa Art Magazine* in Ireland and *Wired* magazine in San Francisco. He is currently an associate professor in the Department of Art at The Ohio State University in Columbus, Ohio, teaching 3D modeling, rapid prototyping and robotics. Rinaldo is a descendent of the American inventor of the steamboat, Robert Fulton.

XIS ROCKMAN (P.110)

erican artist Alexis Rockman's paintings and drawings explore the rsection of humanity and nature, science and art, documentary fantasy. Having worked with specialists in molecular biology, nat- history and climate change, Rockman uses his in-depth knowl- of both the history of science and the history of art to confront 's effects on the natural world. Born and raised in New York , Rockman cites regular visits to the Museum of Natural History the Bronx Zoo as important childhood influences. His recent jects, *Manifest Destiny* at the Brooklyn Museum and *Wonderful World* at Camden Arts Centre in London, examine, respectively, the effects lobal warming and the biotech revolution. He has taught studio courses at Columbia and Harvard. His work is in the permanent ections of several American institutions, including the Museum ine Arts in Boston, the Brooklyn Museum, the Guggenheim and Whitney Museum of Art. His upcoming projects include *The Bio- que* at the Contemporary Arts Center in Cincinnati in 2007 and a ey of his works on paper at the Rose Museum in 2008.

LI RUBIN-KUNDA (P.124)

.wave.co.il/rubinkunda

ltidisciplinary artist Lezli Rubin-Kunda creates site-specific per- mance-based work in which she uses her body and surrounding erials to directly interact with both natural and man-made envi- ments on an intimate and tactile level. A native of Toronto, Rubin- nda received an MFA from the School of the Museum of Fine Arts Boston in 1989. She currently lives near Tel Aviv and teaches in the hitecture and Town Planning Department at the Technion Institute Haifa, Israel. Her projects have been presented in many festivals venues, including the eBent Performance Festival in Barcelona, Western Front in Vancouver and Gallery One One One at the Uni- sity of Manitoba in Winnipeg; her performance videos have been ened extensively. Her work has been exhibited at the San Francisco Institute, the Arad Museum of Art in Israel, the DeLeon White lery in Toronto and the Espais Foundation in Girona, Spain.

ELLEY SACKS (P.114)

.exchange-values.org

ormed by her studies and collaborations with the German concep- artist Joseph Beuys, and by the framework of his Free International iversity, Shelley Sacks promotes connective practices and ecologi- consciousness through contemporary installation, lecture/perfor- nces and social sculpture processes that create arenas for new vision. serves as the director of the Social Sculpture Research Unit and reader in fine art at Oxford Brookes University in England. She ned a postgraduate scholarship to Kunstakademie at the University Hamburg in 1974. In 2002 her project *Exchange Values* was presented the eleventh time at the World Summit on Sustainable Develop- nt in Johannesburg. Her work has taken place in contexts through- the United Kingdom including the Civil Arts Inquiry, Dublin; Edinburgh Royal Botanic Gardens; and the NOW Festival in Not- gham. Sacks is currently working in Germany, Switzerland, the ited Kingdom and the United States on several long-term social lpture projects, including *University of the Trees, 100/0 Voices, Land of Milk H(m)oney* and *Earth Agenda*, in collaboration with citizens' networks, anizations, cities and museums.

LEDAD·SALAMÉ (P.160)

w.soledadsalame.com

ntemporary Chilean artist Soledad Salamé earned her MA from the aphic Arts Institute, CONAC, in Caracas Venezuela. Her prints, lpture, drawings, paintings and mixed-media installations have ap- ared twice at the National Museum of Fine Arts in Santiago, Chile, as ll as at the Katonah Museum of Art and El Museo del Barrio in New rk, the Milwaukee Art Museum, the Miami Art Museum, the Denver Museum, the Phoenix Art Museum and The National Museum of men in the Arts in Washington, D.C. She is the recipient of a Latina cellence Award and a Pollock-Krasner Foundation grant. Her work represented in private and public collections, including the National useum of Women in the Arts in Washington, D.C., the Baltimore useum of Art in Maryland and the University of Essex in England. e lives in Baltimore, Maryland.

LESLIE SHOWS (P.68)

www.jackhanley.com

Originally from Alaska, Leslie Shows received her MFA in 2006 from the California College of the Arts. Her mixed-media paintings reflect both her childhood memories of playing near glaciers and calcified mining ruins and her current interest in the multilayered relation- ship between geology and culture. Her work has been displayed at the Jack Hanley galleries in San Francisco and Los Angeles. In 2006 Shows participated in the California Biennial at the Orange County Museum of Art in Newport Beach. Shows also participated in *ECO, Art About the Environment*, an exhibit at San Francisco State University in 2005. She is the recipient of a San Francisco Museum of Modern Art 2006 SECA award and the Headlands Center for the Arts 2006-07 Tournesol Award.

DUSTIN SHULER (P.118)

In his paintings, drawings and large-scale installations and sculptures, Pittsburgh, Pennsylvania native Dustin Shuler investigates and chal- lenges our normal human perceptions about the use of space and ma- terials. Since 1977 Shuler has had solo exhibitions in California at the Shoshana Wayne Gallery in Santa Monica, the Laguna Beach Museum of Art, the Natural History Museum in San Diego and the American Gallery in Los Angeles. His public projects and commissions include *Albatross V* at the Santa Barbara Airport, *Pinned: Aircraft as Butterfly* at the American Hotel in Los Angeles and *Spindle* at Cermak Plaza in Berwyn, Illinois. His work has been reviewed and featured in national and in- ternational magazines such as *Sculpture, National Geographic, Stern, the Los Angeles Reader* and *Harper's*, as well as in the *Wall Street Journal* and the *Los Angeles Times*.

KATRÍN SIGURÐARDÓTTIR (P.60)

www.takesyou.to

Based in New York, Icelandic artist Katrin Sigurðardóttir earned her MFA from the Mason Gross School of the Arts at Rutgers University in New Jersey in 1995. Central to her work is scale; from her expansive installations to her miniature models, Sigurðardóttir is interested in perceptions of location and space. Her work has been showcased inter- nationally, beginning with her first solo exhibition at the Sævar Karl Gallery in Iceland in 1993. In 2000 she participated in the Nordic Art Biennale in Moss, Norway. She has been awarded four National Artist Fellowships from the Icelandic Department of Culture, and in 2005 she was the recipient of the Louis Comfort Tiffany Biennial Award and the Rema Hort Mann Foundation Grant.

JENNIFER STEINKAMP (P.40)

www.jsteinkamp.com

Digital video installation artist Jennifer Steinkamp uses video projec- tors and personal computers to create interactive environments de- signed for specific architectural spaces. Entering Steinkamp's work sites, viewers can often participate in her exploration of motion and perception. Her art has been produced for exhibitions at the Lehmann Maupin Gallery in New York, the San Jose Museum of Art in Califor- nia and the Soledad Lorenzo Gallery in Madrid, Spain, among other contemporary art institutions worldwide. She earned her MFA in 1991 from the Art Center College of Design in Pasadena, California. Steinkamp is the recipient of three National Endowment for the Arts grants and a Getty Individual Grant from the California Community Foundation in Los Angeles, and has received several nominations for film, video and multimedia fellowships from the Rockefeller Founda- tion.

PAT STEIR (P.63) ·

www.cheimread.com/steir.html

Steir has said that she creates her work with the attitude of a gymnast, "First the meditation, then the leap." In her art she has given up chasing the self in favor of "something larger." Steir's work has been described as having a Taoist view of nature: a poetic picturing of mankind's re- lationship to the elemental qualities of earth, air, fire and water. She has had more than 120 one-person shows. Her work has been fea- tured at the Venice Biennale, Documenta, the Sao Paulo Bienal, the Museum of Modern Art, the Whitney Museum of Art, the Philadelphia Museum of Art, the Hirschhorn Museum, the Chicago Art Institute, the Walker Art Center, the San Francisco Museum of Modern Art, the Los Angeles County Museum of Art, the Musée d'Art Moderne de la Ville de Paris, The Tate Gallery and the Cabinet d'Estampes, Geneva. She lives in New York.

ERICK SWENSON (P.70)

www.jamescohan.com

Mixed-media artist Erick Swenson finds inspiration in museum exhib- its, set design, special effects on film and model making. His simulated settings are painstakingly detailed and often exceed the ideals of nature. Shortly after earning a BFA in studio art from the University of Texas, Denton, in 1999, Swenson began participating in solo and group exhibitions in Germany, New York, Texas and California. His work was included in the 2004 Whitney Biennial Exhibition at the UCLA Hammer Museum in Los Angeles. He has also been awarded grants from the Arch and Anne Giles Kimbrough Fund at the Dallas Museum of Art in 1999, and from the Joan Mitchell Foundation in 2004.

FRED TOMASELLI (P.14)

www.jamescohan.com

Fred Tomaselli juxtaposes biological illustrations, actual plants and American consumer products such as prescription pills and magazine cutouts in his visually dynamic works. Born in California, Tomaselli earned a BA in painting and drawing from California State University, Fullerton, in 1982. His paintings have been showcased worldwide, col- lectively and individually, since 1984. His work is in the permanent collections of the Museum of Modern Art and the Whitney Museum of American Art in New York, the Museum of Contemporary Art in Los Angeles and the Carnegie Museum of Art in Pittsburgh, among others. He was the recipient of the Joan Mitchell Grant in 1998 and the Art Commission Award for Excellence in Design from City Hall in New York in 1993.

ADRIANA VAREJÃO (P.79)

www.lehmannmaupin.com

Sculptural painter Adriana Varejão was born and raised in Rio de Janeiro, Brazil; her work is deeply rooted in the complex heritage of her country. Using a variety of media, she explores the connec- tions between historic events, specifically the European conquest of the Americas, and contemporary indigenous Latino art. The galler- ies throughout Europe and the United States where her work has been showcased include the Cartier Foundation for Contemporary Art in Paris and the Guggenheim Museum in New York. She participated in the 1998 Sao Paulo Bienal, the 1995 Johannesburg Biennial, and the first Liverpool Biennial of Contemporary Art in 1999.

AMY YOUNGS (P.100)

www.hypernatural.com

After receiving her MFA in 1999 from the School of the Art Institute of Chicago, native Californian Amy Youngs quickly gained international recognition as a mixed-media artist. Her work has been exhibited in Madrid, Spain, at the Círculo de Bellas Artes; in Perth, Australia, at the Biennale of Electronic Arts; and in several galleries and museums in San Francisco, New York, and Chicago. In 2001 she was awarded an Individual Artist Fellowship Grant from the Ohio Arts Council, and, during the same year, her essay on art, technology and ecology was published in the art journal *Nouvel Objet 6*. She is currently an assistant professor in the Department of Art at The Ohio State University. She lives and works in Columbus, Ohio.

WYLAND (P.152)

www.wyland.com

Renowned marine life painter Wyland is best known for his massive mural series Whaling Walls, displayed in more than seventy cities worldwide. Committed to raising awareness about ocean conservation, Wyland formed the Wyland Foundation in 1993. As an environmental activist, Wyland primarily painted dolphins and whales in the 1970s, along with well-known artists Larry Foster of *National Geographic* and Richard Ellis. Through his nonprofit organization, Wyland has worked with and supported many groups, including Greenpeace, the National Audubon Society and the National Wildlife Federation.

Biography text compiled by Alyda Corbett.

colophon

The main text of this book was typeset in MrsEaves.
The main header text was typeset using Campanula.

This is a carbon-neutral book, with recycled material from China on its spine.

Publisher & Creative Director: *Raoul Goff*
Executive Director: *Peter Beren*
Acquisitions & Developmental Editor: *Lisa Fitzpatrick*
Art Director: *Iain R. Morris*
Book Designer: *Barbara Genetin*
Writer: *Noa Jones*
Managing Editor: *Jennifer Gennari*
Design Production Editor: *Carina Cha*
Press Supervisor: *Noah Potkin*

Earth Aware Editions would also like to give a very special thank you to Deanne LaRue, Sonia Vallabh, Mikayla Butchart, Gabe Ely, Pamela Holm, Mariah Bear, Joel Makower, Andrew Ütt and Justin Young.

The ART FOR THE ENVIRONMENT initiative is a joint project of The Natural World Museum and the United Nations Environment Programme. These institutions have joined forces to utilize art as a catalyst to empower individuals, communities, and leaders to focus on environmental values across social, economic, and political realms.

The NATURAL WORLD MUSEUM (NWM) is a mobile and global cultural institution providing innovative art programs to inspire and engage the public in environmental awareness and action.

THE UNITED NATIONS ENVIRONMENT PROGRAMME (UNEP) is the world's leading environmental agency and environmental arm of the United Nations System, providing leadership and encouraging partnerships for conservation efforts by inspiring, informing, and enabling nations to improve quality of life.

Autodesk

THE GLOBAL LEADER in 2D and 3D design software, Autodesk helps designers, architects and engineers experience their ideas before they're real, so they can analyze and predict the real-world performance of their projects. In the end, contributing to the development of sustainable buildings, products and infrastructure that lead to a cleaner and healthier environment.